READ ME

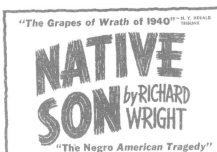

The world is realizing the greatness and humanity of this once-suppressed novel!

James Joyce's
ULYSSES

AFTER 16 years, during which Americans were forbidden to read one of the most noted novels of our time, ULYSSES, released by the Federal Courts, may now be read by all! Its republication in complete, unexpurgated form has been acclaimed by the press and public not merely

F. Scott Fitzgerald, Satirist

He has found, in his new novel, a dazzling field for his powers as a satirist. It is the strange, incredible American present— the queer, glamorous world of today, in which the most fantastic ups and downs of fortune can occur—an era whose extravagant contrasts suggest the crude, flaming days of the later Roman Empire.

THE GREAT GATSBY

Like Trimalchio, who staged his magnificent entertainments in the reign of Nero, The Great Gatsby lavished his wealth on invited and uninvited guests on his estate at West Egg, in what Fitzgerald calls the "great, wet barnyard of Long Island Sound." A romantic, mysterious, frustrate figure, his story as it unfolds in a swiftly moving narrative gives one an almost breathless insight into the life of today—shining and beautiful on the surface, thrilling, glamorous, and yet, at bottom, false.

$2.00 at all bookstores

CHARLES SCRIBNER'S SONS, FIFTH AVENUE, NEW YORK

oni Morrison's The

inquiry into the reasons why beau
try. The beauty in this case is black
cultural engine that seems to
ifically to murder possibilities; th
e blue eyes of the blond Ame
ard the black-skinned and brown-
s inadequate. Miss Morriso
ick-and-Jane-and-Mother-a
graph that appears in our re
h a prose so precise, so faith
pain and wonder that the
have said 'poetry.' But 'The
ogy, folklore, nightmare an
that we have institutionaliz
e under mountains of merch
to demonstrate that waste,
e the lie and die by it. Miss
helms."

The

fresnest, most precise language I've
Morrison is a wizard."

HE BLUES
by Toni Morriso
$5.95 at all book stores

Holt, Rinehart & Winston

READ ME

A Century of Classic
American Book Advertisements

DWIGHT GARNER

WITH A FOREWORD *by* DAVE EGGERS

ecco

An Imprint of HarperCollins Publishers

BRIEN. Her first novel
Green Eyes is the strongest
ing we have ever read about
oman and sexual adventure.

A WICKED MONTH

Edna O'Brien is a lovely writer and this
good novel indeed, tough and contemporary and
y well done."

FRIEDMAN: "A lovely book, one that lingers with
me fine and poignant meeting. Terribly tender
t ultimately quite proud and satisfying. I don't
n, in recent years, I have read a better book by a
r."

$3.95 at all booksellers. Simon and Schuster, Publishers

devastating political
etective story."
—William Hogan, *San Francisco Chronicle*

can't remember reading
ch an exciting–and
luminating–book in years."
—William L. Shirer

CARL BERNSTEIN ALL
AND
BOB WOODWARD THE
PRESIDENT'S
MEN

AL
LLER
ICATION!
copies

PROPERTY OF
COMMUNITY COLLEGE

KEN
KESEY

Photograph by Hank Kranzler

CATCH-22

DREAMS
FROM MY
FATHER
A Story of Race and Inheritance

BARACK
OBAMA

"One of the most powerful books
of self-discovery I've ever read.
Paced like a good novel."
—Charlayne Hunter-Gault, author and journalist

READ ME. Text copyright © 2009 by Dwight Garner. Foreword © Dave Eggers. All rights reserved. Printed in the United States of America. No part of this book may be used or reproduced in any manner whatsoever without written permission except in the case of brief quotations embodied in critical articles and reviews. For information, address HarperCollins Publishers, 10 East 53rd Street, New York, NY 10022.

HarperCollins books may be purchased for educational, business, or sales promotional use. For information, please write: Special Markets Department, HarperCollins Publishers, 10 East 53rd Street, New York, NY 10022.

FIRST EDITION

Designed by Mary Austin Speaker

Library of Congress Cataloging-in-Publication Data is available upon request.

ISBN: 978-0-06-157219-7

09 10 11 12 13 ID/RRD 10 9 8 7 6 5 4 3 2 1

26.99

This book is for Penn and Harriet

A boy has to hustle his book.

—TRUMAN CAPOTE

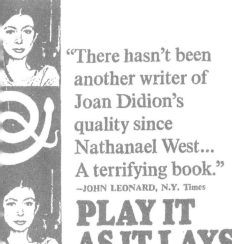
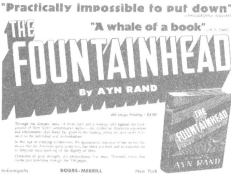

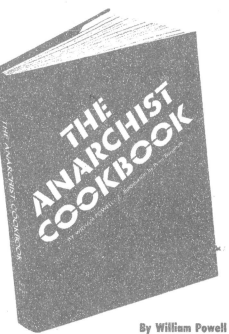

Contents

Foreword

by Dave Eggers

Books are incomparably personal things. That is, they communicate on the most intimate possible level—maybe more so than any other artistic medium. There's plenty of room for debate, sure, and most people would say, for instance, what about music? Isn't music a very intimate thing, that gets you emotional and sweaty, and aren't those sweaty emotions a kind of intimacy?

There's no point in going on about music, because the point here— the point of this introduction, which no one is reading anyway—is that books are even more intimate. Music affects us in a very personal and molecular way, too, but could it be that while music is an all-body sweaty sort of experience, and a powerful one to be sure, books give us a uniquely cerebral, and thus, even deeper experience? Could it be said that when you read, the book might be in your lap, but the author of the book is in your mind? Could it be said that the author is actually tinkering around

in your brain, pulling levers, throwing switches, lighting fires, and opening windows?

And given that the intimacy and intensity of the relationship between reader and author is unique and unparalleled, it inspires a certain evangelical fervor when the reader wants a friend to experience the same thing. When you've read something that moves you profoundly, that has realigned your thinking on a subject, has enabled you to see a subject or character or place anew, you thrust that book into the hands of anyone you can. You push it on your book club or students or, most problematic of all, your family. You become annoying.

You're annoying because it's hard to express just how that book knocked you flat, and how it might knock flat the people upon whom you're thrusting it. We find ourselves blubbering, stuttering, making inappropriate comparisons, and not coming within miles of properly expressing what it is about the work that makes it work. Finally, facing blank stares and offers of borrowed medication, all we can do is beg to be trusted. Please, trust me, we say, this will change your life.

Now imagine that instead of your recommending, casually and without obligation, books to friends and family, you have to do it for a living. You have to get the books you love into the hands of a distracted populace, and your livelihood depends on it. No, more than your livelihood. Also the livelihood of the author. It's up to you whether or not that author can write another book. It's up to you whether the publisher, already broke and almost broken, can live to publish other books. And the bookstores. You're the one who sends people to the bookstores. So you're responsible for the bookstores' employees, and the families of these employees, all living in wonderful book-lined homes, but homes that still need their mortgages paid.

Yes, you're responsible for them all. And you're responsible for the future of all literacy. That, too. If people don't buy the books, then books don't get written, and we become like those blond creatures from H. G.

Wells's *The Time Machine*, those future lotus eaters who are bred by the mole-men just so they, the mole-men, can feast on the succulent flesh of the non–book readers. So you're the one who has to save us from flesh-eating cave dwellers.

All of it relies on you, because you're the one who has to create the ads for the books. (This is the thought experiment we're doing here in this introduction [and you're loving this thought experiment].) Yes, you are the maker of the ads. You have to take what is a very expensive thing—an ad in one of the major book reviews or magazines is back-breakingly expensive for most publishers large or small—and make sure that that ad pays dividends. You have to find a way to communicate the essence of a book, while also creating some kind of excitement about the author generally, and also getting the reader of the ad to purchase the book that day, that week—before the ad and book and publisher and author are forgotten that week or forever. You have to start a fire about that book, hoping that a small group of people will take a chance on that book, and that that small group reads that book, creates a spark of some kind, then tells their friends, and those friends fan that fire, and that fire grows to burn down a vast section of Southern California, including Orange County (without burning all the books that were bought). Thankfully, no one was hurt.

The publisher, and the many departments within, editorial and promotional, have to find a way to get those books into the hands of those who want and need them. This book by Dwight Garner presents some of the most innovative ways they've done so, some of the most original, most desperate, most passionate, and even misguided. The range of work herein is startling, and so much of it is wildly eccentric, but in a way, it's all kind of unsurprising. It's unsurprising that publishers have been grabbing people by the lapels, promotionally and otherwise, for centuries, trying to spread the word about the books that matter to them. It's even unsurprising how personal some of the ads are, how pleading and even intimate. Books are personal and intimate things, this we've established,

so it follows that the ads promoting them would be personal, eccentric, that the ads would be full of passion and innovation and even hyperbole. The makers of the ads have been engaged in nothing less than the preservation of the written word and salvation from the mole-men who would like nothing better than, in a bookless world, to feast on our flesh. So consider this a book about the most essential undertaking ever by humankind—the creation of ads promoting books—and that, by extension, this book, the one you're holding, which collects all the best book ads ever, is the most essential of all books yet created by humans. Nice job, Dwight Garner. ❧

READ ME

LAUGHING TORSO
by NINA HAMNETT

Only the author of

FROM HERE TO ETERNITY
James Jones
could have written

THE THIN RED LINE

HISTORY
-written by the Man who Made It! . . .

H AD Robespierre been able to set down the history of the French Revolution, had Bonaparte employed his desolate St. Helena hours to record the Napoleonic era, had Cromwell turned from the sword to the pen, books might have been born comparable to this of Leon Trotsky.

Never before has the history of so epochal an event been written by a man who played a dominant part in it. Never before has so colossal a revolution—perhaps the most significant single event in

Second Printing of Leon Trotsky's Book Now Ready

. . . as exciting as a truthful diary, as tense as a good scenario . . .

"Trotsky has in this volume done for history what Strachey did for biography. Under his brilliant pen the past palpitates. The book is as exciting as a truthful diary, as tense as a good scenario.—LOUIS FISCHER in *Herald-Tribune "Books"*

". . . *history for all its dimensions of glory and pain . . .*

"Unquestionably Leon Trotsky's 'History' is the most remarkable piece of writing that has yet appeared on the greatest event under the French Revolution. It is more than that. It is also a work of art. Trotsky, however, is no ordinary historian. The reader feels her is living history in all its dimensions of glory and pain, and understanding it too.—SIDNEY HOOK in the *Saturday Review of*

SEX AND THE SINGLE GIRL

"With this new book,
Robert Lowell
becomes a poet as vital to our present
as Whitman was to our past."
—PHILIP BOOTH, *Christian Science Monitor*

THE imagination behind the poems is like the imagination of a great historian, at once passionately literal and fiercely prophetic."
—G. S. FRASER, *front page N. Y. Times Book Review*

Books by
Robert
Lowell

ROBERT LOWELL'S
FOR THE UNION DEAD
3rd Printing

$3.95, now at your bookstore FARRAR, STRAUS & GIROUX

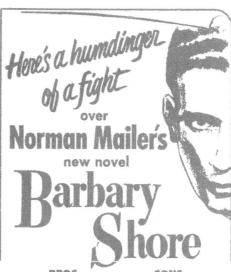

Here's a humdinger of a fight over
Norman Mailer's
new novel
Barbary Shore

PROS

❝ We think it is beyond question that it will generate more talk and publicity than any other book of the month. If the fact of Mailer's talent needed any further confirmation that is now taken care of completely,

CONS

❝ The most hopeless piece of undiluted gibberish I've encountered in a long time . . . It is surprising that the author of *The Naked and the Dead*, whose debut was hailed with such wild superlatives, should

MALCOLM X

With the assistance of Alex Haley. Introduction by M. Handler. Epilogue by Alex Haley. With illustrations. 2 printing before publication.

$7.50, now at your bookstore, or direct from the publisher. (Please enclose payment with order)
GROVE PRESS
80 University Place, New York, N. Y. 10003

*The Author of OIL!
Now Turns His
Searchlight
of Exposure
on the
Literary World—*

MONEY WR
by UPTON SINCL

DORIS LESSIN

Introduction

by Dwight Garner

Far too many readers, Gustave Flaubert wrote in 1863, have the quaint notion that "books dropped like meteorites from the sky." And for most of us, books still seem to appear as if by secular miracle. There they are—sleek, virginal, solemn, artful, alluring—in the bookshop window. It's as if each were beamed down fresh this morning, direct from its author's vexed forehead.

In reality, getting a serious book published and into a potential reader's line of sight is a long, difficult, sometimes anguished process, involving an intellectual and commercial conga line of dozens of people. A manuscript must be written, an agent found, a sale haggled over and consecrated—with champagne, or bitter tears, or both. The text is groomed and tweaked by editors and then copy editors, with marked-up proofs flying back and forth. A typeface must be chosen,

a title determined, a cover designed, jacket copy written, photographs taken, blurbs sought, print runs calculated.

If a writer is lucky, he'll pop out at the other end of this machine, many months later, blinking in the strange sunlight, staring at eager young publicity staffers, there to arrange things like book tours and radio appearances. If he is even luckier, there will be talk of commissioning that least literary but most ego-friendly of objects: a national newspaper or magazine—or, these days, Web—advertisement.

The book you are holding is a visual survey of book advertisements, plucked from yellowing newspapers, journals and magazines large and small, from across the United States during the twentieth century. Together these random advertisements tell a story—a kind of secret history, narrated in public—about America's literary culture over the past century or more. These telling documents have been buried for too long.

Great books, like every other kind of book, are new only once, and for only a short time. The advertisements in *Read Me* show us works like *On the Road*, *Sister Carrie*, *Catch-22*, *Invisible Man*, *Silent Spring*, *The Great Gatsby*, *Fear and Loathing on the Campaign Trail '72*, and hundreds of others at a time when they were simply books, jostling on the shelves with other new books, not yet monuments of our literary culture.

What's more, many of these advertisements capture writers—Toni Morrison, Ernest Hemingway, Cormac McCarthy, Harper Lee, John Updike, Hunter S. Thompson, Mary McCarthy, Harry Crews, and Norman Mailer among them—at moments before their careers were ensured, before their personae had hardened into those of "famous writers" or (in a few cases) into caricature. In many of these ads, there is a sense of destiny but also of vulnerability.

These advertisements are full of insights about how publishers sought to market provocative and intellectually thorny works of literature to mass audiences. They are packed with smaller, odder insights and delights as well. Who knew that Ralph Ellison blurbed Calvin Tril-

lin's first book, *An Education in Georgia*? Or that Jack Kerouac provided a blurb for Ken Kesey's *One Flew over the Cuckoo's Nest*? Scanning the twists and turns of some of the blurbs is one of the joys of browsing through these antiquated but resonant advertisements. Did Dorothy Parker mean it as praise when she said of John Updike's first novel, *The Poorhouse Fair*, "It stays with you on and on"? (So do herpes and bad *menudo*.) In an ad for Susan Sontag's first novel, *The Benefactor*, was Hannah Arendt knocking its lack of a discernible plot in saying, "I especially admired how she can make a real story out of dreams and thoughts"? The art of the potentially backhanded compliment is on frequent display here.

Read Me steps up, in part, to fill a gap. In the multiple overlapping and crisscrossing histories of writers and reading in the United States, book advertising is an under-explored topic. Scholars have mostly slipped around the subject. Most of the ads here have not been seen, let alone scrutinized, since they first appeared in print.

WRITERS, AS WELL AS PUBLISHERS, have frequently been wary of speaking about advertising—it's an arena that smacks of grubby commerce rather than genteel literary achievement. Book advertisements are a place where, as the historian Catherine Turner has suggested, "sacred artistic production" meets "profane mass culture." Advertisements mark a messy, fascinating, occasionally fetid crossroads, where the devil sometimes lingers.

Over the centuries, almost since the beginning of the written word—and certainly since Johannes Gutenberg introduced the printing press in the mid-1400s—some writers have fled, screaming, from anything that implied self-promotion. (Or at least they did as much in public.) In Shakespeare's time, before there was newspaper advertising, booksellers issued placards and circulars to drum up sales. Ben Jonson, the playwright, was mortified at this practice, instructing his publisher:

Nor have my Title-leaf on posts or walls,
Nor in cleft sticks, advanced to make calls
For termers, or some clerk-like serving-man,
Who scarce can spell th' hard names: whose knight less can.

Ralph Waldo Emerson was outraged when, after he sent a note of praise to Walt Whitman about *Leaves of Grass*, the entrepreneurial Whitman had the nerve to print some of Emerson's words—"I greet you at the beginning of a great career"—on the spine of the second edition.

And in a 1911 issue of the now defunct magazine *The Bookman*, a writer described the publishing industry's paranoia about crass newspaper ads this way: "A black band around an advertisement was the ironical sign of their inward grief for the death of their old ideals; they paled at Plymouth type; the extension of a picture through its border made an earthquake."

The friction between fine words and loud ones has not diminished, as anyone who witnessed Jonathan Franzen's public agonizing in 2001 over whether to let Oprah Winfrey place her book club's upbeat sticker on his novel *The Corrections* can testify. (Franzen's tortured waffling generated its own mountain of free publicity.)

If many writers have only warily promoted their works, others have eagerly embraced the task. Henry James had a character remark, in his 1903 novel *The Ambassadors*, that advertising can affect sales "extraordinarily; really beyond what one had supposed. . . . It's an art like another, and infinite like all the arts." James was not speaking directly of books, but he might as well have been.

When it comes to getting their words into potential readers' hands, writers have, since the beginning, seized whatever opportunities presented themselves. In the third century B.C., bookselling frequently took place at theaters. Plato's publisher had the following lines declaimed from the stage: "Hermodorus makes a trade of the sale of lectures." The Latin

poet Martial placed sales information directly inside his "epigrams," even going so far as to supply directions for pedestrians:

That you may not be ignorant where I am to be bought, and wander in uncertainty over the whole town, you shall, under my guidance, be sure of obtaining me. Seek Secundus, the freedman of the learned Lucensis, behind the Temple of Peace and the Forum of Pallas.

The world's first paid print advertisement, for any product, was for a book. This ad appeared in April 1647, in No. 13 of *Perfect Occurrences of Every Daie journall in Parliament, and other Moderate Intelligence*, printed in London. It read:

A Book applauded by the Clergy of England, called The Divine Right of Church Government, Collected by sundry eminent Ministers in the Citie of London; Corrected and augmented in many places, with a briefe Reply to certain Queries against the Ministery of England; Is printed and published for Joseph Hunscot and George Calvert, and are to be sold at the Stationers' Hall, and at the Golden Fleece in the Old Change.

This first ad supplied a template for all book ads to come, though later publishers would have seized on a single word: "Applauded!"

In the seventeenth century, printers functioned as publishing houses of a sort; they frequently sold the books from their presses directly to consumers. When actual bookstores began to proliferate in England, John Dunton gave this sage advice to their would-be owners: "Take a convenient Shop in a Convenient Place." Store windows were a prime advertising medium. It was as hard then as it is now to judge books by their appearance. As Charles Dickens observed in *Oliver Twist*, "There are books of which the backs and covers are by far the best parts."

Coffee and books, as it happens, were sold together long before the

provident marriage of Barnes & Noble and Starbucks. The second coffee shop to open in London shared space with a bookseller named Daniel Pakeman.

Notoriety has long brought free publicity. Henry Fielding (1707–1754), the author of the picaresque novel *Tom Jones*, described the case of a writer named Richard Savage, whose books were languishing unsold in storage until he killed a man and was sentenced to hang. Savage's publisher advertised his books the next day, and sold them out. We're as interested in bad publicity today. *Read Me* includes ads for books by men and women who have been convicted of murder, among them Jean Harris (who shot and killed Herman Tarnower, author of *The Scarsdale Diet*) and Jack Henry Abbott (who killed a man and then, after Norman Mailer, among other writers, helped him get out of prison, killed a second).

The first printing press in America was established in 1638. For a good part of the 1700s, however, most books in the United States were still being shipped here from England. The stern Puritan minister Cotton Mather scanned the assortment displayed in Boston's shop windows—in plain sight of impressionable women!—and he did not approve. Mather thundered:

> *Books . . . seen and sold at Noon-day, among us; which I cannot be faithful unto GOD, and unto you, if I do not forewarn you against the Reading of them. There are Plays, and Songs, and Novels, and Romances, and foolish and filthy Jests, and Poetry prostituted unto Execrable Ribaldry.*

Among the first truly American blockbusters—that is, among the first American books to achieve wide renown and sale—was Benjamin Franklin's *Poor Richard's Almanack*. Franklin was a canny promoter of his wares. He played smart, and rough. He used the first edition of his almanac in 1732 to falsely announce the impending death of his rival, an established

almanac publisher named Titan Leeds. Thus Leeds's loyal readers would henceforth, sadly, have to buy Franklin's product.

The Bookman magazine described the Monty Python–like comedy of what happened next: "Leeds rose to the bait with a denial, and for several years a controversy raged back and forth in the prefaces, Leeds insisting that he was alive and still doing business at the old stand, Franklin mourning him as one gathered to the fathers."

Throughout the late 1700s and early 1800s, books were sold in America in a variety of ways: printers would advertise books inside other books, they would sometimes print posters, and there began to be more reviews and (mostly small) newspaper ads. Word of mouth was then, as it is today, a book's best friend.

England was, at this point, still far ahead of the United States in terms of the development of its publishing culture. In fact, there was already a sense in the United Kingdom that publishers were going overboard in terms of soliciting blurbs—"puffs," as they were then called—for writers. The British poet and historian Thomas Babington Macaulay complained:

We expect some reserve, some decent pride, in our hatter and our bootmaker. But no artifice by which notoriety can be obtained is thought too abject for a man of letters. Extreme poverty may indeed in some degree be an excuse for employing these shifts as it may be an excuse for stealing a leg of mutton.

He further grumbled:

The publisher is often the publisher of some periodical work. In this periodical work the first flourish of trumpets is sounded. The peal is then echoed and reechoed by all the other periodical works over which the publisher, or the author, or the author's coterie, may have any influence.

The newspapers are for a fortnight filled with puffs. . . . Sometimes the praise is laid on thick for simple-minded people. "Pathetic," "sublime," "splendid," "graceful," "brilliant wit," "exquisite humour" and other phrases equally flattering, fall in a shower as thick and as sweet as the sugar-plums at a Roman carnival.

America's emerging cohort of great writers of the mid-1800s—Edgar Allan Poe and Nathaniel Hawthorne among them—were far from overnight successes. Their work did not sell well at first. Poe dreamed of founding a national magazine, of the type found in England, that would serialize works to pique readers' interest. Nathaniel Hawthorne famously complained of the "damned mob of scribbling women" whose sentimental work sold better than his own. (When *The Scarlet Letter* was about to be issued, Hawthorne wrote plaintively to his publisher: "If 'The Scarlet Letter' is to be the title, would it not be well to print it on the title-page in red ink? I am not quite sure about the good taste of so doing; but it would certainly be piquant.")

Herman Melville, who'd had early success with his travel books but lost his audience with *Moby-Dick* and *Pierre*, wrote to Hawthorne, in a letter of 1851:

Dollars damn me; and the malicious Devil is forever grinning in upon me, holding the door ajar. My dear sir, a presentiment is upon me,—I shall at last be worn out and perish, like an old nutmeg grater, grated to pieces by the constant attrition of the wood, that is, the nutmeg. What I most feel moved to write, that is banned,—it will not pay. Yet, altogether, write the other *way I cannot. So the product is a final hash, and all my books are botches.*

America's breakthrough novel, in terms of sales and instant critical repute, did not come from one of these distinguished men, or from Emer-

son, Thoreau, or Whitman. The book was Harriet Beecher Stowe's *Uncle Tom's Cabin; or, Life among the Lowly*, published in 1852. Stowe's novel was buzzed about when it was serialized in a magazine called the *National Era* in 1851. But it became a national and then an international phenomenon soon after it was published.

The print advertisements for *Uncle Tom's Cabin* are among the first that seem truly modern. One of them called it "THE GREAT BOOK!" and continued:

> *A sale unprecedented in the history of book-selling in America. On the 20th of March the first sale was made of this unparalleled book, and already 300,000 VOLUMES HAVE BEEN SOLD! Editors of Newspapers, Magazines, and even the staid Quarterlies, have vied with each other in their eulogistic notices. The ordinary style of book notices has been laid aside, and instead of puffs of half a finger's length, the press has sent forth column after column— literally hundreds of columns—of stronger and heartier commendations than were ever bestowed upon one book; and with well-nigh one voice, it has been pronounced to be THE GREATEST BOOK OF ITS KIND.*

Stowe's publisher, John P. Jewett & Co., moved swiftly to capitalize on the success of *Uncle Tom's Cabin*. Jewett commissioned the Quaker poet and abolitionist John Greenleaf Whittier to write a ditty called "Little Eva; Uncle Tom's Guardian Angel," which was published as sheet music. Stowe's book also inspired a pile of spin-offs that Wal-Mart would be proud of: dolls, games, pottery, puzzles, and many other items.

The modern publishing machine was beginning to appear on the American horizon. Yet in the years following the Civil War, books were still frequently sold, outside large cities, by subscription. The historian Nancy Cook has described the practice this way: "Agents used a prospectus—an incomplete sample of the book for sale—to gather subscriptions. Books were later delivered to the purchasers. Subscription publishers could predict sales and adjust production accordingly."

In 1880, Harper Brothers published *Ben-Hur: A Tale of the Christ*, a historical novel by a Civil War Union general named Lew Wallace. Two famous endorsements helped it surpass *Uncle Tom's Cabin* as America's best-selling novel, a distinction it would hold until the publication of Margaret Mitchell's *Gone with the Wind* in 1936. The first was from President James A. Garfield, who wrote a letter, much reprinted in newspapers, recommending it. *Ben-Hur* was also the first work of fiction to be blessed by the pope. By this time, as William Dean Howells, author of the realistic novel *The Rise of Silas Lapham* (1885), put it, a writer had to be a "man of business" as well as a "man of letters."

Mark Twain was a superbly canny salesman of his own work. He not only published *Huckleberry Finn* (1884) himself as a subscription book, but he also understood that controversy was both good fun and his best friend.

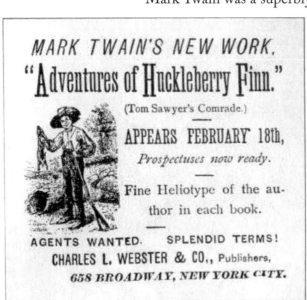

When the Concord Library Committee banned *Huckleberry Finn* from the library's shelves, calling it "the veriest trash," Twain was elated. He called the comment a "tip-top puff" and predicted that it would "sell 25,000 copies for us sure."

Twain was among the first writers who undertook something like the mod-

ern book tour, traveling to talk about his work—and read from it—in city after city. Book buyers, Twain knew, wanted to hear something about a writer and his or her personality. As Joseph Addison had explained in London's *The Spectator* a century earlier: "I have observed that a reader seldom peruses a book with pleasure 'til he knows whether the writer of it be a black or a fair man, of a mild or choleric disposition, married or a bachelor, with other particulars of a like nature, that conduce very much to the right understanding of an author."

In 1890, the book industry trade magazine *Publishers Weekly* was already muttering that "this is an age of ambition," and that aggressive sales techniques had damaged the "dignity" of book publishing. But some publishers handled the task better than others. As a writer said in 1891 in the American magazine *The Critic: A Weekly Review of Literature and the Arts*:

> *There is much to be learned yet in the manner of advertising books, no doubt. The best advertising of this sort that I can think of at this writing is in* The Atlantic Monthly's *bulletin of Houghton, Mifflin & Co.'s books. There you get a concise and temperate synopsis of the contents of the book and printed in such dignified type that you cannot fail to be impressed with the importance of the work under consideration. Publishers as a rule are conservative. They do not think that books should be advertised in such sensational ways, for example, as are patent soaps, and they are right. How, say, would Prof. Drummond feel should he take up a paper and read in its boldest type: 'GOOD MORNING! HAVE YOU READ 'PAX VOBISCUM'? Or what would be the sensations of Mr. Howells on seeing a placard bearing the legend: 'A HAZARD OF NEW FORTUNES'! YOU BUY THE BOOK— HOWELLS DOES THE REST!*

The first regularly published regional best-seller lists in America began appearing in *The Bookman* in 1895; by 1897 this magazine was

publishing national lists as well. The *New York Times Book Review* made its first appearance around this time, in 1896. It was published each Saturday until 1911, when it began to be issued on Sundays. The earliest version of what would become the *New York Times* best-seller list did not appear until October 1935.

BY THE TURN OF THE twentieth century, book advertising was approaching something like its modern form. The century's earliest book ads were generally straightforward, leaning on typography more than on other design elements. That doesn't mean they aren't fascinating.

Take, for example, the June 15, 1907, advertisement for Theodore Dreiser's novel *Sister Carrie*. Here is an ad that spoke, only a few decades after Whitman and Melville, to this country's acute sensitivity about its literary accomplishments. We're still looking over our shoulder at Europe. The ad asks: "Is there a Novelist in this country to rank with Zola and Balzac?" The answer: "Yes!" The ad is right, of course. But look again at the ad and its reasoning. Dreiser must be a master, this patriotic ad suggests, not because of his innate genius but because he's one of us. "The tone of Theodore Dreiser's story is better than anything written by the great French realists," the ad declares, *"because our country is better"* (emphasis mine).

Book advertisements loosened up in the 1910s. An ad for Edgar Rice Burroughs's *Tarzan of the Apes* (1914) is suggestive for its time, speaking of "his strange wooing." Jack London's book *John Barleycorn* (1913) is peddled like one of the first addiction memoirs. As in nearly all book ads before or since, London's book is compared to another classic—in this case, De Quincey's *Confessions of an English Opium Eater*. My favorite part of the ad for *John Barleycorn*? This is the suggestion that "against his wish and will, liquor has been forced upon" the helpless author.

Photographs of writers did not become common in book advertisements until the 1920s. But once these pictures did begin to play a role,

publishers used them to sculpture or mold a writer's public persona. Witness the face-off between the ads for F. Scott Fitzgerald's *All the Sad Young Men* (1926) and Ernest Hemingway's *A Farewell to Arms* (1929). Fitzgerald, his hair center-parted, comes off as the ultimate jazz-age, smart-set city slicker. On the other hand, Hemingway, a barrel-chested he-man, is photographed outdoors, on cross-country skis. You half-suspect he's towing a freshly killed elk.

Writers learned to play along, to a degree. As the sardonic Sinclair Lewis had his narrator suggest in *Babbitt* (1922), "In other countries, art and literature are left to a lot of shabby bums living in attics and feeding on booze and spaghetti, but in America the successful writer or picture-painter is indistinguishable from any other decent business man."

Photographs were put to wackier purposes in the 1920s, too. In 1927, the publisher Doubleday, Page & Company sought to sell an edition of Joseph Conrad's complete works with a wild, busy full-page ad under the titillating headline "Jungle Love—What happened when a white man and a native girl met far from civilization." Doubleday used a photograph from a B-grade movie of one of Conrad's novels, *The Outcast of the Islands*, depicting a bearded man (he looks strangely like John Belushi) who may or may not be about to have his way with a lovely blonde—a "savage beauty"—who has wilted under his masculine gaze. "Her smile," the ad says, "was the forerunner of sunrise and thunder." Conrad, who had died three years earlier, must have been turning in his grave.

It pays to study the fine print in these ads. Look at the small type at the bottom of the ad for Felix Salten's *Bambi* (1928). It reads: "Translated from the German by Whittaker Chambers." Yes, that's the same Whittaker Chambers who would, in the 1950s, play an outsize role in the Alger Hiss espionage case.

In the world of literary salesmanship, the 1920s were important for another reason. This was the decade when the young Alfred A. Knopf began to make his mark, a distinguished and long-lasting one, on Ameri-

can publishing. He'd founded his firm in 1915, and he quickly began putting his individual stamp on his products.

Knopf made his name, in his early years, by publishing the translated work of sometimes forbidding European writers like André Gide, Sigmund Freud, and Thomas Mann. At one meeting Knopf praised Mann's intellectual and literary gifts in the strongest possible terms, but added, "We mustn't forget to *sell* Mann's work."

Knopf, whose father had worked in advertising, paid attention to the look of things. He became well known, Catherine Turner wrote in her book *Marketing Modernism*, for "combining a commitment to high-quality paper and unique typefaces with jackets designed to look different from other company's books. . . . Willa Cather claimed to have changed publishers from Houghton Mifflin to Knopf in part because 'his early books looked very different from other books.'"

Knopf's early ads had a personal touch—he signed many of them himself. Turner writes: "While Knopf often appealed to what he and other advertisers called 'snob' value, he also attempted to make a personal connection with readers through his advertisements, seeming to create conversations with consumers by flattering them on their own good taste."

Knopf's Borzoi logo would become publishing's most famous, even if Ezra Pound scorned it. Pound thought Knopf should "sit the dog up, solid, more or less heraldic and respectful."

To this day, Knopf's books—and its ads—are distinctive. The ads have, for many decades, largely been created under the supervision of one woman, Nina Bourne, easily the most influential book ad designer of the second half of the twentieth century. She gave Knopf's ads their look— clean, uncluttered, heavily bordered, black-and-white. Just as important, she was and is a gifted and concise writer, able to uncork a book's elusive essence with a few perfectly chosen words. Many ads in this volume are her handiwork, or the work of designers aiming to duplicate her classy

but alert vibe. Now in her nineties, Nina Bourne still goes into Knopf's offices every day.

Nina Bourne is one of the few celebrities of the book advertising world. Most of the form's practitioners have been anonymous. But as John Updike wrote, commenting on James Agee's hundreds of unsigned articles for *Time* magazine: "Surely a culture is enhanced, rather than disgraced, when men of talent and passion undertake anonymous and secondary tasks."

BOOKS CAN'T BE SOLD LIKE diswashing liquid or automobiles; each book is a unique product. (Imagine if Chrysler had to market 150 different models every year.) It took a while for American publishers to learn to "brand" their best and most popular writers. But audiences can be persuaded to buy new books from authors they've admired in the past. In the 1930s, newspaper ads increasingly sought to drum an author's name into the public consciousness. Witness the ad for John O'Hara's 1935 novel *Butterfield 8*, one that repeated the author's name four times in large type: John O'Hara, John O'Hara, John O'Hara, John O'Hara.

The 1930s were the first decade when America's critics were famous enough to be frequently quoted by name in book advertisements. (In the past, most ads had merely identified the publications the quotations were drawn from.) For example, have a look at the May 7, 1939, advertisement for John Steinbeck's *The Grapes of Wrath*, with potent snippets of reviews by Clifton Fadiman, Alexander Woollcott, Dorothy Parker, and Louis Kronenberger, among others.

These critics aside, the book you are holding is not one that will increase your estimation of the level of this country's critical discourse. The same terms—magnificent, gripping, explosive (you get the idea)— are repeated in these pages with evil, mind-warping regularity.

In the 1940s, book ads got busier. See, for example, the March 1947 advertisement for James Michener's first book, *Tales of the South Pacific*,

which would go on to win the Pulitzer Prize. This ad has just about everything: a sketch of a sexy girl (check); quotes from major league critics (check); comparisons to other famous writers (check); enticing descriptions of the book's central characters (check). And see the smart shout-out at the bottom of the ad to the servicemen and -women "who were there."

A March 1940 advertisement for Richard Wright's *Native Son* was nearly as busy. Among the many other aspects of this ad, from Harper Brothers, was a mini-profile of the author that tugged at the heartstrings: "When he was five, his family moved to a tenement in Memphis, Tennessee. His father began to drift off for long intervals without leaving coal or food at home, and the child lived for some months in a sort of orphan's home."

The advertisements for Michener's and Wright's books are early examples of "smorgasbord" ads—those setting out a sprawling buffet of visual ingredients. Variegated typefaces are used, certain blocks of text are set off in boxes, and other ingredients would come to be added: visual devices like Victorian brackets, bullet points, and little finger-pointing icons. These ads invited you to sit, pour a stiff drink, and stay for a while.

By the middle of the twentieth century, the publishing world had increasingly taken on its modern form. Many smaller houses had been absorbed into larger ones; publishing became more of an actual business, with executives who had to answer to shareholders. This did not necessarily mean that people knew a lot more about what sold a book. By the mid-1950s, most American publishers were farming out the creation of their print ads to advertising firms, which would come to include such companies as Franklier Spier, Jameson, Mesa Group, Verso, and Sussman and Sugar.

Publishers remained uncertain—they still do—how and if advertising really worked. Bennett Cerf, a founder and longtime publisher of Random House, wrote: "Opinions vary on the effectiveness of book

advertising. I've always quoted Max Perkins, the great old Scribner editor, on the subject. He compared advertising a book to the problem of a car that's stuck: 'If the car is really stuck . . . ten people can't budge it. But if it's moving even a little bit, one man can push it on down the road. By the same token, if a book is absolutely dead, all the advertising in the world isn't going to help. If it's got a glimmer of life, if it's selling a little bit maybe in only one or two spots, it's moving enough to be given a push.'"

One of the virtuosos of book advertising at mid-century was Franklin Spier, who founded and ran the firm Franklin Spier, Inc. In a 1967 essay on the art of book advertising, Spier explained that although some popular books "attract even non-bookminded people simply because 'everybody is talking about them,'" publishers cannot, in the long run, depend upon these occasional readers.

"There is a hard core of regular book readers," Spier declared, "whose support the publisher must depend on, and whom he must influence first, if he hopes ultimately to reach the much larger circle of occasional readers among the public at large. These are apt to be regular bookstore patrons and readers of those magazines and newspapers which consistently carry book reviews. It is this hard core—the regular bookstore customers and readers of reviews—which is the number one target of publisher's advertising."

In his essay, Spier pointed out that publishers advertise for a surprising number of reasons. For one, he said, publishers want to impress booksellers, to show the seller that they are truly behind a book and that the store would be making a mistake not to stock it. Ads also influence authors and agents. "Many an author," Spier wrote, "has left one publisher for another because he felt that the first publisher was not giving his book enough advertising support."

Advertisements can influence reviewers. "The implication here is not that any reputable reviewer can be 'bought' by the use of his paper's advertising columns," Spier said, "but reviewers are apt to watch publish-

er's announcements (particularly those that appear in the trade papers) for information which will aid them in selecting books for review."

Finally, Spier said, ads can affect things like book club sales, reprints, and movie deals. "Publishers sometimes advertise solely to keep a book on the best-seller list while a projected movie sale is in prospect," he wrote. "Occasionally this works the other way around: movie producers have been known to contribute generously to the ad budget of the initial hardcover edition so as to reap the benefit of best-seller publicity for their film, when it finally appears."

Editors of the book review sections in regional newspapers and magazines have long complained that publishers spend too much of their ad budgets in only a few publications, like the *New York Times* or the *New Yorker*. About this problem, Spier wrote: "Since you cannot possibly hope to blanket the nation's press" within a typical ad budget, "you must present your book first to the group of steady readers of the better-known newspapers and magazines which over the years have fostered and developed a known audience of book readers." This tight focus may have been necessary, but culturally a price has been paid. It's been a sad business, watching the review sections of America's smaller big-city newspapers close in recent years.

Spier was around for book advertising's heyday, which truly commenced in the 1950s, with punchy advertisements like the one for Norman Mailer's second novel, *Barbary Shore* (1951). "There's a humdinger of a fight over Norman Mailer's 'Barbary Shore,'" the ad proclaimed, before listing a selection of reviewers' comments both pro and con. Among the cons was David Appel's review in the *Philadelphia Inquirer*, which read: "The most hopeless piece of undiluted gibberish I've encountered in a long time. . . . It is surprising that the author of 'The Naked and the Dead,' whose debut was hailed with such wild superlatives, should flounder so completely on his second attempt." This ad's unspoken premise: read the novel yourself to find out what all the fuss is about.

It's the 1960s and 1970s, however, that seem—to this reader, anyway—like the glory days of American book advertising. The books, and the ads for them, were terrific: fresh, pushy, serious, and wry, often all at the same time. There was a new sense of electricity in the culture and in the book world.

So many of them are worth close attention. See, for example, the November 1962 advertisement for Rachel Carson's *Silent Spring*, a book—drawn from her articles in the *New Yorker*—that exposed the harmful effects of pesticides and helped launch the modern environmental movement. Carson's book came under relentless attack from the chemicals industry, and her publisher undertook a campaign to forcefully rebut her corporate detractors. The ad you see here not only reprints pro-Carson editorials from newspapers and magazines, but provides many "unsolicited, unpaid-for comments by scientists" praising her book. (The odd implication here is that other comments in book ads are paid for.) This ad for *Silent Spring* includes a modest blurb from Supreme Court Justice William O. Douglas, who called the book "The most important chronicle of this century for the human race."

Other book ads from the 1960s playfully tinkered with the form. In 1968, Tom Wolfe had two new books in stores—*The Electric Kool-Aid Acid Test* and *The Pump-House Gang*—and in November of that year, his publisher, Farrar, Straus & Giroux, ran a full-page ad that cheekily sold him the way you might sell a tube of toothpaste. Over a photograph of a hip young couple seated cross-legged on the floor, the man holding one of Wolfe's new books while the woman held the other, the text asked, "Which Tom Wolfe bestseller should you read first?" This ad also repeated an excellent line from the poet Karl Shapiro in the *Washington Post*: "Tom Wolfe is a goddam joy."

Other ads from the 1960s were seriously sexy. Check out the June 1965 ad for Edna O'Brien's novel *August Is a Wicked Month*. At the time, O'Brien was the closest thing the book world had to Marianne Faithfull.

It's too bad Bruce Jay Friedman had to refer to her, in his blurb, as a "lady novelist." No matter. I want a poster of this ad on my wall.

Edna O'Brien aside, Michael Korda, the longtime editor in chief of Simon & Schuster, says that publishers have to be careful about when to use an author's photograph in an ad. "I think it's generally boring to use a photo," Korda told me. "I could not care less what a writer looks like, unless they are exceedingly glamorous. It seems like a waste of money." He added: "There are exceptions to that. There are authors who are themselves trademarks—Mary Higgins Clark's fans care about seeing her face and what she is wearing. The same goes for Danielle Steele. Their ads are based on them, not on the covers of their books. But you'd have to be out of your mind to use Larry McMurtry's photograph in an ad. People don't know or care what he looks like." (McMurtry's friendly, open mug did appear in an ad for his 1972 novel *All My Friends Are Going to Be Strangers*. The book's publisher? Korda's own Simon & Schuster.)

Many of the books discussed here did not become best sellers. But if publishers wanted any hope that a book would become one, the academic Richard Ohmann noted in his essay "The Shaping of a Canon, 1960–1975," they had to work quickly. "If a novel did not become a bestseller within three or four weeks of publication, it was unlikely to reach a large readership later on," Ohmann wrote. "In the 1960s, only a very few books that were slow starters eventually became best-sellers (in paperback, not hardback). I know of three: 'Catch–22,' 'Call It Sleep' and 'I Never Promised You a Rose Garden,' to which we may add the early novels of Vonnegut, which were not published in hard covers, and—if we count its 1970s revival in connection with the film—'One Flew over the Cuckoo's Nest.' To look at the process the other way around, once a new book did make the New York Times best-seller list, many other people bought it (and store managers around the country stocked it) *because* it was a best seller. The process was cumulative."

Ohmann also cited a 1968 study suggesting that there was a "cor-

relation between advertising in the [*New York Times*] Book Review and being reviewed there." (Similarly, he noted a correlation between being a Random House writer in 1968 and having your book reviewed in the *New York Review of Books*, which was cofounded by the Random House editor Jason Epstein and coedited by the late Barbara Epstein, who was then his wife.)

What to make of Ohmann's correlation? Here are two observations, one that somewhat exonerates the *New York Times Book Review* and one that somewhat chastises it. On the one hand, the publishers that can afford to advertise regularly can also afford to buy, at auction or otherwise, the most prized manuscripts from the world's best writers. On the other hand, large publishers can also afford to churn up buzz for a lousy book, and such buzz can make the *Book Review*'s editors feel a title is worth weighing in on. This is a trap that a *Book Review* editor—I was one for nearly a decade—tries not to fall into.

Throughout the 1970s, book ads were often just as beautiful as they had been in the 1960s. To pluck one from among many, see the May 1973 ad for Hunter S. Thompson's *Fear and Loathing on the Campaign Trail '72*. There's Thompson, coolly holding a cigarette between his middle fingers, beneath a headline that reads, quoting the author: "It is Nixon himself who represents that dark, venal and incurably violent side of the American character almost every other country has learned to fear and despise." It's hard to imagine a publisher who would have had the guts to run a similar quote about George W. Bush while he was president.

And speaking of Richard Nixon, have a look at the June 1974 ad for *All the President's Men*. In history, that book has gone down as a work by "Woodward and Bernstein." Check the original cover: Carl Bernstein's name came before Bob Woodward's.

Book ads grew less rowdy and less interesting in the 1980s and 1990s—not that there weren't terrific moments. Roy Blount, Jr., deserves an Excellence in Blurbing prize for his comment about Pete Dexter's

novel *Paris Trout*, which won the 1988 National Book Award. Blount's line: "I put it down once to wipe off the sweat." Those ten words might just constitute the best book blurb I've ever read.

IT'S HARD TO GET A clear sense of why book advertisements, for the most part, lost their punch after the 1970s. According to Alix Nelson, longtime CEO of the advertising firm Franklin Spier (later known as Spier NY), publishers, worried about losses, simply grew more conservative. "When I quit the business in the nineties," Nelson said, "every publisher essentially wanted their ads to say the same thing—you know, 'A Novel of Love, Loss and Redemption.' Which is a line that essentially says nothing. You could say it about a Cormac McCarthy novel."

Interestingly, more than a few well-known novelists began their careers in advertising—Sherwood Anderson, James Dickey, Don DeLillo, and Salman Rushdie among them. But although most novelists will secretly admit that they enjoy seeing their own ads—indeed, the amount of advertising they want is often written into their contracts—in their work they are largely wary of advertising's impact on our age.

One of the strongest novelistic indictments of advertising appeared in Frederick Exley's 1968 novel *A Fan's Notes*, a book that, as the historian Jackson Lears has pointed out, details a would-be writer's misadventures as "he lurches drunkenly from advertising agencies to mental institutions"—as if the two weren't so different.

As Exley's narrator stares at the Kodak and Schlitz ads that blanket the landscape, he thinks: "Surely this was the coveted America, those perennially rosy cheeks and untroubled azure eyes, those toothy smiles without warmth, eyes without gravity, eyes incapable of even the censorious scowl, eyes, for that matter, incapable of mustering even a look of perplexity. Well, it was *not* the America I coveted."

There's no word on what Exley thought of his own book's advertisement, in which a critic named Frank Smith said that *A Fan's Notes* was

"as serious about our cultural tradition as 'Lolita'—and is no more about football, in fact, than that book is about gynecology."

READ ME IS, TO BE sure, not a comprehensive survey of American book advertising. I'll leave that to scholars. Some readers may be disappointed not to find their favorite authors, books, or ad campaigns in this volume; but I have tried to provide as wide a selection as possible. There are ads here from every decade and for almost every sort of book—books on etiquette, self-help, finance, sex, celebrities, and sports heroes. However, I can't deny that I have focused especially on literary books; *Read Me* has a special interest in gazing at the ways high art has been marketed in this country. There is an aesthetic bias at work here, too. I have tried to pluck out those that are the most attractive and attention-grabbing.

There are ads in this book from publications including the *New York Review of Books*, the *New Yorker*, the *Paris Review*, *The Nation*, *Publishers Weekly*, *Dial*, the *Evergreen Review*, *Antaeus*, the *Kenyon Review*, and the *Saturday Review of Literature*, as well as the *New York Times*, the *Washington Post*, the *Los Angeles Times*, the *Atlanta Constitution*, the *Chicago Tribune*, the *Wall Street Journal*, and the *Baltimore Afro-American*.

The greatest number of ads, however, come from the daily *New York Times* and the Sunday *New York Times Book Review*, for reasons both intrinsic and practical. Because of its national distribution and reputation as the newspaper of record, the *Times* was, throughout the twentieth century, the primary advertising vehicle for most American publishers. It received, by far, the majority of publishers' advertising dollars. The *Times* is also where I have worked for the past decade, as an editor at the *Book Review* and now as a daily book critic. It was while browsing through back issues of the *Book Review* that I first became obsessed with these ads, and began to feel impelled to track down more of them.

In 2009, book advertising seems to be a dying business. There are more books being published than ever before, but as some book review

sections are eliminated and others (including the *New York Times Book Review*) are shrinking because of the economy and the migration of readers to the Internet, it seems unlikely we'll see another great resurgence of print ads. In another fifty years, when people look back on the finest book advertisements of the first half of the twenty-first century, it's possible they'll be combing through a loop of YouTube clips.

Book advertising's print heyday is behind us. But it was beautiful while it lasted. ❧

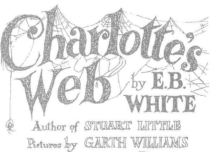

1907

THE
1900s

I s there a Novelist in this country to rank with Zola and Balzac?" That was the question posed by a 1907 newspaper advertisement for Theodore Dreiser's novel *Sister Carrie*. The ad answers its own question with a resounding "Yes!" But the explanation speaks volumes about America's lingering literary insecurity at the turn of the twentieth century. "The tone of Theodore Dreiser's story is better than anything written by the great French realists," the ad reads, "because our country is better."

This advertisement for Dreiser's novel was, like most book ads in the first decade of the twentieth century, simple and straightforward, almost homely. During this period, no photographs, and little other art of any other kind, appeared in American book ads. The ads in this chapter mostly rely instead on typography, and on the kinds of devices that were already familiar to readers—blurbs, testimonials, sales figures, modest hype.

Rudyard Kipling's *Kim* appeared in 1901, and the ad for this novel pounds the title into your head (publishers had not yet learned they had to turn writers into brands, not specific titles) while layering in ecstatic blurbs. When Upton Sinclair's *The Jungle* was issued in 1906, its publisher ran an ad that featured a blistering testimonial from a clergyman "who knows the real conditions in the stockyards." That clergyman told readers, witheringly: "The man who can read [*The Jungle*] without being moved to the depth of his being may know that judgment has been passed upon him." Amen.

Some book ads can seem, in retrospect, almost poignant. Witness the advertisement for the British writer Hall Caine's novel *The White Prophet* (1909). "A novel by Hall Caine appears in six to ten different languages on the same day throughout the world," the ad trumpets. "No other living or dead writer of fiction has had such a record." Hall Caine is all but forgotten now, of course, and his novels are unread—a reminder that, in the end, the only thing that matters is that a writer's work endures. ❧

READY TUESDAY.

Rudyard Kipling's

KIM.

"Kipling himself again."—*New York Sun.*

KIM.

"If Kipling should die now, his future fame would rest upon the authorship of 'Kim.'"
—*Sidney Colvin.*

KIM.

"Kipling at his best—Kipling never wrote anything that so immediately gripped the attention of the reader."—*William L. Alden in the New York Times.*

KIM.

"There is not the slightest doubt that 'Kim,' the mature work of a gifted story-teller and consummate artist, will add measurably to the author's already great reputation."
—*New York Times.*

KIM.

"The questionings and speculations of the critics may now cease. Mr. Kipling has answered them superbly, even magnificently, in the book which has just come from the press in its complete form."
—*N. Y. Commercial Advertiser.*

PUBLISHED BY

DOUBLEDAY, PAGE & CO.

34 Union Square, E., New York,

1901

Is there a Novelist in this country to rank with Zola and Balzac?

Yes!

THEODORE DREISER

Author of

SISTER CARRIE

Not that SISTER CARRIE is like any novel written by a Frenchman any more than America is like France.

True realism must have atmosphere, and SISTER CARRIE is an American novel by an American about America.

The tone of Theodore Dreiser's story is better than anything written by the great French realists because our country is better.

A great book has arrived. Buy it now and be able to say ten years from now "I bought SISTER CARRIE when it first came out."

2nd week, 2nd edition; 10th thousand ready. Large 12mo; over 500 pages. Colored illustrations. $1.50.

1907

HALL CAINE

Messrs. D. Appleton and Company beg to announce the publication, on August 27th, of Mr. HALL CAINE'S new novel, "THE WHITE PROPHET."

The appearance of a new work by this distinguished author is an important event in contemporary literature.

A novel by Hall Caine appears in from six to ten different languages on the same day throughout the world. No other living or dead writer of fiction has had such a record.

Something over 500,000 copies of each of his books are demanded by the reading public. No writer of fiction since Charles Dickens has had such an audience.

His "The Manxman," "The Eternal City," "The Christian," "The Bondman" have all taken their place in literature and laid their impress upon the times.

Now comes "The White Prophet." It is first of all a vivid, vital love story. It is, further, a story of religious fervor which though laid in the Egypt of to-day reproduces the religious exaltations of the beginning of the Christian era. The British Consul-General might well be Pontius Pilate. The white-robed Arab Mahdi might well be another Christ. The hero, a descendant of New England, might well be any man torn between his training to respect what his brain tells him is law and his instinct to follow what his soul tells him is right. When these elemental emotions are combined into a love story that is as deep as it is strong, you have such a book as only Hall Caine, after four years of tireless labor, can produce.

The novel, consisting of upwards of 600 closely printed pages, is illustrated by Caton Woodville, and may be secured from any bookseller or from the publishers.

1909

1903

1905

TUSKEGEE
AND ITS PEOPLE.

Prepared by officers and former students of the Normal and Industrial Institute at Tuskegee, Alabama, under the direction of

BOOKER T. WASHINGTON.

Portraits of several authors and views of the school.
12mo, ornamental cloth, $2.00 net; postage additional.

The book contains an introduction by Mr. Washington; a chapter on the ideals and achievements of the Institute by Emmett J. Scott, Mr. Washington's secretary; a chapter by Mrs. Washington on the teaching of girls, and a chapter by Warren Logan, the Treasurer. These are supplemented by autobiographical chapters by former students in various callings.

D. APPLETON & COMPANY, Publishers, New York.

1905

1905

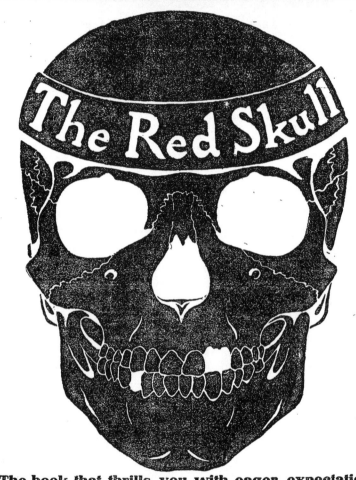

The book that thrills you with eager expectation and spell-bound interest. Fergus Hume's masterpiece. At every bookstore $1.50 Dodge Publishing Company

1908

1909

1908

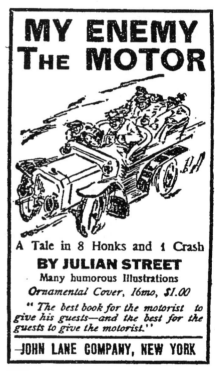

1909

1906

THE
1910s

A New Woman! A New Country! A New Idea!" A 1913 advertisement for Willa Cather's novel *O Pioneers!* captured the exuberance of the best book ads during the 1910s, a period when these advertisements became looser, louder—more modern. They also became nearly omnipresent. By 1913, the publisher Doubleday, Page & Company was asking, in one newspaper ad, "Too many advertisements? It *is* difficult, when they all come at once, to draw adequate attention to many important publications."

Theodore Roosevelt's *African Game Trails* was one of America's best-selling books in 1910, and there are signs, in the ad for it, that readers had already become wary of shoddy "celebrity" books. "I regard this book as a serious thing," Roosevelt declares in the ad, putting suspicions to rest. "I have put my best into it."

Jack London's book *John Barleycorn* (1913) was marketed like one of today's addiction memoirs. Poor London: "Against his wish and will," the ad reads, "liquor has been forced upon" him. The 1912 novel *The Melting of Molly*, by Maria Thompson Daviess, charted a woman's quest to "grow slim as a string-bean in just three months" in order to win a suitor.

During this decade, some of the literary ads went over the top. Witness the 1919 advertisement for a collected volume of Robert Louis Stevenson's work, with the headline "The Fight in the Round House!" This ad also touts the utilitarian quality of Stevenson's writing: it will "put life" into a "tired businessman." An ad for Edgar Rice Burroughs's *Tarzan of the Apes* (1914) was suggestive, speaking of Tarzan's "strange wooing."

Other ads took a softer approach. A small, self-consciously dignified notice for D. H. Lawrence's 1913 novel *Sons and Lovers* featured just text, and a zen-calm note from the publisher: "I do not ask you to buy it, but I do tell you that *Sons and Lovers*, by D. H. Lawrence, is one of the great novels of the age." ◆

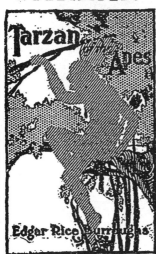

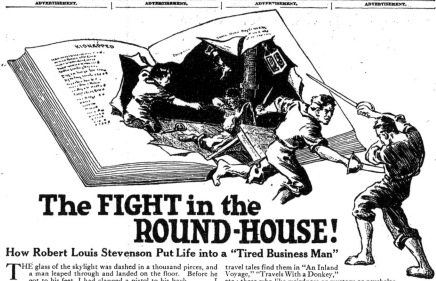

1913

1917

More E·K·Means

More of "dem delightfully funny Tickfall folks." More of the Tickfall "Whoop," of "Revun" Vinegar Atts of Shoo-fly Church and those laughter-loving pranksters—Figger Bush and Skeeter Butts. More of those inimitable stories of the Louisiana negroes that have made E. K. Means famous.

Illustrated by Kemble
At all bookstores $1.60 net

G.P. Putnam's Sons,
NEW YORK ——— LONDON

1919

 ## Shall We Profit Today By the Lessons Learned on the Mexican Border?

A year ago our whole military organization was put to an acid test by the call to the Mexican Border, and every defect and weakness was illuminated. It devolves on us now to apply the knowledge gained to the present situation.

How we can do so is shown in an uncommonly vivid and interesting book entitled WATCHING AND WAITING ON THE BORDER, written by ROGER BATCHELDER, a member of one of the machine gun companies.

To everyone who wants to see America make a record in the present war which she can be proud of, we recommend a study of this book.

Ask at your bookstore for

WATCHING AND WAITING ON THE BORDER
By ROGER BATCHELDER

With a notable introduction by E. Alexander Powell, the famous war correspondent

A book that shows from actual experience just why we need universal compulsory service

Profusely illustrated, $1.25 net.

16 E. 40th Street **HOUGHTON MIFFLIN COMPANY** *New York*

1917

1911

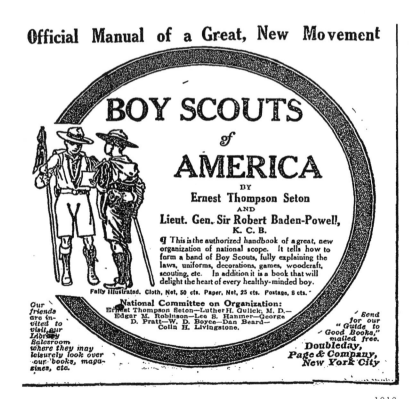
1910

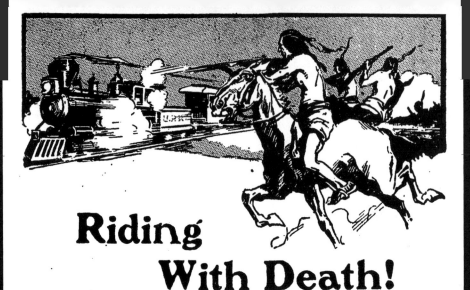

Riding
With Death!

IT would have been a massacre—but for Casey.
He was on a work car running wild downhill,
and alone he held up the band of Sioux. If they
had gotten through—

But this is just one thrilling incident of hun-
dreds crammed into the pages of The U. P. Trail.

It is a story of a brave and daring man—and of a girl
lovely as a flower, left at the mercy of Indians and white
men who are worse.

And back of it all lies the story of the building of the
Union Pacific Railroad—a romance beyond imaginings.
For in those days railroads were built of the blood of men
—every rail meant the body of a man. As you ride by
today in your comfortable train, you pass graves by the
side of the railroad where brave men sleep—about you
dance the ghosts of Indians.

This is a tale of the brawny sons of a stalwart age—a
tale you drink in eager gulps. And it proves—if such a
thing needed proving—that Zane Grey is not only a glorious
teller of tales, but a big writer—an artist—the Far West's
gift to the ranks of the great.

Get your copy today at your bookseller's, and breathe
the fresh, clean air of an earlier day.

Zane Grey's
Latest and Greatest Book
The U. P. Trail

1912

1913

1910

1915

1916

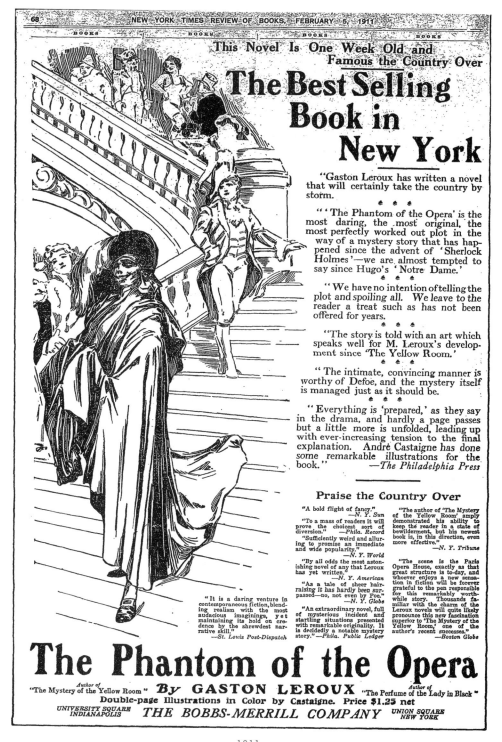

"No man of business...can afford to be without it!"

—Vice-President of the National City Bank, New York.

With such authority behind it, this frank statement ought to make all business men think. Isn't it shortsighted not to equip *yourself* and *your employes* with this most wonderful of all instruments of human knowledge—the *new* Encyclopaedia Britannica?

Any day down at the National City Bank

in Wall Street you will find the new Encyclopaedia Britannica in use in a working business library that is the product of the highest grade of business acumen.

The **Standard Oil** interests have never been behindhand in seizing upon aids to success. The men conducting this great institution appreciate the value of expert knowledge; knowledge that is available at any time it is wanted, and on any possible sort of occasion. They are men quick to recognize the latest and best means for improving efficiency. They make money work, whether they put it into an encyclopaedia or a share of stock. And they know that system counts, in making information accessible no less than in the handling of checks.

A **large manufacturer of flavoring extracts** found that information the book gave him about materials used in his business was alone worth more than its price.

A **big company engaged in the manufacture of steel and brass** products had the article on Iron and Steel reproduced for special use in connection with its business.

An **expert on commerce,** writing of the Industrial articles, says: "This work ought to find a place on the shelves of every manager of big works in the English-speaking world."

INDIA PAPER IMPRESSION

29 quarto volumes; 1,000 pages each; 44,000,000 words; 400 plates; 7,000 other illustrations; 300 maps. Occupying a cubic space of only 2 feet.

NATIONAL CITY BANK
Wall St., New York. The largest bank in America.

ELBERT H. GARY
Chairman of U. S. Steel Corporation.
Subscriber No. 15,767.

HOWARD ELLIOTT
President New York, New Haven & Hartford R. R.
Subscriber No. 29,705.

THE NEW ENCYCLOPAEDIA BRITANNICA

11th Edition (Published by The Cambridge University Press)

is the most highly perfected instrument for making *knowledge available for use.* It is the only complete systematized inventory of all the knowledge that has practical value, and is the product of the organized cooperation of acknowledged leaders of the world's thought in every department of human activity.

The Index—a Unique Feature

THE most comprehensive and highly perfected card-index system ever put together was probably that maintained in the editorial offices of this work for gathering, sifting, classifying and checking the knowledge of today, in all fields of achievement in its most recent developments. (The index volume, volume 29, with its 500,000 references, grew out of this great intelligence bureau. No other encyclopaedia is indexed. It more than doubles the efficiency of the Britannica.)

Fifteen hundred practical experts and specialists from 21 countries worked together on a systematic plan to produce this entirely new work, and the unprecedented sum of $1,500,000 was spent to make it.

Whether you are manager or clerk, banker, merchant, manufacturer or salesman, steel man or grocer, this work has a claim upon you. It renders a service unparalleled in this day of specialization.

"The best library for the business man. Progressive firms should see to it that it is not only in their offices, but in the homes of those on whom their business success depends," says a specialist on business system.

OFFICE OF THE EDITOR, THE N. Y. TIMES.
With the Britannica on the shelves at right.

HON. WILLIAM C. REDFIELD
Secretary of Commerce in President Wilson's Cabinet.
Subscriber No. 15,021.

Where the new Encyclopaedia Britannica is in daily use

A few representative firms out of many thousand subscribers in the world of finance, business, manufacturing, etc.

Fidelity Casualty Co.
American Book Co.
Tiffany & Co.
John Wanamaker.
American Telephone & Telegraph Co.
Berkshire Life Ins. Co., Pittsfield, Mass.
General Electric Co., Schenectady, N. Y.
Metropolitan Life Ins. Co.
Jones & Laughlin Stl. Co., Pittsburgh.
The J. K. Gill Co., Portland, Ore.
New York Edison Co.
Home Life Insurance Co.
American News Co.
New York Life Insurance Co.
International Harvester Co., Chicago.
American Optical Co., Southbridge, Mass.
N. W. Ayer & Son, Philadelphia.
Studebaker Bros. Mfg. Co., South Bend, Ind.
National Tube Co., Pittsburgh.
Travelers' Insurance Co., Hartford, Conn.
Equitable Life Ins. Co.

Last Opportunity on Monthly Payments

THE CLOSING OF THE SUBSCRIPTION LIST opened by the *Cambridge University Press* for the sale of the New Encyclopaedia Britannica at specially low prices and by monthly payments of only $5 marks a radical change in the method of purchase, and the successful conclusion of a bold enterprise.

The 11th Edition of this work, an entirely new and original survey of human knowledge, was designed to meet the need of the present day for a work of universal reference based upon the latest authority. Upon its completion by the editors, after eight years' continuous labor, an introductory offer was made, at an exceptional price, by direct sale to the public.

The price was exceptional because it was 40 *per cent less* per volume than the price at which previous new editions of this work had been issued.

The purpose of this early sale at a low price and for small monthly payments was to bring a great educational work, **upon the preparation of which over $1,500,000 had been expended,** within reach of the largest circle of readers, and to make its usefulness widely and rapidly known. These two objects have now been achieved, more than 50,000 sets having been distributed.

IN ENGLAND, THE OFFER AT THE PRESENT PRICES WILL BE TERMINATED ON DECEMBER 20TH, AND IN THIS COUNTRY, SHORTLY THEREAFTER.

MANAGER

The Encyclopaedia Britannica
120 West 32nd St., New York

Photo, Topical Press
THE BANK OF ENGLAND
Threadneedle St., London, where the Britannica is used.

OFFICE LIBRARY OF CURTIS PUBLISHING CO.
With the Britannica on the second shelf from the top.
Subscriber No. 28,993.

Full sets, in 7 different bindings, both on India and ordinary paper, together with bookcases, on display in the Exhibition Rooms, 9th floor, 120 West 32d St. Open every week day, including Saturday, from 9 to 5.
Telephone 8530 Madison Sq.

N. Y. T. 1.

—this remarkable book for the mere asking—

You may send, without obligation to me, your 160-page illustrated *Prospect us,* with specimen pages of India paper, prices and terms of payment.

Name ..

Address ..

..

1913

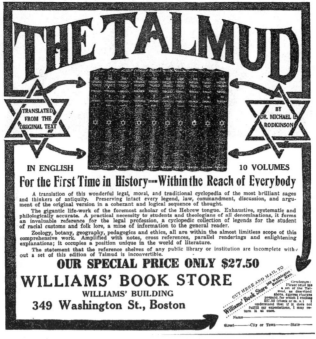

1925

THE
1920s

During the 1920s, a good deal of the best American writing traced the moral and intellectual aftershocks of World War I. Among the first important writers to address the war in fiction was John Dos Passos, in his novel *Three Soldiers* (1921).

Dos Passos could be a difficult writer, and his publisher, the George H. Doran Company, acknowledged this in an intriguingly honest advertisement for *Three Soldiers*. "Even those who go down before the torrent of the author's truthtelling will be the first to credit him with the creation of a veritable piece of literature," the ad read. (It even mentioned, perhaps to Dos Passos's dismay, the "necessary editing" his manuscript had required.) George H. Doran Company deserves credit: this unusual ad actually does make you want to surrender to Dos Passos's torrent of truth telling.

The "roaring twenties" were on their way, and etiquette guides prospered. See, for example, Doubleday's 1921 advertisement for a two-volume set of the *Encyclopedia of Etiquette*, an oddly moving bit of narrative salesmanship. "Even before I met Ted Farrel, I felt strangely attracted to him," says this ad's heroine. But because she hadn't read the *Encyclopedia of Etiquette*, Ted was lost to her. The ad's headline: "The Price I Paid for One Little Mistake." (You're a prig, Ted Farrel.)

Photographs became commonplace in American book advertising during the 1920s, and publishers used these photos to form their writers' personae. In an ad for *All the Sad Young Men* (1926), F. Scott Fitzgerald comes off as a jazz-age city slicker, with his hair parted neatly in the center. A macho ad for *A Farewell to Arms*, by contrast, had Hemingway outdoors on skis.

Publishers still sought new ways to repackage the classics. See the amusing ads for collected sets of the work of Edgar Allan Poe and Joseph Conrad in this chapter. My favorite, I think, is the one for Conrad, which reads: "Jungle Love—What happened when a white man and a native girl met far from civilization." ❧

The Price I Paid for One Little Mistake

EVEN before I met Ted Farrel, I felt strangely attracted to him. Whenever any one mentioned his name, a thrill of inexpressible happiness surged through me. And once, when the newspapers wrote up the story of how he had saved a youngster from drowning, I clipped out his picture and pasted it in my scrapbook. Oh, how I cherished that picture, and dreamed over it, and wondered, and hoped.

If I could only meet him—if I could only see him, and talk to him, and tell him how much I admired him. I felt, somehow, as though I had known him all my life. I just *knew* that to meet him would be to kindle an immediate friendliness, a responsive feeling.

Then, one day, came a glorious surprise. An old school chum of mine, from whom I had not heard in a long time, invited me to a little informal dinner at her home. "Ted Farrel will be here," she wrote in her letter, "and I know you will be glad to meet him." Glad! It seemed to me that I had nothing left to wish for in all the world!

I Begin My Happy Preparations

Exulting with joyous anticipations, I began to plan and prepare for that wonderful day when I would meet Ted. Of course, there was nothing in my wardrobe that would do justice to the importance of the occasion. I paid a visit to my dressmaker and confided in her, impressing her with the utter necessity of the new gown being the prettiest one she had ever made.

"I'm going to meet Ted Farrel," I laughed jestingly—but I'm quite sure that she noticed how elated I was.

Well, at last the day of the dinner arrived. My new dress seemed to fall in particularly charming waves. Happiness had brought a warm glow to my cheeks, a keen brilliance to my eyes. I felt, as I surveyed myself in the mirror, that I had never looked so pretty before, never felt so well-poised—and confident.

All My Joy Is Shattered

Helen was delighted to see me. "Come," she cried gayly, "let me introduce you to my guests."

As I entered the big drawing room I felt unaccountably restless. I knew Ted immediately. He was standing near the window talking with Helen's mother. In a frenzy of impulsive eagerness, I did something which I did not know was incorrect, but which caused the others to laugh at me.

It was over in a moment. Before I realized what had happened, I had committed an awful blunder, an unforgivable breach of etiquette! All my happiness, my weeks of planning, my anticipations vanished in a maze of miserable humiliation. I wanted to run wildly from the room, to hide from the amused glances of the guests. And most of all I wanted to cry.

In my confusion I failed dismally in acknowledging the introductions that followed. Helen acted just the least bit disappointed—although she tried hard to be kind to me, to put me at ease. I noticed that several of the guests glanced at each other. And I began to wish fervently that I had never come—or that I had at least prepared myself by reading up somewhere about introductions and how to avoid impulsive blunders in etiquette.

Then, vaguely, I realized that I was being introduced to Ted—actually being introduced to Ted Farrel! But all the pretty phrases, the pleasing sentiments I had planned to say were forgotten. Instead, I mumbled something about being "glad" and "happy." But I hurried away so that he could not see how miserable I really was.

I Spend a Miserable Evening

Oh, how unhappy I was when I realized what a mess I had made of the meeting that was to have been a triumph! Here I was in the very same room with Ted—just as I had always hoped and dreamed of being—and yet I dreaded to look at him! I had planned to tell him all about my strange attraction for him and about the newspaper writeup and the clipping. But how could I speak to him after that ridiculous blunder? Oh, if it had only not happened!

Later, at the table, I felt uncomfortable and ill at ease whenever any one looked at me or spoke to me. I was frankly wretched. I began to wonder how soon it would be permissible to leave without appearing rude. And instead of conversing happily with Ted, as I had hoped to, I avoided his every glance.

I was glad when the time came to leave. I wanted to be alone to drown my mortification in a good long cry. When I saw Ted approach me, smiling, I wondered, in panic, whether it were proper for me to offer him my hand or just say "Good night." I hesitated a moment—and then with a stiff little nod hastened away.

That evening I cried as though my heart would break. I knew that I could never face Ted Farrel again after the miserable blunders I had made. And bitterly I reproached myself for not knowing better. "I will get a book of etiquette the first thing tomorrow morning," I promised myself grimly. "And I'll make sure that a thing like this never happens again."

I Buy the "Encyclopedia of Etiquette"

The very next day I sent for the famous "Encyclopedia of Etiquette." I determined to find out just what was the correct thing to do and say at all times, under all conditions, so that I would never again suffer such a mortifying evening.

I had always prided myself upon being cultured and well-bred. I had always believed that I knew just how to act—that I followed the conventions of society to the highest letter of its law. But, oh, the serious breaches of etiquette I was making almost every day!

Why, the first chapter I read proved that I knew pitifully little about dinner etiquette. I didn't know the proper way to remove fruit stones from my mouth, the cultured way to use a finger-bowl, the correct way to use napkins and many other similar points of etiquette. If I had only had the book before!

Etiquette at the Dance

I glanced over the chapter called "Etiquette at the Dance." In a few moments, I discovered that I had been making some very bad blunders indeed. I had never known whether it were proper for a woman to ask for a dance; whether she could refuse a dance without reason; whether it were proper to wander away from the ballroom with a fiance. I had never known how many times a young girl may dance with the same partner without breaking the rules of etiquette.

And when I read the chapter on introductions, the very mistake I had made was pointed out! If I had only read this chapter before, I would never have made that awful blunder. Instead, I would have been able to establish an immediate and friendly understanding between Ted and me.

I found that I actually did not know how to introduce two people correctly! I didn't know whether to say "*Mrs. Brown, meet Miss Smith,*" or "*Miss Smith meet Mrs. Brown.*" I didn't know whether to say, "*Bobby, this is Mr. Blank,*" or "*Mr. Blank, this is Bobby.*" I didn't know whether it were proper for me to shake hands with a gentleman upon being introduced to him, and whether it were proper for me to stand up or remain seated. Every day people judge us by the way we make and acknowledge introductions. The "Encyclopedia of Etiquette" made it all so clear to me that I can never make a mistake again.

To the Young Man and Woman—

I would like to give you a bit of advice. The world is a harsh judge. It will not tolerate the illiterate in the art of etiquette. To be admitted to society, to enjoy the company of brilliant minds, and to win admiration and respect for one's self, it is essential for the woman to cultivate charm, and for the man to be polished, impressive. And only by adhering to the laws of etiquette is it possible for the woman to be charming and the man to be what the world loves to call a gentleman.

I will never forget that miserable evening I spent—and the many other miserable evenings that followed because of the memory of it. I can never face Ted Farrel again—Ted Farrel whom I had always longed to meet and talk to—and impress. I am glad to write my story here—glad to help other happy young people from shattering their hopes and gladness by blundering in the important art of etiquette. My advice to men and women who desire to be cultured rather than coarse, who desire to impress by their delicacy of taste and finesse of breeding, is—send for the splendid two-volume set of the "Encyclopedia of Etiquette"!

"Encyclopedia of Etiquette"
IN TWO BIG VOLUMES
SENT FREE FOR 5 DAYS

The Encyclopedia of Etiquette is excellent in quality, comprehensive in proportions, rich in illustrations. It comes to you as a guide, a revelation toward better etiquette. It dispels lingering doubts, corrects blunders, teaches you the *right thing* to do.

There are chapters on etiquette at the wedding, etiquette at the ball, dinner etiquette, dance etiquette, dress etiquette—etiquette problems that must be faced almost every day of your life. And each one is solved for you so thoroughly, so exhaustively, that you will *always*, at all times, impress by your absolute knowledge of the correct and the cultured.

For a short time only the complete and intensive two-volume set of the "Encyclopedia of Etiquette" is being offered at the special price of $3.50. Don't wait until the happiest day of YOUR life, the day YOU have planned for and looked forward to, is spoiled by a blunder. Don't delay—send for your set NOW, before you forget.

The coupon below entitles you to a 5 days' FREE examination of the two-volume set of the "Encyclopedia of Etiquette." At the end of that time, if you decide that you want to keep it, simply send $3.50 in full payment—and the set is yours. Or, if you are not delighted, return the books and you won't be out a cent. Send for your set today! You need send no money—just mail the coupon, Nelson Doubleday, Inc., Dept. 33, Oyster Bay, New York.

I wanted to run wildly from the room, to hide from the amused glances of the guests.

1921

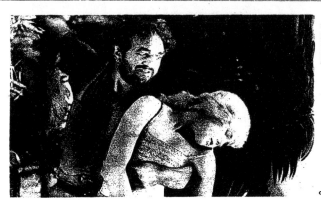

"I'se yo' mammy—
yo' is *his* slave!"

Hᴵˢ mother—that yammering slave woman? That body servant lying there whom he had been beating all these years, his master?

Impossible! He'd thrash her within an inch—but the slave woman's steady gaze stayed him. Something told him she spoke the truth—that of the two white skinned men, raised together from the cradle, his was the blood that contained the African taint of bondage.

The proud family whose estate and name he was to inherit, must never know—he would be sold "down the river." How did the world finally know?

One of the most absorbing crime detection stories ever written carries you spellbound through mystery after mystery. It is one of Mark Twain's classic medleys of mystery and humor.

MARK TWAIN

25 Volumes: Novels · Boys' Stories · Humor · Essays · Travel · History

Perhaps you think you have read a good deal of Mark Twain. Are you sure? Have you read all the novels? Have you read all the short stories? Have you read all the brilliant fighting essays?—all the humorous ones and the historical ones? Think of it—25 volumes filled with the laughter and the tears and the fighting that made Mark Twain so wonderful.

In the history of the world nobody has made so many people laugh as Mark Twain. Wherever there is written language his humor is famous. Yet he is not only a great humorist, but also a wonderful story-teller, historian, travel writer.

In his work we find all things, from the ridiculous in "Huckleberry Finn" to the sublime in "Joan of Arc"—the most spiritual book that was ever written in the English language, of serene and lovely beauty, as lofty as Joan herself.

The Only Complete Edition

The Author's National Edition, originally published by Harper & Brothers, and now published by P. F. Collier & Son Company, is the only complete edition of Mark Twain's writings. Here you join "Huck" Finn and Tom Sawyer in their boyish pranks—you live the quaint life of steamboat days and the Far West—you see foreign lands and people through the eye of the master humorist—you thrill to every wholesome human emotion. Mark Twain's versatile mind gave to the world a perfectly balanced library of humor, adventure, philosophy, and inspiration. You should at least know something about this famous author's complete works.

We shall be glad to send you a booklet containing interesting and worth-while information about them. The booklet is free. Sending for it in no way obligates you. Merely clip the coupon and mail it today.

Sign and send the coupon for the free booklet which tells about these wonderful 25 volumes

1922

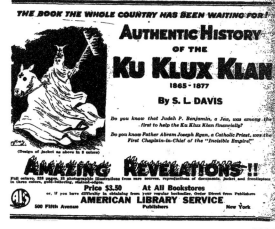

1924

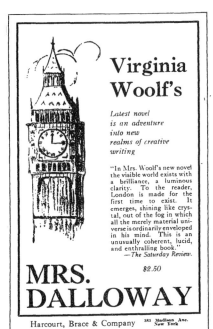

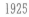

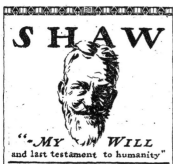
1928

1924

No critic hesitates to call it a great novel

Soldiers' Pay

by William Faulkner

"It is a novel without heroics or heroes. It has the gusto and mockery of more spacious days. Faulkner evokes with fine selection, avoiding the dreary piling-up of details of naturalism — the high moments of life. It is poignant with beauty as well as a penetrating irony. There is a sensuous regard for the feeling of life that is quite Hellenic. About the events of SOLDIERS' PAY humor plays its part. A deft hand has woven this narrative of mixed and frustrated emotions and has set it down with hard intelligence as well as consummate pity. This book rings true."—*The N. Y. Times*

"In our opinion, for originality of design and beauty of writing, this book stands alone. Here are revealed a masterly vigor of imagination, a lofty and profound detachment from the concerns of the obvious, the sure touch of an able craftsman in perfect accord with his materials. Pathos, sacrifice, heroism, a magical beauty are here in abundance."
—E. C. Beckwith, *The N. Y. Eve. Post*

"Faulkner has launched SOLDIERS' PAY with a What Price-glorified gusto . . . Makes you wait gapingly for the next line from this acid pungent pen."—Harry Salpeter in *The First Reader, N. Y. World.* $2.50

Boni & Liveright, N. Y.

GOOD BOOKS

1926

John Dos Passos, in May last, brought a manuscript entitled **THREE SOLDIERS** to the office of George H. Doran Company. It was read and immediately created a sensation. It was promptly accepted. Everyone who read the novel in its original MS form agreed that it deserved to be read widely because it said frankly, sincerely and for the first time those things which thousands of young men thought and felt about the war, its incident and consequent influence upon the established order of things governmental. It voices the protest of youth, its energy and progress. But it was also agreed that even after necessary editing the book would probably come as a distinct shock to many, especially to those who had not previously been made aware of the intense anguish of many youths who suffered bitter disillusionment in the decay of an idealism that alone made possible their surrender of personal liberty. The publishers believe, however, that even those who go down before the torrent of the author's truthtelling will be the first to credit him with the creation of a veritable piece of literature. This explanation is made because it seems but fair to state frankly the facts about a book that is certain to become a subject of heated controversy. The author would ask his reader to remember that he writes as a novelist—not as an historian.

Mark Hand

THREE SOLDIERS. A Novel by John Dos Passos—Just Published—$2.00

1921

Edith Wharton

"American novelist of international fame. Chevalier of the Legion of Honour in France . . . Her books are marked by sincerity in art, beauty in construction, distinction in style . . . She is a master in the creation of original and living characters, and her powers of ironical description are exerted to salutary ends. She is a realist in the best sense of the word; revealing the inner nature of men and women without recourse to sensationalism and keeping ever within the boundaries of true art. She holds a universally recognized place in the front rank of the world's living novelists. She has elevated the level of American literature. We are proud that she is an American."

—*From the address accompanying the conferment of the degree of Doctor of Letters upon Mrs. Wharton, Yale University, June, 1923.*

Edith Wharton's

greatest novel

A SON AT THE FRONT

"The publication of a full-length novel by Edith Wharton is probably the most important thing that can happen in any current year of American fiction, for there is no doubt that, soberly speaking, she is the best of living American novelists."—New York Times.

Mrs. Wharton's magnificent gift of story-telling here is matched with a situation of vast human significance, one which places her characters under the stress of the greatest passions. From its opening, the novel moves forward in an atmosphere of deepening excitement, with that mastery of plot which is disclosed in all her stories.

Now on sale everywhere. $2.00

CHARLES SCRIBNER'S SONS, FIFTH AVENUE, NEW YORK

1923

The Authentic Life of
BILLY the KID

By Pat F. Garrett
Edited with Introduction
By Maurice G. Fulton

THIS authentic story of Billy the Kid, told by the Sheriff who killed this most notorious of Western bad-men, will hit the bull's eye for those who admire courage, love daring and picturesque action, and enjoy a well-spun yarn of the old frontier.

At Your Dealer's $2.50

The Macmillan Co. New York

1927

The Author of OIL!
Now Turns His
Searchlight
of Exposure
on the
Literary World—

SINCLAIR LEWIS
EDNA FERBER
CARL SANDBURG
THEODORE DREISER
GERTRUDE ATHERTON
JOSEPH HERGESHEIMER
JAMES BRANCH CABELL
CARL VAN VECHTEN
W. E. WOODWARD
H. L. MENCKEN
LOUIS BROMFIELD
JACK LONDON
ALDOUS HUXLEY
etc., etc.

MONEY WRITES!
by UPTON SINCLAIR

What a glittering array of talent and independence! Simply no one would suggest that they had been bought. Sinclair does not, and yet he sets out to prove that through them Wall Street writes. With a mass of knowledge of literary markets, of details of transactions between authors and editors and publishers gained in twenty years of prominence as an author, and as friend of nearly all the important authors of his time, he does not hesitate to use his information to prove his contention. $2.50

ALBERT & CHARLES BONI ~ 66 Fifth Ave. ~ NEW YORK

1927

The Diary of a Drug Fiend
By ALEISTER CROWLEY

A terrible story, yet one of hope and beauty, a revelation of a startling abyss, and of a saving power. The feeling grows as one reads that this story is true not only of one weakness but of all kinds of human weakness. It is not the painful pages which haunt the reader; the vision of strength sublime is what remains.

At any bookstore, $2.00; postage extra.

E. P. DUTTON & CO., 681 Fifth Avenue, New York

1923

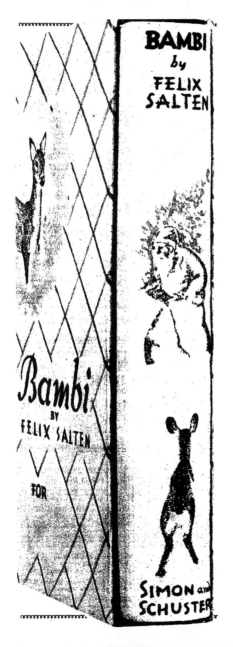

10,000 *Bambis have been boxed for Christmas!*

2,756 traveled out of bookstores last week. (We bet over 2,000 of these are now being wrapped for Christmas trees.)

7,244 remain to be carried off this week.

There hasn't been a rush like this since Trader Horn last year. All summer long people have been quietly reading Bambi . . . thousands of them. And tens of thousands haven't read Bambi simply because it was "an animal story . . . and how could an animal story be interesting?"

But the 84,000 who have within the past six months bought Bambi have loved this story of a deer . . . Until now (beginning the first of this December) the word has spread around like wild-fire that Bambi "is really all that they have been saying about it."*

Well, 7,244 more of this boxed edition. Even while they leave the bookstores this week another edition of 10,000 is on press. And the box manufacturer says "tell them to rush for that first lot—I can't promise 10,000 more before Christmas."

To those who come too late for the boxed edition, all we say is: "The box is pretty, but you will probably reread and relove Bambi long after the 10,000 boxes are forgotten."

*As good as they say

"Bambi is a better book than *Green Mansions* and that is praise of the highest. Felix Salten takes you out of yourself and makes his deer far more exciting to read about than hundreds of human beings who crowd the pages of our novels."—The New York *Times Book Review.*

"The most important new author to be discovered and imported swiftly to America is Felix Salten. No star of similar magnitude looms elsewhere on the horizon."
—The Boston *Evening Transcript.*

"Bambi is delicious, and it is charming. It is a rarely beautiful story about a deer, and about the woods and the meadows and the skies and the brooks and the forests; about nature, therefore, but nothing wearisome, or boresome, or dull, or draggy about it; not a paragraph, not a sentence, not a word!"—*The World-Herald* (Omaha, Nebraska)

"Bambi is all of the things that sound utterly impossible when you are told about them and that turn out to be delicately lovely when you read them. As a matter of fact, *Bambi* might be—perhaps was—written for children. I don't know, but like many another great book, it is as real a gift to children as it is to adults, and as lovely a one. Yes, *Bambi* has sweetness and light, two of the noblest qualities any book can have."
—The Chicago *Tribune.*

"Occasionally a book is written with such ineffable charm that its fragrance lingers unbidden. Felix Salten in *Bambi* has produced a story so simple it can be appreciated by a child; yet so beautiful and forceful that the adult finds himself inextricably caught in its spell. *Bambi* is the idyll of a deer in a forest along the Danube. In all probability Mr. Salten aimed his work at the small coterie of nature lovers who religiously read such titles. If so he is destined to an agreeable surprise."—The Detroit *News.*

Bambi—with an introduction by John Galsworthy, is translated from the German by Whittaker Chambers. The book contains twenty-five full-page illustrations by Kurt Wiese. The format is a large 12 mo. Published by Simon and Schuster, New York, and available everywhere, price $2.50

1926

1934

THE

1930s

A re you one of the wise men of 1934?" That question was posed in an ad for *The Tired Business Man's Library of Adventure, Detective and Mystery Novels*. It was time, this advertisement suggested, to "learn to relax."

It was hard to blame readers, during the 1930s, for sometimes wishing their minds were elsewhere. The Great Depression had settled in, fascism was on the rise in Europe, and the books that made the most intellectual noise—James Joyce's *Ulysses*, for example, finally issued widely in the United States in 1934—could be headache-makers.

Random House's canny advertisement for *Ulysses* stressed the novel's popularity—"5,000 readers a week" were picking it up—and hinted at the controversy surrounding it. "After 16 years, during which Americans were forbidden to read one of the most noted novels of our time, 'Ulysses', released by the Federal Courts, may now be read by all! Its republication in complete, unexpurgated form has been acclaimed by the press and public not merely as a victory against vicious and stupid censorship, but for the intrinsic interest of a great novel written on Homeric lines."

American book critics were, if this decade's ads were any indication, finally well-enough known to be brand names themselves. An ad for John Steinbeck's *The Grapes of Wrath* (1939) scooped most of them up: Clifton Fadiman, Alexander Woollcott, Louis Kronenberger, and Dorothy Parker, among others. See also the advertisement for Nathanael West's novel *Miss Lonelyhearts* (1933). Edmund Wilson's name is as large as the author's own.

Meanwhile, a different controversial book was being advertised in American periodicals: Adolf Hitler's *Mein Kampf*. The headline on a 1933 ad for an edition of the book from Stackpole Sons promised: "No Royalties to Adolf Hitler!" ❧

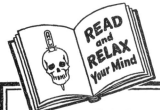

ARE YOU ONE OF THE WISE MEN OF 1934? Successful business men are finding that they can shake off the high nervous tension of business hours, take their minds off cares and problems, and obtain refreshing recreation by reading well written, completely absorbing mystery and adventure stories. To provide business men with such reading matter we announce the publication of:—

The TIRED BUSINESS MAN'S LIBRARY
of ADVENTURE, DETECTIVE and MYSTERY Novels

Just Published

15 BRAND NEW VOLUMES

Learn to RELAX

For your health's sake—for your job's sake, learn the secret of many famous men who refresh their minds with exciting books like these.

Every one is, of necessity, sticking to his job these days. Long vacations are out of the question for most business people. But many of the country's foremost men in various fields of activity—supreme court justices, government officials, bankers, lawyers, factory managers, merchants, ministers —have found that they can obtain forgetfulness of cares and anxieties and relaxation from their ever active, high pressure occupations through the reading of lively, entertaining masculine books of adventure and mystery. They have discovered that exciting reading completely releases the mind from the tense nervous strain of the day and brings about the relaxation necessary. These men have found the way. And now you, too, can follow their methods.

THE TIRED BUSINESS MAN'S LIBRARY

has been specially prepared to provide the utmost in relaxation, recreation and enjoyment for men.

A Board of highly trained Editors has combed the fiction markets of America and England to obtain a group of the best written, most ingenious and most exciting books to be had. Some of the authors are well known names, some are "dark horses" appearing for the first time in the field, but each has contributed an unusual book to make up what is the first group of recreational books ever assembled in this way to give pleasure and entertainment and afford relaxation to the Tired Business Man.

Put Yourself in His Place

How To Get
The TIRED BUSINESS MAN'S LIBRARY

Leading booksellers all over America are now featuring this library. Step into any good bookstore and ask one of the sales people to show you the set. Or, if this is not convenient, you may order the books by mail. These books are for all men: Merchants, Bankers, Lawyers, Doctors, Ministers, Office Workers, every business man. You may buy one at a time, or five at a time, but if you are wise, you will get the complete library of varied and well rounded stories—stories that make you feel like Sherlock Holmes, a Rodeo Show, a Round the World Flyer, Scotland Yard and the best of the amateur sleuths all rolled into one.

The Set $30.00 Groups of five $10.00 Each book, $2.00

(Please mention this paper when ordering.)

ALL BRAND NEW

In this Alphabetical Year we present the T. B. M. L.

1. **THE READY BLADE,** by *A. Edwards Chapman*
 A lively story of old England, in the days when knights were bold, packed with lively adventure.

2. **SCRAMBLED YEGGS,** by *Octavus Roy Cohen*
 The unique detective, Jim Hanvey, fat and apparently slow and lazy solves some puzzling crimes.

3. **CRIME AT COBB'S HOUSE,** by *Herbert Corey*
 A smartly written story about a series of murders in the fashionable Virginia riding set.

4. **THUNDER IN THE WEST,** by *Robert Crane*
 A story of ranch life, cattle rustling, gun fights and murder. A thriller with a rich vein of humor.

5. **MURDER BELOW WALL STREET,**
 by *Roger Delancey*
 In the unusual setting of New York's most closely guarded community, the financial district, unfolds a baffling murder mystery.

6. **THE PLEASURE CRUISE MYSTERY,**
 by *Robin Forsythe*
 Murder during a pleasure cruise—with a surprising solution.

7. **OUT OF THE DARK,** by *George Gibbs*
 The extraordinary mystery of a young girl found starving, and with her mind a blank.

8. **INSPECTOR HIGGINS SEES IT THROUGH,**
 by *Cecil Freeman Gregg*
 A thrilling episode in the life of Scotland Yard's ablest detective.

9. **THE EMPTY HOUSE,** by *Francis D. Grierson*
 A prospective tenant opens a cupboard door and discovers a murder. "The Perfect Crime."

10. **DEATH AND THE DOWAGER,** by *Bertrand Huber*
 The extraordinary series of events which befell Lord Banbrooke.

11. **MURDER IN CHURCH,** by *Babette Hughes*
 A visiting English scientist dies mysteriously at a Western college, with nearly everybody, from the President down, suspected.

12. **THE KING IN CHECK,** by *Talbot Mundy*
 An adventure story laid in the Near East with the famous character "Jimgrim" circumventing a French plot.

13. **SMASH AND GRAB,** by *Clifton Robbins*
 Smash the jeweler's window! Grab diamonds! The chase is on!

14. **SHADOWS,** by *Florence Ryerson* and *Colin Clements*
 A curious and absorbing tale of murder in Hollywood during the taking of a Russian film.

15. **MARKED MAN,** by *H. C. Wire*
 A western story with a fine mystery to keep the reader on tenterhooks.

D. APPLETON-CENTURY COMPANY, 35 West 32nd Street, New York, N. Y.

CALL IT SLEEP

SELLING 600 WEEKLY

"One of those rare books which go on breathing after one has put them down a work of art, a book to treasure and read again and again . . . far beyond praise."

Dorothy M. Richardson

"The exquisitely sympathetic portrait of the artist as a child one of the most substantial and satisfying novels written of America by an American."

Evelyn Scott

"A swell book!"

Louis Adamic

BALLOU, N. Y. $2.50

by HENRY ROTH

1935

By JOHN DOS PASSOS

AUTHOR OF "MANHATTAN TRANSFER," *and* "THREE SOLDIERS"

his first novel in five years

"Dos Passos *may* be, more than Dreiser, Cather, Hergesheimer, Cabell or Anderson, the father of humanized and living fiction not merely for America but for the World." —SINCLAIR LEWIS

now on sale at all bookstores
$2.50

THE 42ND PARALLEL

HERE is pungent hearty humor, sharpened by overtones of bitter experience; here are people who jostle you day by day upon the street. Here through the microscope of genius you may see in sharp relief the squirming mass of human organisms which spread across a continent to make America. Unusual in structure as in substance, this new novel encompasses the converging stories of many subsidiary and five central characters.

Mac, whose career embraced everything from selling *The Queen of the White Slaves* from a buggy to consorting with wobblies and running a bookstore in Mexico.

Janey, whose brother joined the Navy, whose mission in life was to be an adoring secretary.

J. Ward Morehouse, who divorced the dissolute daughter of a Philadelphia doctor, spent the night with a Pittsburgh heiress, married her and became an eminent Public Relations Counsel with the aid of her fortune.

Eleanor, who as a girl swore that she would kill herself if a man ever touched her, who later entered into a very beautiful and very platonic friendship with Morehouse.

Charley, who was in love with Emiscah until he thought he had to marry her, who ended up on a boat for France and the War.

From the vari-colored threads of these five lives John Dos Passos has woven an authentic strip of American fabric. The fabric is neither silk, nor wool, nor cotton; neither red, nor white, nor blue. It is a curiously life-like combination of them all—bright here and dingy there, frayed in spots, but inherently enduring.

This is John Dos Passos' first novel in five years. In theme and setting it is entirely American, it is full of richness and written with characteristic brilliance and gusto for all the details of human experience.

Just as *Manhattan Transfer* startled with its new and dazzling pattern, so this novel cuts through the familiar shell of things to reality.

HARPER & BROTHERS, 49 EAST 33rd STREET, NEW YORK

1930

Just published!

PYLON

by WILLIAM FAULKNER

author of SANCTUARY

AS sure to make a ripple as a ten-ton boulder in a quiet lake, this new novel is the most astonishing William Faulkner has ever written. Intense, passionate, human, unexpected . . . it is as different from *Sanctuary* and *Light in August* as it is even more powerful. Regular edition, $2.50; signed edition, 300 copies only, $5.00.

HARRISON SMITH AND ROBERT HAAS, PUBLISHERS

1935

JOHN O'HARA

has done it again . . . His new novel is as slick, as tough, as readable as 'Appointment in Samarra,' and that means you can't put it down.—GEORGE STEVENS, SATURDAY REVIEW.

JOHN O'HARA

has lost nothing . . . He is completely honest and unsparing . . . The book will carry you along with the tide of its swiftly rising tension until you feel that you can stand no more, but you'll be wrong, because you *will* stand more, and when you've finished it you will not forget it. — BERNARD SMITH, N. Y. HERALD TRIBUNE.

JOHN O'HARA

is gifted, intelligent, witty . . . His book seems to me a dazzling performance . . . As entertainment, 'Butterfield 8' will and should lead the fiction field for some months to come.— CLIFTON FADIMAN, NEW YORKER.

JOHN O'HARA

BUTTERFIELD 8 . . . I've just finished reading it and it has left me so shaken that I have to tell somebody about it. I think it's a brutal and pitiful and beautiful book. I hate the word, but I'm afraid it's literature.—DEEMS TAYLOR

BY THE AUTHOR OF
APPOINTMENT IN SAMARRA

BUTTERFIELD 8

$2.50

HARCOURT, BRACE AND COMPANY, 383 MADISON AVENUE, NEW YORK

1935

The
Pulitzer Prize Play

Our Town

By **THORNTON WILDER**

Copies of the play in book
form are again available. See
your bookseller. $2.00

COWARD-McCANN

1938

BEI MIR BIST
DU SCHÖN

ROBERT
BENCHLEY'S
latest mirthquake
AFTER 1903 WHAT?

Pictures galore and galorious
by Gluyas Williams. $2.50

HARPERS

1938

Enjoy
THE NEW
BOOK BY
the sage
of "The New Yorker"

LAUGH
AT YOURSELF
AND LIKE
IT!

E. B. WHITE
THE FOX OF PEAPACK

WHILE statesmen fiddle, E. B.
White burns—and throws off
showers of scintillating sparks in
verse on the absurdities of human
nature. Don't miss this new book by
the wittiest of America's poets. $2

HARPERS

1938

How to get rid of an Inferiority Complex

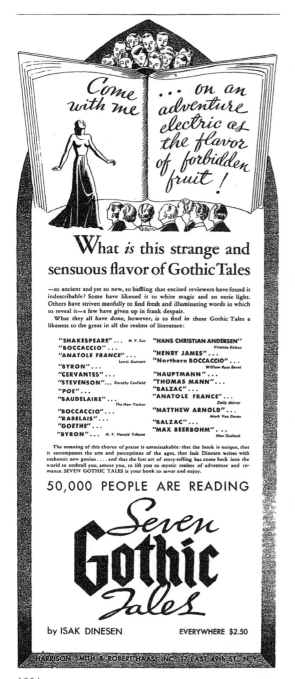

Come with me ... on an adventure electric as the flavor of forbidden fruit!

What *is* this strange and sensuous flavor of Gothic Tales

—so ancient and yet so new, so baffling that excited reviewers have found it indescribable? Some have likened it to white magic and an eerie light. Others have striven manfully to find fresh and illuminating words in which to reveal it—a few have given up in frank despair.

What they all have done, however, is to find in these *Gothic Tales* a likeness to the great in all the realms of literature.

"SHAKESPEARE" ... *N. Y. Sun*
"BOCCACCIO" ...
"ANATOLE FRANCE" ...
Lewis Gannett
"BYRON" ...
"CERVANTES" ...
"STEVENSON" ... *Dorothy Canfield*
"POE" ...
"BAUDELAIRE" ...
The New Yorker
"BOCCACCIO" ...
"RABELAIS" ...
"GOETHE" ...
"BYRON" ... *N. Y. Herald Tribune*

"HANS CHRISTIAN ANDERSEN"
Virginia Kirkus
"HENRY JAMES" ...
"Northern BOCCACCIO" ...
William Rose Benét
"HAUPTMANN" ...
"THOMAS MANN" ...
"BALZAC" ...
"ANATOLE FRANCE" ...
Daily Mirror
"MATTHEW ARNOLD" ...
Mark Van Doren
"BALZAC" ...
"MAX BEERBOHM" ...
New Outlook

The meaning of this chorus of praise is unmistakable: that the book is unique, that it encompasses the arts and perceptions of the ages, that Isak Dinesen writes with authentic new genius.... and that the lost art of story-telling has come back into the world to enthrall you, amuse you, to lift you to mystic realms of adventure and romance. SEVEN GOTHIC TALES is your book to savor and enjoy.

50,000 PEOPLE ARE READING

Seven Gothic Tales

by ISAK DINESEN EVERYWHERE $2.50

HARRISON SMITH & ROBERT HAAS INC. 17 EAST 49th ST. N.Y.

1934

"Russia with the lid off!"

I WAS A SOVIET WORKER

By ANDREW SMITH

★ Considered almost unbelievable when first published in the United States a year ago. Now fully confirmed by recent events!

★ Recently published in England, France, and other European countries, where it is one of the most widely read and discussed books of the year. A prominent English critic calls it "A remarkable book! One of the most candid and bitter attacks on the Soviet Regime since the Revolution...Tales of horror and misery such as were never even conjured from the imagination about conditions under the Czars."

★ Read what actually happened to an American Communist and his wife who gave his life-savings to the Party and went to live in Russia in 1935. Disillusioned, he now tells his story of a Russia imprisoned in a vast bureaucracy, with propaganda smothering truth, with oppression in the name of freedom, with every cause for which he struggled all his life in America perverted into its opposite.

★ All first hand material of the highest importance and interest. Illustrated by photographs and documents. *(E. P. Dutton and Company, $3.00.)*

1937

POWER

By Bertrand Russell

Chicago welcomes the great English thinker Bertrand Russell, and his new book which traces the role of power in the affairs of men from the time of the temporal power of priests and kings to the totalitarian power of dictators today. $3.00.

W • W • NORTON & CO. • NEW YORK

1938

NOT WITHOUT LAUGHTER

"Langston Hughes has written the real Negro novel. Its substance mirrors without distortion the plain typical life of the common people; its style palpitates with the real spiritual essences of Negro life and evokes an intimate sense of the folk soul and temperament. Only gifted poetic realism could accomplish a combination so rare and so desirable." Alain Locke, author of *The New Negro*.

$2.50 at all bookshops

ALFRED A. KNOPF, 730 FIFTH AVE., N. Y.

1930

Overwhelming success—overwhelming praise

The GRAPES of WRATH

by John Steinbeck

**Immediately—
the fastest-selling book in America**

619 pages $2.75

Certainly Steinbeck's greatest work—

"Steinbeck's biggest and ripest book, his toughest and his tenderest. If any book published this year deserves the trite word 'great,' this is it."—LEWIS GANNETT, N. Y. Herald Tribune.

"Worth all the talk, all the anticipation, all the enthusiasm. The epitome of everything Steinbeck has so far given us."—GEORGE STEVENS, Saturday Review of Literature.

"By all odds Steinbeck's greatest novel.—JOHN CHAMBERLAIN, Harpers.

"The Grapes of Wrath is at once Steinbeck's finest and most beautifully constructed novel...of vital interest to all Americans in our time."—PAUL JORDAN SMITH, Los Angeles.

"The finest book John Steinbeck has written...It is, I think for the first time, the whole Steinbeck, the mature novelist saying something he must say and doing it with the sure touch of the great artist...JOSEPH HENRY JACKSON, N. Y. Herald Tribune "Books."

"Magnificent...Steinbeck has created his best novel...far better than Of Mice and Men."—CHARLES POORE, N. Y. Times.

"Steinbeck, in his strongest work, has handled a big theme with great emotion, wide knowledge, and challenging power."—HARRY HANSEN, N. Y. World Telegram.

"A magnificent story, the finest thing he has done."—ALICIA PATTERSON, N. Y. Daily News.

Perhaps the Uncle Tom's Cabin of our time—

"I feel this book may just possibly do for our time what Les Miserables did for its, Uncle Tom's Cabin for its...It is going to be a great and deserved best seller; it will be read and praised by everyone...The Grapes of Wrath is the American novel of the season, probably the year, possibly the decade."—CLIFTON FADIMAN, New Yorker.

"A modern Uncle Tom's Cabin...If you read only one book this Spring read The Grapes of Wrath. It's lightning in print."—Portland Morning Press-Herald.

"It is 'great' in the way that Uncle Tom's Cabin was great...one of the most impassioned and exciting books of the year."—Time.

"It comes, perhaps, as The Drapier's Letters or Uncle Tom's Cabin or some of the social novels of Zola came ...A story that had to be told...a book that must be read."—LOUIS KRONENBERGER, The Nation.

"It was thus that Uncle Tom's Cabin had its origin. The Grapes of Wrath is a long book, and it seems too short..."—WILLIAM KINGSBURY, Nashville Tennessean.

Possibly the great American novel—

"Never before in our day has an American author written more unforgettably."—FANNY BUTCHER, Chicago Tribune.

"I am not forgetting such works as Moby Dick and Leaves of Grass and Life on the Mississippi and Death Comes for the Archbishop when I say that it seems to me as great a book as has yet come out of America."—ALEXANDER WOOLLCOTT.

"It is likely to become one of the literary documents by which this era will be remembered."—CLYDE BECK, Detroit News.

"The Grapes of Wrath is the greatest American novel. It should lead all best seller lists."—W. L., Raleigh News and Observer.

"The Grapes of Wrath will become a literary landmark."—W. M. R., Kansas City Star.

"Truly great...may well be the great American novel of our time..."—MAY CAMERON, N. Y. Post.

"The Grapes of Wrath appears to be the most passionately conceived, emotionally concentrated book to be written in our time in America."—E. B. GARSIDE, Boston Transcript.

"I can think of no novel of a living American to compare with The Grapes of Wrath."—HELEN BUCHALTER, Washington News.

"It is not a decent thing to throw the word great' about...I am glad, now, that I have not let my word 'great' dribble away. I think The Grapes of Wrath is a great novel...I want to say again, and I wish I could say it louder and clearer, that The Grapes of Wrath is the greatest American novel I have ever read."—DOROTHY PARKER, Book Union.

The Viking Press 18 E. 48th St. New York City

1939

IF YOU JOIN THE LITERARY GUILD NOW!

YOURS FREE

Those **Gusty, Daring Novels** *that Shocked Even Paris!*

THE COLLECTED WORKS OF THE IMMORTAL

EMILE ZOLA

A SPECTACULAR MOTION PICTURE HAS PORTRAYED HIS AMAZING LIFE • NOW READ THE WORKS THAT BROUGHT HIM UNDYING FAME

Including the Complete Story of "NANA," the Gay Lover and Her Mad, Devastating Amours and Adventures!

Just one of the dramatic episodes from NANA, the sensational novel which is featured in the great motion picture of the life of Zola.

THE dramatic screen picture of the life of ZOLA has set up a clamor for his works—and here they are! You've wanted to read NANA, the strange story of a low caste but beautiful woman whose alluring charms plunged a whole social register of counts, barons, and bankers into moral and financial oblivion—the novel that Parisians bought with furtive glances and carried home under their cloaks! NANA is included complete in this big volume, together with those other intimate and realistic novels, A LOVE EPISODE and L'ASSOMMOIR—and, in addition, eleven thrilling and impassioned novelettes from the ruthless ZOLA pen that stripped the veil of secrecy from the social life of Paris and laid bare the most amazingly tangled love affairs ever put into story form.

A Big $5.00 Value FREE!
when you join the Literary Guild

Where have you ever bought three full length novels for less than $7.50 to $10.00, not to mention the eleven novelettes included in this one gigantic book? You'll agree that our $5.00 valuation is *understatement*. Then think of getting this volume *free*—as an outright gift from the Literary Guild—just by accepting free membership in this money-saving book club. You'll revel in ZOLA! But act promptly while this special offer holds good.

MAROON CLOTH STAMPED IN GILT AND BLACK FOIL

Collected Works of Emile Zola

LITERARY GUILD MEMBERSHIP IS FREE

The Literary Guild selects for your choice each month the outstanding new books from the forthcoming lists of the leading publishers. The best new fiction and non-fiction is chosen by an able Editorial Staff and a limited edition is beautifully bound for exclusive distribution to Guild members.

Although the publisher's edition is on sale in the regular channels to the public for prices ranging from $2.50 to $5.00, Guild members, who have subscribed in advance for these forthcoming books OF THEIR CHOICE, pay ONLY $2.00 for these same books, to be delivered on the same day the publisher's edition is for sale at retail, and in a distinctive binding that is equally as good as the publisher's edition.

Members are required only to buy as few as four books within a year to obtain these special savings and to get ABSOLUTELY FREE the book advertised above.

So confident are we of the literary quality and excellence of all selections which bear the imprint of The Literary Guild that every book is sent ON APPROVAL. And with the book each month is enclosed a copy of the famous little magazine WINGS. This is the official publication of the Guild and is distributed ABSOLUTELY FREE to members only. It describes the current selection, tells about the author, and contains an article by the author with illustrations pertinent to the book. But in addition, WINGS is an invaluable guide to all of the important new books because each month about 30 new books are reviewed. In this manner members are kept reliably informed about all the new books—any of which they may purchase instead of or in addition to the monthly Guild selection.

To make Guild membership the last word in perfection, the back cover of WINGS contains a description of next month's book. Members, who can tell in advance that the forthcoming book is not of interest, merely have to notify us not to send next month's selection. At the same time, members can order any other book they wish from those recommended in WINGS.

MAIL THIS COUPON TODAY

Get the "Collected Works of Emile Zola" FREE

THE LITERARY GUILD OF AMERICA, Dept. 4-NYT

9 Rockefeller Plaza, New York

Enroll me as a member of the Literary Guild of America. I am to receive free each month the Guild Magazine "WINGS" and all other membership privileges. It is understood that I will purchase a minimum of four books through the Literary Guild within a year—either Guild Selections or any other books of my choice—and you guarantee to protect me against any increase in price of Guild Selections during this time. In consideration of this agreement you will send me at once, FREE, a copy of the "Collected Works of Emile Zola."

Name ..

Address ..

City State

Occupation ..

Canadian Subscribers write direct to the Literary Guild in Canada, 383 Yonge Street, Toronto, Canada.

You Save Up to 50%—And Get Free Bonus Books by Joining the Literary Guild

When you get brand new books for only $2.00 that are on sale at $3.00, $4.00, or $5.00, your book bills are cut in half. But the Guild offers even greater economies by rewarding the consistent buyer with a $3.50 Bonus Book every six months for the purchase of four books during each period.

Join Now—Send No Money

Remember: You buy only the books you want, and you may accept as few as four books a year. The Guild service starts as soon as you send the coupon. Our present special offer then gives you the "Collected Works of Emil Zola" absolutely free. This book will come to you at once with information about the Guild service and Bonus Offer.

ENTIRELY UNABRIDGED EDITION!

3 Full-Length Novels • 11 Novelettes
All Complete, Just as Zola Wrote Them
Unabridged • 993 Pages • 8¼x6x2⅝ Inches

The Finest Works of the Immortal Zola—Acknowledged Leader of the Great School of French Realists

NANA
THE MILLER'S DAUGHTER
CAPTAIN BURLE
THE DEATH OF OLIVIER BECAILLE
JACQUES DAMOUR
THE INUNDATION
NANTAS
COQUEVILLE
NAIS MICOULIN
ANGELINE
MADAME NEIGEON
A LOVE EPISODE
L'ASSOMMOIR

(In the case of "L'Assommoir" only, a few minor details are omitted to give the story still faster action. All other novels and stories in this book are complete, word for word as Zola wrote them.)

THE MYSTERIES OF MARSEILLES

Actual Size of Volume

Limited Edition—You Must Act at Once

LITERARY GUILD OF AMERICA, Dept. 4-NYT, 9 Rockefeller Plaza, New York

1938

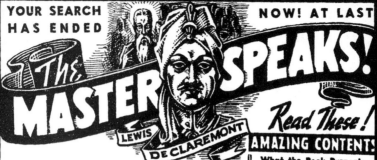
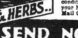

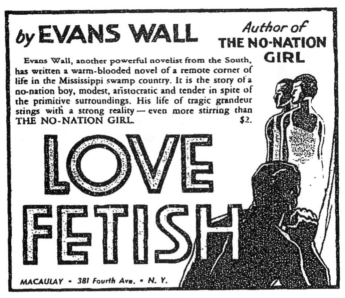

by **EVANS WALL**

Author of
THE NO-NATION GIRL

Evans Wall, another powerful novelist from the South, has written a warm-blooded novel of a remote corner of life in the Mississippi swamp country. It is the story of a no-nation boy, modest, aristocratic and tender in spite of the primitive surroundings. His life of tragic grandeur stings with a strong reality — even more stirring than THE NO-NATION GIRL. $2.

LOVE FETISH

MACAULAY • 381 Fourth Ave. • N. Y.

1932

The high tempo of life among Negro artists and writers

INFANTS
OF THE
SPRING
by WALLACE THURMAN
author of
THE BLACKER THE BERRY

This sharply real novel skeptically and satirically shows the Negro artists, writers and musicians in their racial isolation and revolt. They fore-gather in Nig-geratti Manor and try to hide their sense of futility by free living and excessive carousing. $2.

Macaulay
381 Fourth Ave.
New York

1932

1933

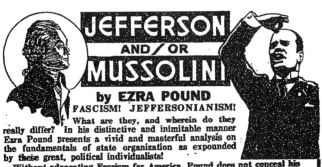

1936

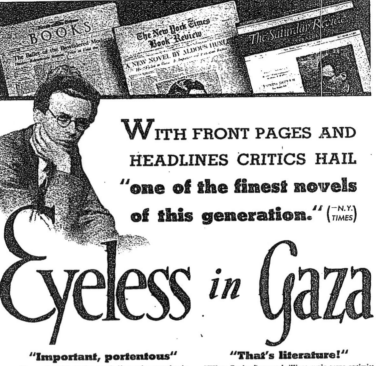

WITH FRONT PAGES AND
HEADLINES CRITICS HAIL
"one of the finest novels
of this generation." ($-$N.Y. TIMES)

Eyeless in Gaza

"Important, portentous"

"A novel which is the equal, if not the superior in intellectual and spiritual content, of any in our time. No thinking man or woman of the twentieth century can read it without stimulation and deep respect."
—N. Y. TIMES BOOK REVIEW

"Relentlessly honest"

"The brave rebellions, the hope and disillusions... the experiments with continence and promiscuity—all of the pathetic ballet of the moderns...in this relentlessly honest novel."
—N. Y. HERALD TRIBUNE "BOOKS"

"Magnificently readable"

"Insight and originality ... magnificently readable, acutely intelligent, and, in its succession of narrative episodes, humorous, compassionate and dramatic."
—SATURDAY REVIEW OF LITERATURE

"That's literature!"

"When England's most brilliant cynic turns optimist —that's news! And when he does so in a novel as excellent as *Eyeless in Gaza*—that's literature!"
—CHICAGO DAILY NEWS

"Deepest, most complete"

"Huxley proves that his whole career has been moving toward a rediscovery of the truth. *Eyeless in Gaza* is his deepest, most serious, most complete novel."
—THE NATION

"Soul-searching"

"He knows altogether too much about people and their naked souls." —N. Y. SUN

BY *Aldous* HUXLEY

1936

How to enjoy JAMES JOYCE'S *great novel*

ULY

FOR THOSE who are already engrossed in the reading of *Ulysses* as well as for those who hesitate to begin it because they fear that it is obscure, the publishers offer this simple clue to what the critical fuss is all about. *Ulysses* is no harder to "understand" than any other great classic. It is essentially a story and can be enjoyed as such. Do not let the critics confuse you. *Ulysses* is not difficult to read, and it richly rewards each reader in wisdom and pleasure. So thrilling an adventure into the soul and mind and heart of man has never before been charted. This is your opportunity to begin the exploration of one of the greatest novels of our time.

JAMES JOYCE

STUART GILBERT, in his masterly essay on ULYSSES, says: "It is like a great net let down from heaven including in the infinite variety of its take the magnificent and the petty, the holy and the obscene. In this story of a Dublin day we read the epic of mankind."

This monumental novel about twenty hours in the life of an average man can be read and appreciated like any other great novel once its framework and form are visualized . . . just as we can enjoy *Hamlet* without solving all the problems which agitate the critics and scholars. The structure of *Ulysses* is composed of three elements: the symbolic narrative of the Odyssey, the spiritual planes of the Divine Comedy and the psychological problem of Hamlet. With a plot furnished by Homer, against a setting by Dante, and with characters motivated by Shakespeare, *Ulysses* is really not as difficult to comprehend as critics like to pretend.

The real clue to *Ulysses* is simple: the title itself. Just as the Odyssey was the story of Odysseus, Telemachus and Penelope: the father who tries to find his home; the son who seeks his father; the constant wife who puts off her suitors and waits for her husband's return . . . so *Ulysses* is the story of Leopold Bloom, Stephen Dedalus and Molly Bloom: the father, an average man whose life is incomplete because his only son died in infancy and whom no one will honor or remember after his death; the son, a young poet who finds no spiritual sustenance in art or religion, and who is looking for a symbolic father—a certainty on which he can base his life; the wife, who is the earthly element, a parody of Penelope in her inconstancy, her bawdiness, her animal existence. The theme of the Odyssey has been called "the dominance of mind over circumstance"; and the theme of *Ulysses*, "the dominance of circumstance over mind."

Each of the characters in *Ulysses* exists on three different planes of reality. First, the naturalistic which involves the adventures of Stephen and Leopold during one day in Dublin; second, the classical which concerns the parallelism between *Ulysses* and the Odyssey in respect to the characters, events, and pattern; third, the symbolic which brings in the allusions to philosophy and to Irish history which have given *Ulysses* a special esoteric significance to a few learned readers. Here Joyce makes every chapter represent a color, a science or art, a symbol, an organ of the body, and a literary technique. But these things need not concern the general reader whose enjoyment of *Ulysses* depends on its humor, its wisdom, and its essential humanity. Beyond the esoteric significance of parts of the book, and beyond the tremendous wealth of details it offers about manners, morals, customs, thoughts, gestures, and speech, there lies as the solid basis of it one of the most exciting stories offered by modern fiction: the complete, unexpurgated record of a man's uninhibited adventures, mental and physical, during the course of one full day.

To better understand the action of *Ulysses* and the relation of the characters in it to real life as well as to their counterparts in the Odyssey, the following list of principal characters will be helpful.

THE CHARACT

In *Ulysses*	In N
Stephen Dedalus	Joyce
Leopold Bloom	An Iri 'sover
Molly Bloom	Wife with Jewish blood.
Buck Mulligan	Young student Stephen fird as 39. Jo friend
Blazes Boylan	Cheap town.
Paddy Dignam	Deceas Bloom.
Mr. Deasy	Master where teaches
The Citizen	A a who Bloom
Gerty MacDowell	Romant attracts
Bella Cohen	Propri brothel

But the deepest pl reading *Ulysses* is not able to identify the cha involves recognition o this story of vast pro detail.

Here are brief summ ters that compose the

PAR

THE PRELUDE: Stephen emachus in the Odyssey. father.

1 BREAKFAST on the Buck Mulligan, wit Haines, in Ireland for "Ir supply it facetiously, sou sion of Irish art and histo

2 STEPHEN teaches S Talks with Mr. D Stephen will remain long

3 STEPHEN walks on his life. Correspon Menelaus meets Proteus.

PAR

LEOPOLD BLOOM's day— Bloom is an advertising contacts"—hence his time eyes we see the whole s Lord Lieutenant to the *homme moyen sensuel*, w to try to discover as he about.

4 BLOOM prepares b cooks a kidney for letters to Molly in bed Boylan, impresario for Mo responds to Calypso's ca is held against his will.

a RA

PLAN OF DUBLIN

2

1

4

5

LEGEND

1. ROUND TOWER (Part I. Chapter 1) like the one where Stephen Dedalus and Buck Mulligan have breakfast.

2. THE MUSEUM (Chapter 8) where Bloom stops on ways to the library to look at the nude statues.

3. THE LIBRARY (Chapter 9) the scene of the famous discussion of *Hamlet* between Stephen, Buck and the Irish literati.

4. THE BEACH (Dublin Bay) (Chapter 13) where Bloom goes to rest from his day's wanderings.

5. THE MEDICAL SCHOOL. The students meet (Chapter 14) in the Maternity Hospital attached to it.

1934

from his day's wanderings. Gerty romanticizes Bloom as a hero, and day-dreams a love-affair with him. Bloom's thoughts and actions in regard to Gerty are more direct and realistic.

14 THIS is the culminating chapter of parodies, more or less summarizing the outstanding prose styles of English literature from the mediaeval to the present. The medical students are at dinner in the Lying-In-Hospital, Dublin, while Mrs. Purefoy is being delivered of a child upstairs. It ends in a mixture of dialect and slang, as Stephen and the students, followed by Bloom, go to a barroom and get drunk. Homeric parallel: The Oxen of the Sun.

15 PROBABLY the most famous chapter of *Ulysses* —the Circe episode in the brothel, all of it in dramatic dialogue. Many new characters are involved—soldiers, prostitutes, an idiot; and various characters in Bloom's and Stephen's imaginations, as these are worked upon by alcohol. This scene is a magnificent orgy, which outlines all the significant events of Stephen's and Bloom's lives.

PART THREE

THE MEETING of Odysseus and Telemachus; the return to Penelope.

16 BLOOM takes Stephen to the shelter of the cabman, Skin-the-Goat, to recuperate. (In the *Odyssey*, Telemachus meets Odysseus in the cave of Eumaeus, the goat-herd, but does not recognize him.)

17 BLOOM takes Stephen home with him. (The return to Ithaca.) The style is that of a theological catechism. Stephen departs, and Bloom goes to Molly.

18 IN the final chapter the story returns to earth, in the Gargantuan coda of the earthly Penelope —Molly Bloom's soliloquy in bed. The story comes down to the terms of the animal as we see what Molly thinks of Bloom and Boylan, of herself and her life. The triumph of circumstance over mind is complete.

Molly; would prefer to live in the sunny Mediterranean land of his ancestors.

5 BLOOM goes to post-office, receives letter addressed to "Henry Flower," the name he adopted to carry on lonelyhearts correspondence. Goes to mass, reflects on Catholic religion; emerges, buys soap, goes to public baths. Bloom's characterization and lively thoughts are the substance of this episode, which corresponds to that of the Lotus-Eaters in the Odyssey.

6 BLOOM goes with Stephen's father and others to the funeral of Paddy Dignam. They pass Stephen. Theme of Death developed; Bloom recalls his father, who committed suicide, and his son Rudy, who died in infancy.

7 THIS chapter is told in journalese, with sections broken by headlines. Bloom visits newspaper office to insert advertisement. The newspaper men and their work are described. Stephen enters, to arrange for publication of Mr. Deasy's article, but does not meet Bloom. *Evening Telegraph* office corresponds to Cave of the Winds in the Odyssey.

8 BLOOM looks for a place to have lunch; passes various people, including sandwichmen and the poet A. E.; talks with Mrs. Breen of Mrs. Purefoy, who has been in labor three days and whose child is to be born in a later episode. One lunch room reminds him of slaughter house where he once worked; he gets a sandwich elsewhere; sets out for library, where he has to look up ad in back newspapers; stops en route at Museum to look at nude statues.

9 THE scene is the National Library: Stephen Dedalus (Joyce), Mulligan (Gogarty) discuss *Hamlet* with Irish literati including A. E. and John Eglinton. Father-son theme of *Hamlet* predominantly parallels the same theme in *Ulysses*. Opposing points of view represent Scylla and Charybdis of *The Odyssey*.

10 THIS chapter consists of 18 short episodes, the events befalling various Dublin characters. Blazes Boylan buys fruit for Molly Bloom whom he is to see at 4 o'clock. Mr. Bloom buys novels for his wife. Chapter closes with passage through Dublin of the Lord Lieutenant of Ireland. Homeric parallel: the course of Odysseus at sea.

11 THE scene is the barroom of the Ormond Hotel; the barmaids, Miss Douce and Miss Kennedy, hear the Lord Lieutenant's carriage go by. They flirt with Boylan who then leaves to go to Mrs. Bloom; Bloom enters for a belated lunch. Simon Dedalus (Stephen's father) and two others sing at the piano. Bloom, as "Henry Flower," answers letter from Martha Clifford, received that morning.

12 THE "Cyclops" chapter, the most gorgeously humorous in the book. It is told by a Dublin bum, in racy Irish dialect (perfectly comprehensible), and it tells of the meeting of Bloom and "The Citizen" —a drunken banshee of a Sinn Feiner—in a saloon. He wants to kill Bloom, chases him into the street, throws a biscuit-tin at him but misses, because—like Polyphemus—he is blinded by the sun. Bloom and the Citizen are gorgeously taken off in parodies of scientific jargon, cheap journalism, romance; showing the difference between their opinions of themselves and the realities which they represent.

13 ANOTHER extremely humorous chapter, almost entirely a parody of cheap romantic fiction—the self-projection of Gerty MacDowell (Nausicaa) at the beach, Dublin Bay, where Bloom has gone to rest

1931

1938

HERE'S YOUR BOOK

By Way of THE AFRO-AMERICAN

LONESOME HEARTS

JOIN

HANDS ACROSS THE WORLD

CANADA

RUSSIA

U.S.A.

THE ISLANDS

AFRICA

By

Albertine Ashe

Price 15c

Published By

THE AFRO-AMERICAN

628 N. EUTAW STREET BALTIMORE, MD.

1937

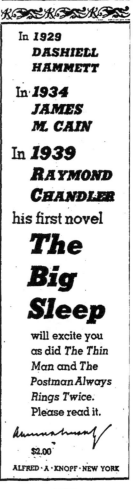

In *1929*
DASHIELL HAMMETT

In *1934*
JAMES M. CAIN

In *1939*
RAYMOND CHANDLER

his first novel

The Big Sleep

will excite you as did *The Thin Man* and *The Postman Always Rings Twice.* Please read it.

$2.00

ALFRED · A · KNOPF · NEW YORK

1939

"NATIVE SON" SALES NEAR QUARTER MILLION WITHIN TWO WEEKS!

• A BOOK-OF-THE-MONTH CLUB SELECTION FOR MARCH •

Public Storms Bookstores in Record Numbers for Richard Wright's Novel Following Sensational Reviews from Coast to Coast

"Wright is not only the best Negro writer but an American author as distinctive as any now writing," says the N. Y. Times Book Review

"An astonishing piece of work"
"An astonishing piece of work. Judge it by the directly opposite standards of a thriller and a psychological novel, and you will find it supreme from both points of view."—*Fanny Butcher, Chicago Tribune.*

"Murder-mystery suspense"
"Only a Negro could have written NATIVE SON; but until now no Negro has possessed either the talent or the daring to write it. For all its murder-mystery suspense, it is no more simply a crime story than was *Crime and Punishment*."—*Time Magazine.*

"A superb novel to stagger the conscience of the nation"
"It is even more shocking than *Grapes of Wrath*, its problem even more difficult to attack. This book will give you no peace until you've finished it and precious little afterward, either. A superb novel to stagger the conscience of the nation." —*Washington D. C. News.*

"Difficult to write temperately about"
"It is difficult to write temperately of a book which abounds in such excitement, in so profound an understanding of human frailty. If the tests of a memorable novel are that it engage the reader completely, move him profoundly and constitute a revelatory intellectual experience, then NATIVE SON will not soon be forgotten."
—*N. Y. Herald Tribune "Books"*

"Invites immediate comparison with 'The Grapes of Wrath'"
"Far and away the finest novel ever written by an American Negro and the finest ever written about an American Negro. It invites immediate comparison with *The Grapes of Wrath*. A powerful and timely book."
—*Kansas City Star*

"Tremendous"
"NATIVE SON is a novel of tremendous power and beauty."—*Newsweek.*

"Something new in American fiction"
"NATIVE SON is something new in American fiction . . . a deeply compassionate and understanding novel. As near as anything can be, it is *The Grapes of Wrath* of 1940."—*Lewis Gannett, N. Y. Herald Tribune.*

"The most powerful novel since 'The Grapes of Wrath'"
"NATIVE SON is the most powerful American novel to appear since *The Grapes of Wrath* . . . so overwhelming is its central drive, so gripping its mounting intensity. It does for the Negro what Theodore Dreiser's *American Tragedy* did for the bewildered, inarticulate American white."—*Clifton Fadiman, The New Yorker.*

"A story to haunt the imagination"
"NATIVE SON is an enormously stirring novel . . . a story to trouble midnight and the noon's repose and to haunt the imagination."—*Charles Poore, N. Y. Times.*

"Shakes one's private world"
"So demanding, so real, so disturbing it shakes one's private world to its very foundations."—*Sterling North, Chicago News.*

"Terror . . . utter and compelling"
"For terror in narrative, utter and compelling, there are few pages in modern American literature that will compare with NATIVE SON."—*Jonathan Daniels, Saturday Review.*

"Written with consummate skill"
"Written with consummate skill, an intense and powerful novel not only of American Negro life but of life in America."—*N. Y. Post.*

"On his way to the very top rank of American novelists"
"That he is one of the most courageous of today's writers is self-evident. His command of language, his deep insight into the problem of the Negro in America, place his work in a category by itself. He is on his way to the very top rank of American novelists."—*Dallas News.*

"It is packed with dynamite"
"He has written a tremendously vital story. It is exciting, hard-bitten, sensational. It is an engrossing, terrible story. It is packed with dynamite." —*Des Moines Register*

"Negro American Tragedy"
"He is not merely the best Negro writer but an American author as distinctive as any now writing. A ready way to show the importance of his novel is to call it the *Negro American Tragedy*."—*Peter Monro Jack, N. Y. Times Book Review.*

RICHARD WRIGHT
Author of "Native Son"
Compared by the critics to Steinbeck, Dreiser, Dostoevski

OUT of the experiences of an amazing life has come this amazing novel, whose basic material is an integral part of Wright's own background and observation.

He was born thirty-one years ago on a plantation twenty-five miles south of Natchez, Mississippi. When he was five, his family moved to a tenement in Memphis, Tennessee. His father began to drift off for long intervals without leaving coal or food at home, and the child lived for some months in a sort of orphan's home. As he grew older, he hung round the front doors of saloons and sold papers in the streets. He was taken in, first by a grandmother, then by an uncle. The uncle, says Wright, "soon gave up trying to stop me from fighting, stealing, lying and cutting school, and shipped me back to my grandmother, who predicted I would end on the gallows."

But somehow, in school, the boy developed the habit of reading. And after he left home, in Memphis, in Chicago and elsewhere, he read everything he could find. He came across Mencken's PREFACES, which served him as a literary Bible for some years. During that time he earned a living by sweeping streets, digging ditches, selling insurance and clerking in the Post Office.

The depression put him out of work and he turned one hand to writing. His first book was *Uncle Tom's Children*. His second was *Native Son*. And *Native Son* is now on its way to becoming one of the most popular books of the Twentieth Century. It is a success story which inflames the imagination.

THE
1940s

Who remembers *Letter of Credit*, a 1940 novel by Jerome Weidman? I didn't. But the advertisement for Weidman's novel in this chapter makes me want to score a copy immediately. Over a mighty pileup of praise from reviewers, this ad declares: "One might conclude that the reviews below were conjured up in a marijuana session. But we have no Marijuana Department." That's a pity. This is an ad that actually does feel like it was created by stoners.

That same year, Harper Brothers published Richard Wright's novel *Native Son*—the book ad is a classic. Under a screaming headline ("'NATIVE SON' SALES NEAR QUARTER MILLION WITHIN TWO WEEKS!"), the ad is among the earliest of the so-called "smorgasbord" book ads, which do indeed set out an assortment of treats, from blurbs to mini-profiles of the authors to descriptions of the book's primary characters. These ads were visually busy as well, with multiple typefaces and features like bullet points and Victorian brackets.

One of the most famous author photos in the history of American letters appeared in the full-page advertisement for Truman Capote's *Other Voices, Other Rooms* (1948). That photograph, showing a reclining Capote looking into the camera with a direct, sexual gaze, shocked readers and boosted sales. (Compare Capote's photograph with Saul Bellow's in the ad for his 1944 novel *Dangling Man*. Bellow, a young fogy at age twenty-nine, is smoking a pipe.)

The 1940s also saw one of the first examples of a publisher buying space to reprint a glowing review in full. See the ad here for Betty Smith's 1943 novel *A Tree Grows in Brooklyn*. The review, by Orville Prescott of the *New York Times*, called Smith's book "a profoundly moving novel, and an honest and true one. It cuts right to the heart of life." ◆

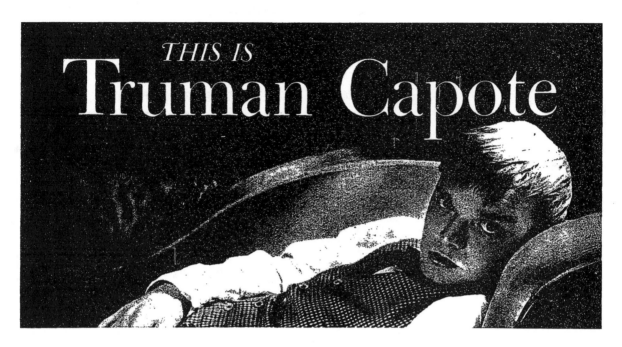

THIS IS
Truman Capote

His amazing first novel marks the debut
of a powerful new talent in American literature

Other Voices, Other Rooms

➡ It happens rarely, perhaps once in a decade, but every now and then an author appears who has that magical quality that fires discussion months before his book is published. This was true of William Saroyan. It is especially true of Truman Capote.

➡ Six months ago, LIFE magazine ran an article about *Young American Writers;* a full-page photograph of Truman Capote headed the piece. Almost as many months ago, a San Francisco bookseller had individual orders for 23 copies of OTHER VOICES, OTHER ROOMS; what made this so unusual was the fact that our own West Coast representative had not yet begun selling the book! These were the first inklings that something impressive had begun to happen. There were others.

➡ When the manuscript finally arrived we understood why everybody was saying that *Capote* was *the* important new name in American letters. For here was a tour de force . . . vaguely reminiscent of *William Faulkner* and *Carson McCullers* yet utterly unlike either of them. In a style as infinitely varied as the scenes and episodes, *Truman Capote* tells the wonderful tale of a sensitive adolescent's discovery of the beauty and horror of adult life.

➡ On one level it is the story, sometimes amusing, sometimes uncanny, of a boy's wandering search for his father, and of how he becomes entangled in the feverish lives of some people in a desolate Southern rural community during one long and lowering summer. On another level it is a deeply moving, haunting study of evil . . . as terrifying and unforgettable as anything you have ever read.

➡ But there is much more to this book than its iridescent plot. Joel's adventures, whether of mind or body, reveal themselves through a new dimension in language . . . the words have color and music . . . there are weird undertones of unnamed peril, and the almost unbearable pain and excitement of a young boy's growing awareness of, the lights and shadows of the adult world.

➡ With OTHER VOICES, OTHER ROOMS, Truman Capote has become an important American novelist. Though he is only 23 years old, he is more than "a young man of promise." As the author of many brilliant short stories and now this distinguished and exciting first novel, he is the young man who has delivered on his promise. $2.75

Random House
Bestsellers

AT ALL BOOKSTORES, **RANDOM HOUSE,** *NEW YORK*

1948

Second Printing
Price $2.75

Not from "The Marijuana Department"

JEROME WEIDMAN'S *new book was published two weeks ago. One might conclude that the reviews below were conjured up in a marijuana session. But we have no Marijuana Department. These reviews are not only real, but are sending real people scurrying to real bookshops to get copies of this, one of the most real books we've ever published. Take a look at the evidence – it should make you want to join the thousands who are saying, "read it and whoop!"*

SIMON AND SCHUSTER, Publishers
1230 SIXTH AVENUE, NEW YORK CITY

EXHIBIT A — THE REVIEWERS

"Mr. Weidman has a great literary gift in his ear for dialogue and delicate shading of spoken phrase which equals Ernest Hemingway's. He is at his magnificent best when he is hearing and seeing other people. Then he is firm and tender and bold. The result is one of the most readable travel books in many years. These portraits are superbly done, contain more shrewd by tandem observation, in a handful of pages than is to be found in the average full-length novel. If Mr. Weidman had not written the season's most financially readable book it might also have been its most significant one." —*N.Y. Herald-Tribune "BOOKS"*

"*Letter of Credit*, is to our mind, the most engrossing record of travel by any American writer since Henry James published 'The American Scene' (1907). Not that there is the most tenuous kinship between this volume and the James masterpiece. Neither in theme nor handling. But both books we read with the same kind of breathless, ecstatic excitement. Our conviction is that 'Letter of Credit' will be very much alive three and thirty years from now. It is literature. How Brentano would have gurgled with gleeful homage over the art of the chapter on the American medical students in Edinburgh, the almost incredible and impossible Mr. Frade, whom Conrad would have given his right hand to create. Mr. Weidman already belongs to significant American literature. But this latest fruit of his pencraft amazes us by its wise certainty, its magnificently thorough understanding of men and women, the clear clean economy of the serviceable prose. In his kind of writing, one wonders if there be a more satisfying writer in America to-day." —*Buffalo News*

"A travel book? Oh, yes. But nevertheless a thing apart, to bring you a spate of chuckles, some roars of mirth, and some thought. Jerome Weidman can dish up people in a brilliant round-the-world succession of *pieces de resistance* throughout a delightful book. These keen eyes looked on a world as it tottered. Human pictures and characterizations so shrewd and suggestive as to be all we need for novelettes, and sharp, honest observation which may first seem to dazzle by an almost wisecracking brightness but which has the retentive force of simple truth. There's a whole world of event and character and response, much of it funny, all of it shrewd, every sentence good reading. You may never see anything like it again." —*N.Y. Times Book Review*

"Jerome Weidman has Goya and Daumier in his fingers, a bit of Dickens in his heart, and the sidewalks of New York in his blood. You'll find delineation of degradation, of humor,

of despair, of fear, doubt, and the masks are hardly hollow. They are brim full. They ooze with the oils of living and laughing and weeping and dreaming. It is a book we wouldn't trade the dozen prophetic travel prognostications for, and we feel you'll think so too." —*New York Mirror*

"A tart, brash and extremely readable personal record. He pickles the eerie present of 1939 forever in his book. He loves people, singly and in masses, preferably when they are on the queer side, as Daumier loved them, and he can put them down unforgettably on paper." —*LEWIS GANNETT in the N.Y. Herald-Tribune*

"It is excellent and entertaining reading and excellent and intelligent reporting, and so fresh as though nothing of the kind had ever been thought of before. If the trip cost Mr. Weidman his fortune, he ought to get it back. He deserves to, with interest, and I expect he will." —*RALPH THOMPSON in the New York Times*

EXHIBIT B — THE BOOKSELLERS

"On Saturday somebody borrowed a copy of 'Letter of Credit' from our library. Today it was returned, and in the flyleaf is the following note: 'May I recommend this book wholeheartedly; it is one of the finest and interesting things it has ever been my pleasure to read.' This is the only time I have ever known anybody to do that." —*E. A. PILLER, Waverly Book Store, Boston, Mass.*

"Seven cheers for Jerome Weidman! I swore I'd never read a travel book and like them, but last night I ate them words and was still eating them when I put the book down at 1:30 A. M.—and on with a job to get to this morning!" —*As E. H. Macy Reader*

"This is the kind of writing that sings. I'm still laughing. For us, who couldn't visit Europe and Asia just before the great war broke, Jerome Weidman's book is the next best thing. I can still rave about a book. I really like, and how I like this one!" —*DOROTHY WOODS, Manager of the Book Dep't, Stix, Baer and Fuller, St. Louis*

"Next time you publish such an entertaining book please warn me that if I start in, I will not wish to stop reading it. I read until after 2 A. M., which is very difficult for a poor working girl. It should be a best-seller, for it has appeal for everyone." —*M. L. THOMPSON, Post Box Book Service, N. Y. C.*

LETTER OF CREDIT

BY JEROME WEIDMAN

1940

Who – or what – is

WOUK?

FIRST of all you should know that his name is pronounced "woke." It is a point worth clearing up, because it is a name you will be hearing and using often.

By education and natural bent he is a philosopher and a scholar. By profession he is a radio gag writer.

He has written a novel, AURORA DAWN, which sounds as if it might have been penned with an ostrich quill in a peaceful sidewalk cafe. But it was begun on a U. S. destroyer in the South Pacific during the war, while the author was a Navy Lieutenant.

It is his first novel. But he writes as if he has been polishing off novels all his life and getting better at it all the time.

Inevitably his book will, because of certain views on advertising it contains, be compared to *The Hucksters*. But in style and approach the two novels have about as much in common as *Vanity Fair* and *The Sun Also Rises*.

He has some rather serious things to say. But he refuses to be deadly serious in saying them.

His story of the dramatic deadlock between a backwoods radio evangelist and a tyrannical soap tycoon—and his counterplots involving the young radio executive who is made miserable by the competing charms of two beautiful young ladies—are both as Twentieth-Century as radar. But he has sharpened their contemporary flavor in a curious and unexpected way: by roguishly assuming the mantle of the mock-heroic romancer of the Eighteenth Century.

In short, HERMAN WOUK is a highly paradoxical new American writer, and (it is our passionate belief) as brilliant as he is paradoxical. In an era of standardization and mass production, he has, out of sheer perversity, carved by hand a literary style that defies description or comparison. The pure delight it affords can only be suggested by samples of it; and AURORA DAWN is so rich in quotable passages that dozens of them can be given away without appreciably depleting its wealth. You are invited to help yourself to the samples on the right.

FREE SAMPLES OF WOUK

PAGE 10. *In Which the Author Makes an Observation about Carol Marquis.*
Hey body was shaped according to the Freudential design for young ladies' bodies, and was soon pleasing to the view of Andrew, whose own declared little from the Prudential design for young men's eyes.

PAGE 53. *In Which Laura Beaton's Charms Are Appraised.*
She was painfully fair to look upon. She was a toast to man, a reproach to woman. Faithful husbands felt a stir of sinful grief as against their will, they compared her to their spouses and knew that Fate had caged them forever in gray little traps. The flames of ardent lovers flickered and guttered as though the wind of truth had suddenly blown a gust into their overheated imaginations, and an odious little valet warned them that their own Collas were, after all, but so many muddle-complexioned, lumpy wives-to-be. Young bachelors formed, old barbarians mourned. Not a woman within range but felt her presence as an indignity and took revenge in a patronizing analysis of her hair.

PAGE 136. *In Which Preparations Are Made for Laura's Marriage to a Millionaire.*
The day is named, Friday. The elaborate clockwork has come to life, dancing the gay jig that ensues in our community upon the utterance of the magic word "Wedding." The printing press sight and groans in stamping

not the announcement as though it were a disappearing cousin; the disappearing cousin spread the news as though they were printing presses; the dressmakers danced, hard of eye and quick of tongue, to sell the virgin more dresses than she has ever owned, in honor of the occasion of her casting the charms of dress aside; the pastry-cook, proportioning the number of layers in the cake to the number of digits in the bridegroom's fortune, is at work on a terraced pyramid bearing an unfortunate resemblance to Purgatory; the musicians are hired, the caterer instructed, the wine ordered, the flowers assembled, the ring selected, the minister informed, the guests bidden; Stephen English has an efficient secretary, and were it possible formally to remind angels to be present it would certainly be done.

PAGE 173. *In Which "The Young Man That Was" Is Saluted.*
Ladies, on next paragraph is for the gentleman readers; do me the grace to stand aside. And You young men, the age of my hero, Andrew Reale, or greener yet, stand you aside too, for I speak to others—but listen.

Now then, my jolly boys who were young and are old; who were foolish and are sensible; who quitted the years trickishly and now member the days in wisdom; who desperately clutched girls and now fondly pat wives; open the closed books, wake the memories, sniff the dried roses of regret, and then let us fill a cup, and drink with here to that most noble, ridiculous, laughable, sublime departed bygone in all our lives—the Young Man That Was. Let us drink to his dreams, for they were rainbow-colored; to his appetites, for they were strong; to his blunders, for they were huge; to his beloved, for she was sweet; to his pain, for it was sharp; to his time, for it was brief; and to his end, for it was—to become one of us. In the land where the bright sunlight bathes us, where the flowers are spring flowers and the grass is an April green forever, let still walks his jaunty, immortal; mistaken way. God pity us all—with what precious veins have we bought our philosophy, oh, so late!

AURORA DAWN

A Novel by HERMAN WOUK · A BOOK-OF-THE-MONTH CLUB SELECTION
Price $2.75, wherever books are sold · SIMON AND SCHUSTER, Publishers

1947

"**Challenging**" —ST. PAUL DISPATCH "**Ingenious**" —N.Y. TIMES BOOK REVIEW

"**Powerful, original, brilliantly written**" —CHICAGO TRIBUNE

"**Inspiring**" —WASHINGTON TIMES-HERALD "**Compelling**" —SAN FRANCISCO CHRONICLE

"**Strong, dramatic . . . a pleasure to read**" —SATURDAY REVIEW OF LITERATURE "**Magnificent**" —PITTSBURGH PRESS

"**Exciting events . . . colorful characters**" —N.Y. HERALD TRIBUNE

"**Distinguished**" —PROVIDENCE JOURNAL "**Provocative**" —BOSTON HERALD

"**Practically impossible to put down**" —PHILADELPHIA INQUIRER

"A whale of a book" —N.Y. TIMES

THE FOUNTAINHEAD

By AYN RAND

6th Large Printing · $3.00

Through the dramatic story of three men and a woman, told against the background of New York's architectural skyline—the symbol of American aspiration and achievement—Ayn Rand has given to the reading public the *first* novel dedicated to the individual and Individualism.

In this age of creeping collectivism, the spontaneous response of the readers has shown that the American spirit is not lost, that there is a need and an audience for an eloquent voice speaking of the dignity of Man.

Characters of great strength. An extraordinary love story. Dramatic action that carries you breathless through the 754 pages.

Indianapolis **BOBBS-MERRILL** New York

1943

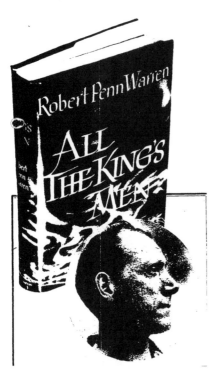

Robert Penn Warren's novel about Southern politics and manners is the most distinguished best-seller of the year.

ALL THE KING'S MEN

At all bookstores, $3.00

— HARCOURT, BRACE AND COMPANY —

1946

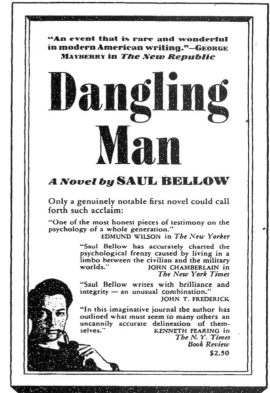

"An event that is rare and wonderful in modern American writing."—GEORGE MAYBERRY in *The New Republic*

Dangling Man

A Novel by **SAUL BELLOW**

Only a genuinely notable first novel could call forth such acclaim:

"One of the most honest pieces of testimony on the psychology of a whole generation."
EDMUND WILSON in *The New Yorker*

"Saul Bellow has accurately charted the psychological frenzy caused by living in a limbo between the civilian and the military worlds."
JOHN CHAMBERLAIN in *The New York Times*

"Saul Bellow writes with brilliance and integrity — an unusual combination."
JOHN T. FREDERICK

"In this imaginative journal the author has outlined what must seem to many others an uncannily accurate delineation of themselves."
KENNETH FEARING in *The N. Y. Times Book Review*
$2.50

1944

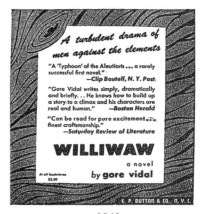

A turbulent drama of men against the elements

"A 'Typhoon' of the Aleutians ... a rarely successful first novel."
—Clip Boutell, N. Y. Post.

"Gore Vidal writes simply, dramatically and briefly. . . He knows how to build up a story to a climax and his characters are real and human."
—Boston Herald

"Can be read for pure excitement ... finest craftsmanship."
—Saturday Review of Literature

WILLIWAW
a novel
by gore vidal

At all bookstores
$2.50

E. P. DUTTON & CO., N. Y. C.

1946

1948

The story of a white newspaperman who lived as a Negro in the South —and didn't like it.

WHEN RAY SPRIGLE. Pulitzer Prize-winning reporter, first suggested the idea to his editors they agreed it might make a good story. He wanted to pose as a Negro, living black in the white South, to find out what life in the land of Jim Crow was really like.

That's how it started.

For four fear-filled weeks Ray Sprigle ate, slept, traveled, lived black. He lodged in Negro households. He ate in Negro restaurants. He crept through the back and side doors of railroads and bus stations. He met and talked with hundreds of Negro leaders, colored Americans, whites. He saw and listened, learned and cringed.

He deliberately sought the evil and the barbarous aspects of the white South's treatment of the Negro That was his assignment, and that was his story. He came back with a sensational news scoop.

Less than half of the material has appeared in newspapers. This book contains the whole shocking, almost incredible story of how, for ten million American citizens, the American way of life is nothing but a pipedream. It is not a preachy book; it merely reports the facts as a skillful and courageous newspaper reporter found them.

IN THE LAND OF JIM CROW

By RAY SPRIGLE. Foreword by MARGARET HALSEY
$2.50, at all bookstores. SIMON AND SCHUSTER, PUBLISHERS

1949

Second-Class Citizens!

Even if you were born in America and have lived here all your life, you cannot possibly be fully aware of all the laws and customs which impose second-class citizenship on certain racial and religious minorities.

For a complete digest of these highly variable and often contradictory codes, don't miss the

JIM CROW GUIDE TO THE USA

By Stetson Kennedy and Elizabeth Gardner

This comprehensive study, which is to be published in book form by Gaer Associates of New York City this Spring, will appear in serial form in the AFRO-AMERICAN exclusively, beginning next week.

Here is shocking proof that Jim Crowism is not a malady peculiar to the Southern States, but a virulent disease that is rapidly assuming epidemic proportions in all parts of America.

If you favor the abolition of second-class citizenship—are for a second emancipation in this country—for passage of the civil rights program—don't miss.

JIM CROW GUIDE TO THE USA

1949

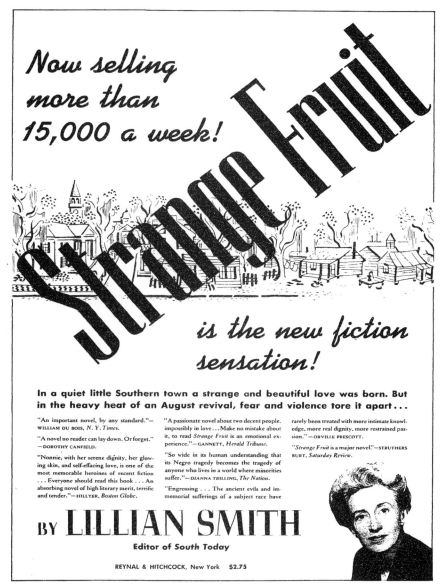

Now selling more than 15,000 a week!

Strange Fruit

is the new fiction sensation!

In a quiet little Southern town a strange and beautiful love was born. But in the heavy heat of an August revival, fear and violence tore it apart . . .

"An important novel, by any standard."—WILLIAM DU BOIS, *N. Y. Times*.

"A novel no reader can lay down. Or forget."—DOROTHY CANFIELD.

"Nonnie, with her serene dignity, her glowing skin, and self-effacing love, is one of the most memorable heroines of recent fiction . . . Everyone should read this book . . . An absorbing novel of high literary merit, terrific and tender."—HILLYER, *Boston Globe*.

"A passionate novel about two decent people, impossibly in love . . . Make no mistake about it, to read *Strange Fruit* is an emotional experience."—GANNETT, *Herald Tribune*.

"So wide in its human understanding that its Negro tragedy becomes the tragedy of anyone who lives in a world where minorities suffer."—DIANNA TRILLING, *The Nation*.

"Engrossing . . . The ancient evils and immemorial sufferings of a subject race have rarely been treated with more intimate knowledge, more real dignity, more restrained passion."—ORVILLE PRESCOTT.

"*Strange Fruit* is a major novel."—STRUTHERS BURT, *Saturday Review*.

BY LILLIAN SMITH

Editor of *South Today*

REYNAL & HITCHCOCK, New York $2.75

1944

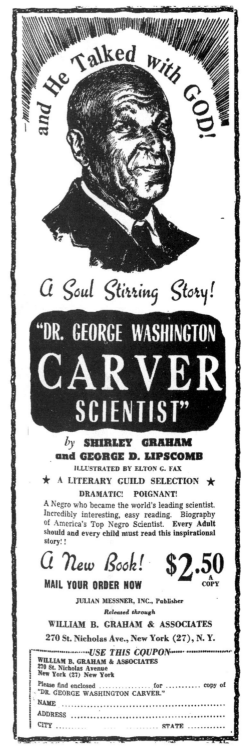

What keeps HITCHCOCK in suspense?

☛ You will see murder done in a sky-scraper elevator that has gone out of control.

☛ You will know you have an enemy in the house—but know it only subconsciously.

☛ You will meet a huge, gentle fellow who "lives simply among his books" and leads a fairly active life as a homicidal maniac.

☛ A beautiful French girl will hand you a blue paper with mysterious scribblings which will make the whole world revile you.

☛ Before your horrified eyes a school of giant octopuses will swarm aboard a schooner and drag every member of the crew overboard.

☛ A stranger will invite you to a seance where you will become the victim of an odd experiment.

If it all sounds like a Hitchcock thriller, it should. Alfred Hitchcock, director of such un-nerving film classics as "The 39 Steps," "The Lady Vanishes," "Rebecca," "Notorious," has at last found a way to paralyze you with fear right in the comfort of your own home.

From his own library of the literature of suspense, he has chosen his 27 favorite stories, by such writers as William Irish, Lord Dunsany, John Dickson Carr, James M. Cain, Graham Greene.

If you are a Hitchcock fan and would like to read the stories that managed to keep Hitchcock himself in suspense, you will want—

ALFRED HITCHCOCK'S Fireside Book of SUSPENSE

Edited with commentaries by Mr. Hitchcock

Price $3.50 · SIMON AND SCHUSTER, *Publishers*

1947

Mary McCarthy,
AUTHOR OF

THE COMPANY SHE KEEPS

THE PUBLISHERS are certain that the publication of *The Company She Keeps*, Mary McCarthy's first novel, marks the inception of a distinguished literary career.

It is a novel in six episodes, dealing with the experiences of a girl in her twenties alone in New York. The milieu is the world of advertising men, radicals, writers, publishers, art dealers, teachers —glorified white-collar workers and declassed professional people.

Mary McCarthy approaches her heroine in the manner of an experimental photographer. Each episode is a different portrait of her, shot from a different angle, in a different light, and the author shifts the point of view as the photographer moves his camera. The result is a three-dimensional portrait of a woman. (Just published. Price $2.50)

SIMON AND SCHUSTER · PUBLISHERS · NEW YORK

1942

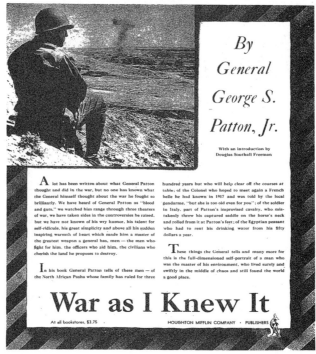

By General George S. Patton, Jr.

With an introduction by Douglas Southall Freeman

A lot has been written about what General Patton thought and did in the war, but no one has known what the General himself thought about the war he fought so brilliantly. We have heard of General Patton as "blood and guts," we watched him range through three theaters of war, we have taken sides in the controversies he raised, but we have not known of his wry humor, his talent for self-ridicule, his great simplicity and above all his sudden inspiring warmth of heart which made him a master of the greatest weapon a general has, men — the men who fight for him, the officers who aid him, the civilians who cherish the land he proposes to destroy.

In his book General Patton tells of these men — of the North African Pasha whose family has ruled for three hundred years but who will help clear off the courses at table; of the Colonel who hoped to meet again a French belle he had known in 1917 and was told by the local gendarme, "but she is too old even for you"; of the soldier in Italy, part of Patton's improvised cavalry, who mistakenly threw his captured saddle on the horse's neck and rolled from it at Patton's feet; of the Egyptian peasant who had to rent his drinking water from his fifty dollars a year.

These things the General tells and many more for this is the full-dimensioned self-portrait of a man who was the master of his environment, who lived surely and swiftly in the middle of chaos and still found the world a good place.

War as I Knew It

At all bookstores, $3.75 HOUGHTON MIFFLIN COMPANY · PUBLISHERS

1947

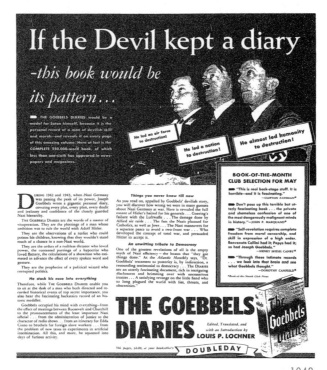

If the Devil kept a diary

-this book would be its pattern...

THE GOEBBELS DIARIES would be a model for Satan himself, because it is the personal record of a man of devilish skill and morals—and reveals it on every page of this amazing volume. Here at last is the COMPLETE 250,000-word book, of which less than one-sixth has appeared in newspapers and magazines.

He led an air force to destruction!

He led a nation to destruction!

He almost led humanity to destruction!

During 1942 and 1943, when Nazi Germany was passing the peak of its power, Joseph Goebbels wrote a gigantic personal diary, covering every plot, every plan, every doubt and jealousy and confidence of the closely guarded Nazi hierarchy.

The Goebbels Diaries are the words of a master of vituperation. They are the plottings of a man whose ambition was to rule the world with Adolf Hitler.

They are the observations of a realist who could poison his children, knowing that they wouldn't stand much of a chance in a non-Nazi world.

They are the orders of a ruthless dictator who loved power, the contented purrings of a hypocrite who loved flattery, the calculations of a showman who estimated in advance the effect of every spoken word and gesture.

They are the prophecies of a political wizard who corrupted politics.

He stuck his nose into everything

Therefore, while The Goebbels Diaries enable you to sit at the desk of a man who both directed and recorded historical events of top secret importance, you also hear the fascinating backstairs record of an historic meddler.

Goebbels occupied his mind with everything—from the effect of meetings between Roosevelt and Churchill to the pronouncements of the least important Nazi official . . . from the administration of justice to the character of radio shows . . . from an itinerary for Edda Ciano to brothels for foreign slave workers . . . from the problem of new taxes to experiments in artificial insemination. All this, and more, he squeezed into days of furious activity.

Things you never knew till now

As you read on, appalled by Goebbels' devilish story, you will discover how wrong we were in many guesses about Nazi Germany at war. Here is revealed the full extent of Hitler's hatred for his generals . . . Goering's failure with the Luftwaffe . . . The damage done by Allied air raids . . . The fate the Nazis planned for Catholics, as well as Jews . . . The Nazi maneuvers for a separate peace to avoid a two-front war . . . Who developed the concept of total war, and persuaded Hitler to accept it.

An unwitting tribute to Democracy

One of the greatest revelations of all is the empty myth of Nazi efficiency—the boasts that "they got things done." As the *Atlantic Monthly* says, "Dr. Goebbels' testament to posterity is, by indirection, a resounding testimonial to democracy . . . The Diaries are an utterly fascinating document, rich in intriguing disclosures and brimming over with unconscious ironies . . . A satisfying revenge on the little fiend who so long plagued the world with lies, threats, and obscenities."

BOOK-OF-THE-MONTH CLUB SELECTION FOR MAY

"This is real back-stage stuff. It is horrible—and it is fascinating."
—CLIFTON FADIMAN

"Don't pass up this terrible but utterly fascinating book . . . the private and shameless confession of one of the most dangerously malignant minds in history."—JOHN P. MARQUAND*

"Self-revelation requires complete freedom from moral censorship, and skill in expression of a high order. Benvenuto Cellini had it; Pepys had it; so had Joseph Goebbels."
—HENRY SEIDEL CANBY*

"Through these intimate records . . . we look into that brain and see what Goebbels thought."
—DOROTHY CANFIELD*

*Book-of-the-Month Club News

THE GOEBBELS DIARIES

Edited, Translated, and with an Introduction by LOUIS P. LOCHNER

566 pages, $6.00, at your bookseller's DOUBLEDAY

1948

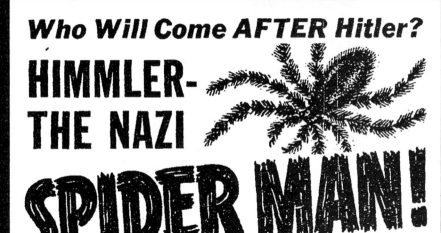

1942

A ROYAL AMERICAN WELCOME

*for an unassuming
British lady*

Mrs MINIVER

BY JAN STRUTHER

*Who is she? She is the epitome of what we know
and love about England. She is . . . but let the
reviewers introduce you to Mrs. Miniver. . . .*

Christopher Morley: "My favorite heroine this
summer . . . the twentieth century's only humane
achievement, the civilized woman. If you don't relish
Mrs. Miniver you are not a connoisseur of human
beings."

Clifton Fadiman, The New Yorker: "Mrs. Min-
iver, like Charles Lamb, will place a gentle hand on
your elbow and bid you stop to observe something
quite insignificant, and lo! it is not insignificant at all
. . . That touch, the touch of Lamb, even of Shakes-
peare in a minor mood, is one of the indefinable things,
quite unimportant, that Englishmen and Englishwomen
are fighting and dying for at the moment."

New York Times Book Review: "Tears do not
fall in this book; laughter is above the collar . . . the
endearing charm of Mrs. Miniver."

Lewis Gannett, New York Herald Tribune:
"Reading it, you understand why the poets have
written so many of their loveliest lines about 'this
England.'"

New York Herald Tribune Books: "All that was
best in English life is in this delightful book."

Donald Friede, Hollywood Reporter: "The most
heart-warming character since Mr. Chips."

*Quick to your nearest bookstore
. . . . and meet Mrs. Miniver!*

2 big printings before publication, $2.00

1940

GYPSY ROSE LEE'S BOOK IS A RUNAWAY!

L ESS than a year ago when the publishers saw the first few
chapters of *The G-String Murders*, it was their convic-
tion that Gypsy Rose Lee was a writer strictly from the top
drawer. As more chapters came in, from the road where the
author was "making with the book words" (her own phrase
for writing) between shows, their excitement increased.

Now, just two weeks after publication, *The G-String
Murders* is selling at a Standing Room Only rate. First
and second editions are sold out, third is nearly exhausted.

☞ What the boys in the front row say:

"It is a lurid, witty, and highly competent detective story. Ecdysiast
Lee's Minsky background, rich show-business vocabulary and stage-
door gags make her book almost a social document. *The G-String
Murders* builds up to a hair-raising climax. Agatha Christie herself
could not have contrived the tag line of the book." **TIME MAGAZINE**

"A mystery that hits High C." **CARL VAN DOREN**

"Her novel is a rich and lusty job, brimming over with infectious
vitality and a hilarious jargon of her own." **LIFE MAGAZINE**

"It is a high spot of the season, a book to read and to re-read when
life seems dull and drab. It's a shocker in more ways than one. You'll
be straining the old diaphragm with loud, raucous laughter and rev-
eling in the skill and address of a new and salty writer, to wit,
Miss Gypsy Rose Lee. It's terrific!"
WILL CUPPY, New York Herald Tribune BOOKS

THE G-STRING MURDERS

THE STORY OF A BURLESQUE GIRL

by Gypsy Rose Lee

AN INNER SANCTUM MYSTERY ◆ PRICE $2.00

1941

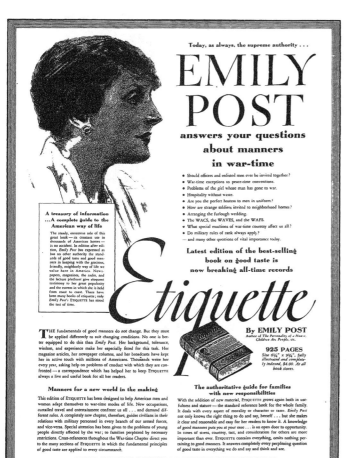

Today, as always, the supreme authority . . .

EMILY POST

answers your questions
about manners
in war-time

- Should officers and enlisted men ever be invited together?
- War-time exceptions to peace-time conventions.
- Problems of the girl whose man has gone to war.
- Hospitality without waste.
- Are you the perfect hostess to men in uniform?
- How are strange soldiers invited to neighborhood homes?
- Arranging the furlough wedding.
- The WACS, the WAVES, and the WAFS.
- What special exactions of war-time courtesy affect us all?
- Do military rules of rank always apply?
- — and many other questions of vital importance today.

Latest edition of the best-selling
book on good taste is
now breaking all-time records

Etiquette

By EMILY POST
Author of *The Personality of a House, Children Are People*, etc.

925 PAGES
Size 6¼" x 9¼", fully
illustrated and complete-
ly indexed, $4.00. At all
book stores.

**A treasury of information
. . . A complete guide to the
American way of life**

The steady, enormous sale of this great book — its constant use in thousands of American homes — is no accident. In edition after edition, *Emily Post* has expressed as has no other authority the standards of good taste and good manners in keeping with the gracious, friendly, neighborly way of life we value here in America. Newspapers, magazines, the radio, and the lecture platform give eloquent testimony to her great popularity and the esteem in which she is held from coast to coast. There have been many books of etiquette; only *Emily Post's* ETIQUETTE has stood the test of time.

THE fundamentals of good manners do not change. But they must be applied differently to suit changing conditions. No one is better equipped to do this than *Emily Post*. Her background, tolerance, wisdom, and experience make her especially fitted for this task. Her magazine articles, her newspaper columns, and her broadcasts have kept her in active touch with millions of Americans. Thousands write her every year, asking help on problems of conduct with which they are confronted — a correspondence which has helped her to keep ETIQUETTE always a live and useful book for all her readers.

Manners for a new world in the making

This edition of ETIQUETTE has been designed to help American men and women adapt themselves to war-time modes of life. New occupations, curtailed travel and entertainment confront us all . . . and demand different rules. A completely new chapter, therefore, guides civilians in their relations with military personnel in every branch of our armed forces, and vice-versa. Special attention has been given to the problems of young people directly affected by the war; to families perplexed by necessary restrictions. Cross-references throughout the War-time Chapter direct you to the many sections of ETIQUETTE in which the fundamental principles of good taste are applied to every circumstance.

**The authoritative guide for families
with new responsibilities**

With the addition of new material, ETIQUETTE grows again both in usefulness and stature — the standard reference book for the whole family. It deals with every aspect of morality or character or taste. *Emily Post* not only knows the right thing to do and say, herself . . . but she makes it clear and reasonable and easy for her readers to know it. A knowledge of good manners puts you at your ease . . . is an open door to opportunity. In times of stress, courtesy, tact, and consideration for others are more important than ever. ETIQUETTE contains everything, omits nothing pertaining to good manners. It answers completely every perplexing question of good taste in everything we do and say and think and are.

FUNK & WAGNALLS COMPANY, 354 FOURTH AVENUE, NEW YORK 10

1943

ANIMAL FARM

Tomorrow is the publication date of ANIMAL FARM by George Orwell—a book which has been written about and heatedly discussed long before publication.

In the Book-of-the-Month Club News, Christopher Morley says: "In a narrative so plain that a child will enjoy it, yet with double meanings as cruel and comic as any great cartoon, George Orwell presents a parable that may rank as one of the great political satires of our anxious time." Harry Scherman, President of the Book-of-the-Month Club, made a personal statement to the Club's subscribers urging them not to miss ANIMAL FARM because of its "worldwide importance" and its "extraordinary character."

ANIMAL FARM is the story of a group of animals who stage a successful revolution and take the place over, but to understand its "extraordinary character" you have to read the book for yourself. Don't wait for your friends to tell you the story. Buy a copy as soon as possible.

$1.75 *at all bookstores*
A BOOK-OF-THE-MONTH CLUB SELECTION

HARCOURT, BRACE & COMPANY

1946

1949

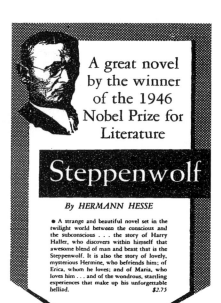

A great novel by the winner of the 1946 Nobel Prize for Literature

Steppenwolf

By HERMANN HESSE

● A strange and beautiful novel set in the twilight world between the conscious and the subconscious . . . the story of Harry Haller, who discovers within himself that awesome blend of man and beast that is the Steppenwolf. It is also the story of lovely, mysterious Hermine, who befriends him; of Erica, whom he loves; and of Maria, who loves him . . . and of the wondrous, startling experiences that make up his unforgettable helliad. $2.75

1947

THE
Plague
by ALBERT CAMUS

TRANSLATED FROM THE FRENCH BY STUART GILBERT

*To be published tomorrow—
the most important novel to come out
of Europe in the last decade!*

&• Comparable to the work of Mann, Gide, and Undset, this is a book that is in the direct line of the great creative works by contemporary European writers.

&• In THE PLAGUE, Albert Camus has tempered horror with dignity, frailty with compassion, and tragedy with hope. A close-knit, intensely human story, working up in a vast crescendo to a climax of fatality unique in modern writing, it combines the fascination of a magnificently told tale with a searching analysis of the human predicament.

&• "No book has been more eagerly awaited, since of all the writers of the younger generation, it is Camus who has aroused our boldest hopes."—ANDRÉ GIDE

&• "In France, the three vital writers are André Malraux, Jean-Paul Sartre, and Albert Camus. Of these, the greatest is Camus. His new work . . . is almost a masterpiece, a classic."—ARTHUR KOESTLER

Designed by Warren Chappell · Jacket by Jean Carlu

$3.00 wherever books are sold

Published by ALFRED A. KNOPF, New York 22, who will send you his fall catalogue on request

1948

nausea

JEAN-PAUL SARTRE

French critics agree that *La Nausee*, Sartre's first novel, is the best book he has done. In the story of Antoine Roquentin, who could not endure his own existence, Sartre has written an absorbing psychological novel. 2.50

A NEW DIRECTIONS BOOK

1949

America's most beloved reporter

wrote dispatches from Africa that not only made the front pages of scores of newspapers, but were avidly followed by the fighting men themselves —to learn about their war. Ernie Pyle's columns made journalistic history; now they form the basis of a great book about the American soldier.

HERE IS YOUR WAR is our soldiers' story written in all its smallest and most human terms straight from the foxholes Ernie Pyle shared with the men, and out of his own heart, to the folks back home. Here are the boys from the Main Streets, Broadways and farms throughout America. They emerge from these pages as the living, gallant, unpretentiously heroic Americans who are writing one of the great chapters of our history. Ernie Pyle takes you to live with them on their first big campaign . . . the great adventure of their lives, and his, and *yours*.

JUST PUBLISHED. With drawings by Carol Johnson. $3.00

HENRY HOLT AND COMPANY, 257 FOURTH AVENUE, NEW YORK 10, N. Y.

1943

No Nazi
censor
can
stop him
now

William L. Shirer's
record-breaking success

BERLIN DIARY

passes *a quarter of a million!

MILLIONS of Americans heard Mr. Shirer's "dry, twangy mid-Western" voice bringing to them daily over the radio the news from Berlin, during those fateful years which led up to the present war. But informative as those broadcasts were—and Mr. Shirer is considered by many to have been the best American reporter in Europe at the time—they were, of necessity, censored. Every paragraph, every word had to be watched, for the censor was always there leaning over the broadcaster's shoulder, watching lest he give away any information that might be prejudicial to the Nazi cause. But what Mr. Shirer could not say in his broadcasts, he took good care to note in his diaries, and what he could not even commit to his diaries, he stored away in his memory for the time when he would be able to return home and write the truth about inside Germany.

Now, at last, he has written the book for which we have been waiting, a book which has aroused the widest interest and is being discussed everywhere. In its first week Shirer's *Berlin Diary* became the fastest selling non-fiction book in America and has headed the list ever since. *The New York Times* says it is "a book that everyone in the country should be reading now." Are *you* reading it?

$3.00 at any bookshop.

*285,600 copies (including Book-of-the-Month Club) in print and on order July 10.

ALFRED·A·KNOPF·NEW YORK

LELAND STOWE, ace reporter of this war in 19 countries, has written a great book, NO OTHER ROAD TO FREEDOM. Publication August 18. Watch for it!

1941

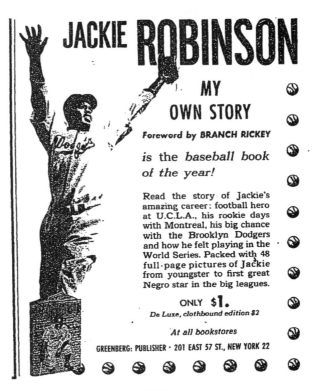

JACKIE ROBINSON
MY OWN STORY

Foreword by BRANCH RICKEY

is the baseball book of the year!

Read the story of Jackie's amazing career: football hero at U.C.L.A., his rookie days with Montreal, his big chance with the Brooklyn Dodgers and how he felt playing in the World Series. Packed with 48 full-page pictures of Jackie from youngster to first great Negro star in the big leagues.

ONLY **$1.**
De Luxe, clothbound edition $2

At all bookstores

GREENBERG: PUBLISHER · 201 EAST 57 ST., NEW YORK 22

1948

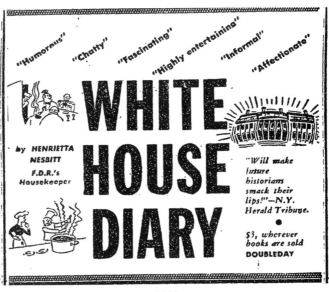

"Humorous" "Chatty" "Fascinating" "Highly entertaining" "Informal" "Affectionate"

WHITE HOUSE DIARY

by HENRIETTA NESBITT
F.D.R.'s Housekeeper

"Will make future historians smack their lips!"—N.Y. Herald Tribune.

$3, wherever books are sold
DOUBLEDAY

1948

1943

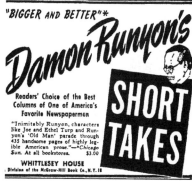

1946

1949

When you have read
J. D. SALINGER'S
The Catcher in the Rye
you will understand

why HENRY SEIDEL CANBY, AMY LOVEMAN, JOHN P. MARQUAND and CHRISTOPHER MORLEY promise that "Every page of Mr. Salinger's novel will be a source of wonder and delight."

why CLIFTON FADIMAN says "In Mr. Salinger we have a fresh voice. That rare miracle of fiction has again come to pass: a human being has been created out of ink, paper and the imagination."

why HARRISON SMITH calls it "A remarkable and absorbing novel, profoundly moving and disturbing."

why DAVID APPEL predicts that "This year will produce no book quite as explosive."

why CHARLES POORE picks it as "Probably the most distinguished first novel, the most truly new novel in style and accent of the year."

why FRANCIS LUDLOW says "It will shock you, it will amuse you. You will discover new treasures in it with each rereading."

. . . and why the publishers (and other publishers, too), the Book-of-the-Month Club judges, newspaper reviewers, magazine editors, movie scouts, everyone who has seen it, have instantly recognized that CATCHER is "real news"—a book with magic in it, the work of a fresh, startling, extravagant talent, wholly authentic, owing nothing to the influence of anybody anywhere around.

A Book-of-the-Month Club Selection
At all bookstores • $3.00

1951

THE
1950s

One of the most notorious ads in the history of American book publishing appeared in the spring of 1951. It was for Norman Mailer's second novel, *Barbary Shore*. Critics had fallen hard for Mailer's war novel, *The Naked and the Dead*, published three years earlier. But now there seemed to be a backlash. The reviews for *Barbary Shore* were, for the most part, scathing.

Mailer's publisher, Rinehart & Company, tried to take advantage of the mixed reviews. "There's a humdinger of a fight over Norman Mailer's new novel *Barbary Shore*," the ad's headline read, over a series of snippets from dueling reviewers. Publishers had tried this tack before, running bits from negative reviews in the hope of stirring up controversy. But the ad for *Barbary Shore* perfected the technique. The first "con" quote read: "The most hopeless piece of undiluted gibberish I've encountered in a long time." The subtext of the ad was clear: if you don't read *Barbary Shore*, you're out of the national conversation.

In the 1950s, publishers tried to steer the talk about controversial books in other ways. When Grace Metalious's humid novel *Peyton Place* became a bestseller in 1956, her publisher, Julian Messner, concentrated on the book's literary merits rather than just its scenes of adultery, incest, and abortion. "This year's sensational bestseller," the ad trumpeted, "is also a literary triumph." Among the reviews it cited was Carlos Baker's in the *New York Times Book Review*. Baker wrote that "the late Sinclair Lewis would have hailed Grace Metalious as a sister-in-arms against the false fronts and bourgeois pretensions of allegedly respectable communities, and certified her as a public accountant of what goes on in the basements, bedrooms and back porches of a 'typical American town.'"

By the end of the decade, Grove Press got a chance to announce the good news about D. H. Lawrence's *Lady Chatterley's Lover*, finally available in the United States. "The *Lady* is free," the ad read, "but harried." ❧

Here's a humdinger of a fight

over

Norman Mailer's

new novel

Barbary Shore

PROS

"We think it is beyond question that it will generate more talk and publicity than any other book of the month. If the fact of Mailer's talent needed any further confirmation that is now taken care of completely, for the man is fascinating to read."—DONALD GORDON

"He still has the phonographic ear for vulgar American speech which made *The Naked and the Dead* so disturbingly memorable. Guinevere is an appallingly convincing lady of burlesque, vocally bored with the male reaction to her fleshy charms. Monina in her brief appearance is obscenely real . . . Hollingsworth who pauses in his expert sleuthing to date a cafe waitress *is* a character of expertly defined talents and limitations."—LEWIS GANNETT, *N. Y. Herald Tribune*

"The new book has a far stronger imaginative coloring and it shows a remarkable advance in Mailer's writing: his style has become rounder, more flowing, and even tinged with poetry . . . has certainly furnished further evidence that he has one of the stronger talents of his generation." — CHARLES ROLO, *Atlantic Monthly*

CONS

"The most hopeless piece of undiluted gibberish I've encountered in a long time . . . It is surprising that the author of *The Naked and the Dead,* whose debut was hailed with such wild superlatives, should flounder so completely on his second attempt." — DAVID APPEL, *Philadelphia Inquirer*

"It is intolerable that this dismal blob of literary garbage should be foisted upon the American reading public merely because Norman Mailer wrote *The Naked and the Dead* . . . The pity, as I see it, is that it did not die in Mr. Mailer's typewriter."—*Omaha World Herald*

"Mr. Mailer has divorced his people and his frame so utterly from reality that it can stand for only a fringe of the psychically warped."—EDMUND FULLER, *Chicago Tribune*

"I presume the success of *The Naked and the Dead* emboldened Norman Mailer to the point where he believed he could write and publish anything he wanted to. . . . When one has finished reading this novel one has an overwhelming urge to take a hot bath." —STERLING·NORTH

$3.00 at all bookstores

RINEHART & COMPANY, New York 16

1951

Have you discovered
the thrill of being
jolted by this
exciting new writer?

MURIEL SPARK

Memento Mori A NOVEL

These people have had the
excitement of discovering
Muriel Spark, and here's
what they say about
Memento Mori—

GRAHAM GREENE:
"This funny and macabre
book has delighted me
as much as any novel I have
read since the war."

EVELYN WAUGH:
"A brilliant and singularly
gruesome achievement."

JOHN DAVENPORT:
"Shockingly funny: an
ironical extravaganza that
might have been dictated
in modern idiom down
some ghostly telephone by
Swift . . . Extremely
entertaining."
— in *The Observer* (London)

Of *The Comforters*,
Miss Spark's first novel,
the *N.Y. Times Book Review*
said: "Trend-watchers
are advised to note the name
of MURIEL SPARK.
Before long they may be
able to boast that they
read her when."

**Let yourself in for
a thrilling good
time. Read**

Memento Mori A NOVEL

By MURIEL SPARK

At all bookstores · $3.95

LIPPINCOTT

1959

➡ In THE SHELTERING SKY, Paul Bowles
described the disintegration of a woman in
the effortless sensuality of North Africa.
Now he explores the stranger and perhaps
more terrifying things that can happen
there to a young man. $3.50

Let It Come Down

By PAUL BOWLES

1952

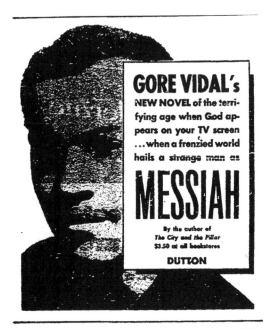

GORE VIDAL's
NEW NOVEL of the terri-
fying age when God ap-
pears on your TV screen
. . . when a frenzied world
hails a strange man as

MESSIAH

By the author of
The City and the Pillar
$3.50 at all bookstores

DUTTON

1954

1959

1953

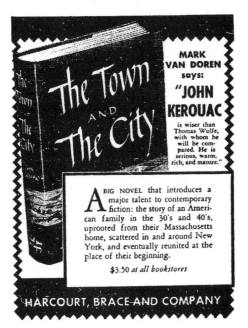

MARK VAN DOREN says:

"JOHN KEROUAC is wiser than Thomas Wolfe, with whom he will be compared. He is serious, warm, rich, and mature."

A BIG NOVEL that introduces a major talent to contemporary fiction: the story of an American family in the 30's and 40's, uprooted from their Massachusetts home, scattered in and around New York, and eventually reunited at the place of their beginning.

$3.50 *at all bookstores*

HARCOURT, BRACE AND COMPANY

1950

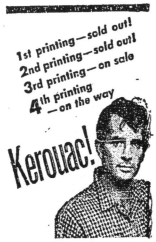

1st printing—sold out!
2nd printing—sold out!
3rd printing—on sale
4th printing —on the way

Kerouac!

His newest! His greatest! A sharp, beautifully-written novel of love, lust and despair among the young writers, poets and artists of San Francisco today: *The Subterraneans*. A soft cover EVERGREEN ORIGINAL. At bookstores everywhere, only $1.45

The Subterraneans

by JACK KEROUAC, author of *On the Road*

1958

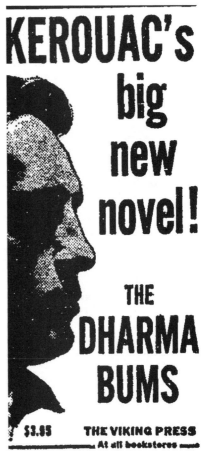

KEROUAC's big new novel!

THE DHARMA BUMS

$3.95 THE VIKING PRESS
At all bookstores

1958

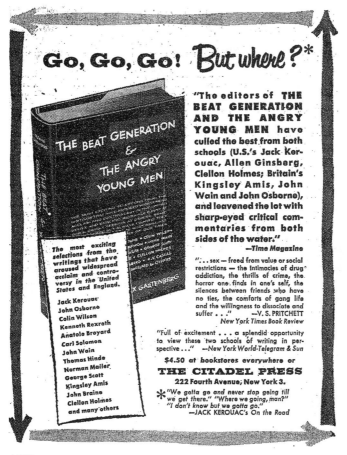
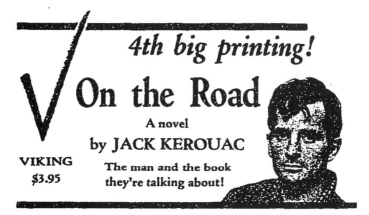

RICHARD HEYD

ANDRÉ GIDE

NOVEMBER 21, 1869 FEBRUARY 19, 1951

One of the immortals

&§ "France's most influential man of letters . . . [He] has had as much influence on modern literature as his late great compatriot Marcel Proust."
—*Life*

&§ "One of the most brilliant and original philosophical writers of the twentieth century . . . André Gide has been judged the greatest French writer of this century by the literary cognoscenti."
—*New York Times*

&§ "Taken as a whole, Gide's body of work . . . constitutes a passport to the highest possible intellectual adventure . . . he stands out as the genius of nonconformity—the solitary rebel."
—*The Atlantic*

&§ "His contemporaries considered him their greatest writer, one who had shaped the trend of modern French writing and thought."
—*New York Herald Tribune*

&§ "Gide, perhaps more than any other living author, meets the definition of a man of letters in the Renaissance sense. He has written brilliantly as a novelist, playwright, story teller, poet, critic, and journalist. He is one of a handful of men who have charted new paths in literature, not in style or construction, but in the way he looks at man."
—*Washington Star*

&§ "One of the last great voices of the Western European Protestant conscience. . . . Like Rilke, or Kafka too, Gide is an almost classic example of the modern genius."
—*Saturday Review of Literature*

His final work

VOLUME IV—The Journals of André Gide, 1939-1949

In which Gide concerns himself largely with World War II, the fall of France, the German occupation, and his flight to and stay in North Africa and in which his literary comment ranges all the way to E. M. Forster, John Steinbeck, and Dashiell Hammett.

"Gide's journals . . . are almost certain to take their place among the few masterpieces of reflective literature produced in this century."
—LLOYD MORRIS, *New York Herald Tribune*

Volume I, 1889-1913 Volume II, 1914-1927 Volume III, 1928-1939
Each volume $6.00 The set of four $20.00

In addition to the *Journals* the following books by André Gide are available in English:

Imaginary Interviews, $2.50
The Fruits of the Earth, $3.00
The Counterfeiters
with *Journal of "The Counterfeiters"*, $3.50
The Immoralist, $2.75
Lafcadio's Adventures, $2.75
Strait is the Gate, $2.75
Two Legends, $3.00 • *Two Symphonies*, $2.75
The School for Wives, $2.75

Wherever books are sold

Published by ALFRED · A · KNOPF, *New York 22*

1951

paul valery

SELECTED WRITINGS

First American publication of a representative selection of Valery's work in translation... poems, prose poems, essays, philosophical and aesthetic writings $3.50

A NEW DIRECTIONS BOOK

1950

1955

1952

*"One of the greatest stories of our American heritage."**

Stride Toward Freedom

THE MONTGOMERY STORY

By MARTIN LUTHER KING, Jr.

"Dr. King tells how he and his colleagues were able to set the pattern of victory [over bus segregation] through non-resistance regardless of any provocation."
—*HARRY GOLDEN, author of *Only in America*

"A valuable book . . . necessary reading for those who would understand how complex the deep South problem is."
—RALPH McGILL, Editor, *Atlanta Constitution*

"Tells a remarkable story."—NORMAN COUSINS. "By far the most important book on the current situation in the South."—LILLIAN SMITH. "Should bring light to countless minds."—JOHN LAFARGE, S.J. "Beautifully and eloquently written."—BENJAMIN MAYS. "A revelation of the power of religion in practical action."—ROGER BALDWIN. "As gripping as a good detective story or historical novel."—BISHOP JAMES A. PIKE. "A shocking revelation and a hopeful record of progress."—HARRY EMERSON FOSDICK

With 8 pages of photographs • $2.95

1958

Out of these pages steps an American family dominated by a beautiful woman, almost white . . .

LILLIAN TAYLOR was blessed with the good things that add up to happiness. Hers was the kind of beauty that strikes the eye —and caresses it. She married a man who was wise and patient, tender and loving, successful and respected. They had three sons, dear as three sons can be. Her undoing was love . . . a strange, warped love that focused on her youngest boy . . . and it drove all of them, step by step, toward disaster.

In THE THIRD GENERATION Chester Himes, fulfilling the promise that critics praised in his earlier work, has written a major novel. The power that marks all his writing is under masterly control and its impact is unforgettable. Perhaps his greatest achievement is that he has written a story peopled by Negroes with whom the reader, regardless of color, becomes identified. It is worth noting that you have never read a novel like it before.

RALPH ELLISON: "By far the most intense and compassionate probing of the psychological predicament of a middle-class Negro family yet written." LOUIS BROMFIELD: "This is it — the big novel I knew Chester Himes would write."

THE
Third Generation
By CHESTER HIMES

At all booksellers $3.95. THE WORLD PUBLISHING COMPANY • Cleveland and New York.

1954

1956

THE NEW BEST SELLER
that everybody wants to read!

KON-TIKI

By THOR HEYERDAHL

**Six men cross the Pacific on a raft...
as told by the man who led the expedition**

"A man with the heart of a Leif Erics-
son and the merry story-telling gift of
an Ernie Pyle." N.Y. TIMES BOOK REVIEW

"No fictional tale of the sea ever writ-
ten—not even 'Moby Dick'—can match
'Kon-Tiki' in action or in thrills."
—CHICAGO DAILY NEWS

With 80 photographs
of the voyage. $4

At all bookstores · RAND McNALLY & CO.

1950

The Man in the Gray Flannel Suit

will be in all book and
department stores tomorrow

A novel by
SLOAN WILSON
Price $3.50
Simon and Schuster

1955

Washington's foreign service and Iquitos, Peru, will never forget this greenhorn consul and his bride, who became Uncle Sam's

Dancing Diplomats

By the late HANK KELLY, and his wife DOT

... nor will anyone who reads their fascinating account of true adventures in the heart of the fabulous jungle metropolis on the Upper Amazon.

"Fun to read ... keen observation ... only a natural writer could keep his pages so consistently entertaining," says Oliver LaFarge of this book, finished by Dot Kelly following her husband's tragic death at 29, shooting the rapids of the Rio Grande. Here is their story of heart-breaking deprivations and side-splitting makeshifts, Iquitos' floods and drought, parrots and penguins, sophisticated cosmopolites and mestizo natives. Here, too, are the behind-the-scenes events of the history-making Ecuador-Peru boundary settlement, the shipping of rubber, barbasco and mahogany for World War II, and the story of how Hank's negotiations and Dot's dance steps turned many a tense situation into a diplomatic victory.

JANUARY SELECTION—Catholic Book Club
Illustrated. $4.00 at your bookstore, or from

THE UNIVERSITY OF NEW MEXICO PRESS, Albuquerque, N. M.

1950

ALL TOGETHER NOW...
Get your Cuppy today!

AUBURN LA
GLEE C

The NEW laugh festival by the author of
**THE DECLINE AND FALL
OF PRACTICALLY EVERYBODY**

HOW TO GET FROM JANUARY TO DECEMBER

by Will Cuppy

"Cuppy was *sui generis*"
—BIRMINGHAM NEWS

... and this sly book is also the only one of its kind. What other book, for instance, tells you how to coax moths to eat old tuxedos? Or how to prepare an egg shampoo for your husband? Or what happens when two scientists independently arrive at the wrong answer?

It's an unorthodox, day-by-day journey through the calendar. The 366 entries cover such important subjects as Button Gwinnett, a tame wasp, Lais the Elder, skinks, McGuffey's Readers, truffles, Java Man, the oblique approach to fly-swatting, Bishop Pontoppidan's Sea Serpent, navy beans, and Gabriel D. Fahrenheit. Since the title has only seven words in it, it's an easy one to remember. Simply drop into a bookstore right away and ask for your copy of the new Cuppy.

Edited by
FRED FELDKAMP
Copiously illustrated by
JOHN RUGE
$3 at all booksellers

HOLT

1951

His name is ARTIE SHAW and his story will surprise you . . .

It's one of the most startlingly candid self-portraits ever penned by a public personality . . . and one of the most unexpected. For Artie Shaw is giving you the facts behind the facade. This is what it's *really* like to be a celebrity, and what the demands of success and fame can mean to a gifted and sensitive artist. And since this is Artie Shaw's story, it's the story, too, of the music business, filled with anecdotes of people he knew and worked with — jazz greats like Muggsy Spanier, Bix Beiderbecke, Willie "The Lion" Smith, and countless others. But more than just a record of glamorous names and the making of music — of the fun, the frenzies, and the headaches of the syncopated life — it's the story of Artie seeking himself and telling about that search and what he found. Here's the revealing picture of a highly publicized "name" from the inside — out!　　　　$3.75

THE TROUBLE WITH CINDERELLA

FARRAR, STRAUS AND YOUNG · 101 Fifth Ave., New York 3, N. Y.

1952

Man, here he is!

A book as hot as his trumpet!

his autobiography . . .　his racy memories . . .
. . . in his own words

SATCHMO

MY LIFE IN NEW ORLEANS
by Louis Armstrong
Illustrated
$3.50 at all bookstores
PRENTICE-HALL, N. Y. 11

1954

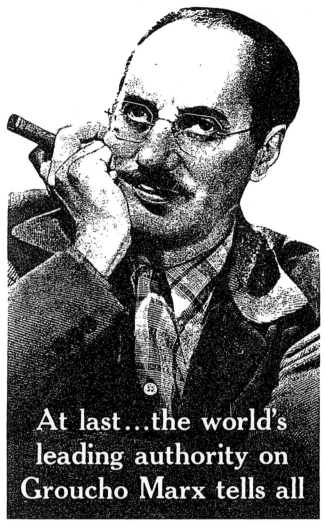

At last...the world's leading authority on Groucho Marx tells all

For the first and last time. Groucho tells about Groucho as only he can. From his tenement childhood (he didn't know he was underprivileged) through his vaudeville days and Hollywood nights, these are the uproarious memories, the private thoughts and public philosophy of one of the world's funniest men. Illustrated with 22 photographs.

GROUCHO AND ME
By GROUCHO MARX

$3.95, now at your bookstore

Published by **BERNARD GEIS ASSOCIATES** · Distributed by Random House

1959

1959

LOLITA

Heads Into Its
Second Precedent-Shattering Year

After a record-breaking sale of 165,000 copies in the fall of 1958, LOLITA has entered a bright new year near the top of the best-seller lists. What lies ahead for 1958's most controversial book?

Arrangements have been made to publish in England, and LOLITA has already been the subject of a violent debate in the House of Commons.

The vacillating French banned LOLITA twice in a year, twice lifted the ban and as 1959 enters have banned it anew.

A search has begun for a bright new star to play the title role in the movie version.

In brief, spurred on by such controversy and by comments from famous writers all over the world, the most talked about American book of 1958 bids fair to become the most talked about book all over the world in 1959.

PHILIP WYLIE

"One of the most hilarious books I ever read... one of the most telling spoofs of the American infatuation-with-youth complex imaginable."

TERENCE RATTIGAN

"An extraordinary book, very moving, very funny and very true. It is also, I admit, genuinely shocking, but in a way in which only a work of the highest moral purpose could possibly be."

COLIN WILSON

"LOLITA is undoubtedly a major novel in the great comic-dramatic tradition of *Ulysses*, and I have returned to it as often as to *Ulysses*."

ANITA LOOS

"The only sure-fire classic written in my lifetime."

GORE VIDAL

"LOLITA is a splendid high comedy, in the Meredithian sense, and its deserved success is a sign of maturity in our not always wise society."

CALDER WILLINGHAM

"An extraordinary book. Haunting and horrifying. A diabolical masterpiece."

MEYER LEVIN

"The most exciting reading experience in the modern novel since *Ulysses*."

TAYLOR CALDWELL

"In my opinion, Aristophanes never wrote so broad a comedy, so delightfully and charmingly written, so sardonic and devasting. Of course, I do not recommend it as required reading for any *children* from eight to eighty."

LOLITA
By VLADIMIR NABOKOV

ALBERTO MORAVIA

"A very beautiful novel. It is a book for writers as well as for common readers."

JAMES M. CAIN

"I have read LOLITA with the greatest pleasure, having been a Nabokov fan since his first family reminiscences were published in *The New Yorker*. The book is outstanding."

CHRISTOPHER ISHERWOOD

"I think LOLITA is one of the most brilliant travel-books about the United States which has appeared in our time."

WILLIAM STYRON

"Cleanliness, godliness, beauty, youth, sex and death: our hypocritical attitudes as Americans toward these subjects Nabokov illuminates with a merciless understanding, yet so wondrously and uniquely droll is the Nabokovian imagination that LOLITA becomes that true rarity in literature: a genuinely funny novel."

LIONEL TRILLING

"LOLITA is about love. Perhaps I shall be better understood if I put that statement in this form: LOLITA is not about sex but about love. Almost every page sets forth some explicit erotic emotion or some overt erotic action and still it is not about sex. It is about love. This makes it unique in my experience of contemporary novels."

$5.00 at all bookstores G. P. PUTNAM'S SONS

1959

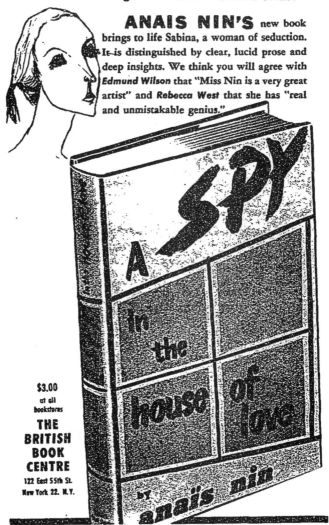

"Few contemporary writers have caused so much commotion in literary circles as ANAIS NIN."—LLOYD MORRIS

"A SPY IN THE HOUSE OF LOVE is to my mind her most mature and distinguished work."—MAXWELL GEISMAR

ANAIS NIN'S new book brings to life Sabina, a woman of seduction. It is distinguished by clear, lucid prose and deep insights. We think you will agree with *Edmund Wilson* that "Miss Nin is a very great artist" and *Rebecca West* that she has "real and unmistakable genius."

$3.00
at all
bookstores

**THE
BRITISH
BOOK
CENTRE**

122 East 55th St.
New York 22. N.Y.

1954

What do you care about sex laws?

You probably haven't thought much about our laws concerning sex and sex offenders.

Maybe you *should* think about them a little bit. The data presented in the Kinsey Report indicate that only a small fraction of 1% of American men and women who violate the sex laws of the states in which they reside are ever apprehended or brought to trial.

And the Kinsey Report points out that these very commonly broken laws *are* occasionally invoked against individuals like yourself. How, and when, and where, makes very informative reading.

Do you think your library can be even nearly satisfactory without this book on its shelves? *842 pages, $8.00*

at any bookseller or

1954

How much should your children know?

That's for you to decide. Certainly the Kinsey Report doesn't tell you.

What the book *does* do is give you a pretty good idea of how people are behaving sexually in America today—and how behavior has changed during the past 50 years.

This information will surely help you to understand your children better, surely help you talk to them more effectively.

842 pages, $8.00
at your bookseller

Published by W. B. Saunders Company

1954

Raise High
the Roof Beam,
Carpenters

and

Seymour
an Introduction

J. D. Salinger

The
new book
by the author of
THE CATCHER IN
THE RYE

NINE STORIES

FRANNY AND
ZOOEY

LITTLE, BROWN — At all bookstores • $4.00 • LITTLE, BROWN • Boston

1959

1959

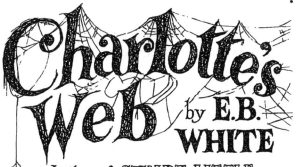

Charlotte's Web

by E.B. WHITE

Author of STUART LITTLE
Pictures by GARTH WILLIAMS

This is the story of a little girl named Fern who loved a little pig named Wilbur—and of Wilbur's dear friend Charlotte A. Cavatica, a beautiful large grey spider who lived with Wilbur in the barn. With the help of Templeton, the rat who never did anything for anybody unless there was something in it for him, and by a wonderfully clever plan of her own, Charlotte saved the life of Wilbur, who by this time had grown up to be quite a pig.

1952

A story that delves deep into heart and mind to reveal the innermost secrets of a woman's soul

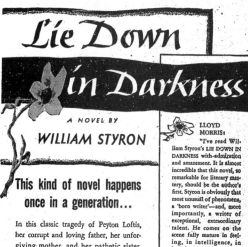

Lie Down in Darkness

A NOVEL BY WILLIAM STYRON

This kind of novel happens once in a generation...

In this classic tragedy of Peyton Loftis, her corrupt and loving father, her unforgiving mother, and her pathetic sister Maudie, a new writer of extraordinary talent has achieved a cleansing and ennobling drama. As you read, you recognize familiar emotions...feelings you thought peculiar to yourself alone, boldly expressed on the printed page. With rapt intensity you share the desperate quest, and, in the end, are uplifted by the final word, invoking that faith and love which must endure if man is to endure.

LLOYD MORRIS: "I've read William Styron's LIE DOWN IN DARKNESS with admiration and amazement. It is almost incredible that this novel, so remarkable for literary mastery, should be the author's first. Styron is obviously that most unusual of phenomena, a 'born writer'—and, more importantly, a writer of exceptional, extraordinary talent. He comes on the scene fully mature in feeling, in intelligence, in insight into life...As an elderly and jaded critic, I make William Styron the deepest and most reverent of bows!"

MAXWELL GEISMAR: "LIE DOWN IN DARKNESS is the best novel I have read so far this year. It is one of the few completely human and mature novels published since the second world war."

MERLE MILLER: "LIE DOWN IN DARKNESS is a great novel. 'Great' is an adjective which should be used sparingly, if at all; but in this instance no other word will do. In his first book William Styron has written the kind of poetic, mature and moving novel which most writers spend years trying to achieve—and almost never do."

JOSEPH WOOD KRUTCH: "LIE DOWN IN DARKNESS is a remarkable achievement. William Styron has the true novelist's knack of making one want to know what happens next. Among the book's many merits there is a suggestion of Thomas Wolfe's flow of continuous excitement."

Lie Down in Darkness

At all bookstores • $3.50

BOBBS-MERRILL

1951

One of the greatest, yet least-known literary geniuses of our century...

ISAAC BABEL

Acclaimed in the 20's, purged in the 30's, his name is taboo in his native Russia — but hailed by those who have read his unforgettable stories.

"A literary event of major significance... His name is a name like that of Chekhov in literature... The free world should give this writer the recognition stolen from him by a police state." — JAMES T. FARRELL, *The N. Y. Post*

"His autobiographical stories are... as anguished and personal as a scream... When it came to the revolutionary scene, [he] could make a single image do the work of a page." — *Time*

"The world of Babel — full of brutal clashes, morbid sexuality and opposition of moods — is that of a romantic, but its tension and poetic melancholy are perfectly controlled." — MARC SLONIM, *N. Y. Times Book Review*

ISAAC BABEL: THE COLLECTED STORIES

The first full collection in English. Edited and translated by Walter Morrison. Introduction by Lionel Trilling.

$5.00 at your bookstore

•

Also for the first time in English

DOSTOEVSKY'S Winter Notes on Summer Impressions

Introduction by Saul Bellow. Dostoevsky's vitriolic impressions of his first trip to Western Europe. $2.75

CRITERION BOOKS, INC. • 100 Fifth Ave., N. Y. 11

1955

1953

Book-paper catches fire when the temperature hits

Fahrenheit 451

This is a fact that you are not likely to forget, because of a book by the same title.

The hero of this story is a fireman of the future who reports to a firehouse and rides out on a truck with his squad when there's an alarm. But when they get to the scene, they *start* a fire. What they burn is books. (In the process they burn down the house, and sometimes the people in it.)

They operate this way because books are non-conformist. Books sometimes contain ideas. Ideas can be dangerous.

The fireman begins to doubt his calling, begins to secrete books, then dares to read them. They lead him into direct opposition to his neighbors, his wife, even his government. And inevitably the moment comes when he has to take his stand.

It is a moment that will live with you a long time. Because there are no glib platitudes in it, there is the genuine stirring emotion of a man who has fought his way through to truths, no matter what the price: the way some men have always done — the way some men always will.

This is the most important point about the story: that Bradbury has projected the cloudy trends of today to their worst possible conclusion — and still finds logically a strong core of hope. The final note is exaltation; and for that reason as well as the ideas it contains, this story may well prove a rallying point for people with faith in people.

FAHRENHEIT 451
By Ray Bradbury

(Note: The book also contains two short stories which substantiate Christopher Isherwood's statement that "Bradbury's is a very great and unusual talent.")

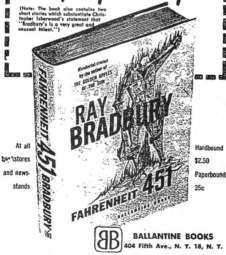

At all bookstores and newsstands

Hardbound $2.50

Paperbound 35c

ⒷⒷ BALLANTINE BOOKS
404 Fifth Ave., N. Y. 18, N. Y.

1953

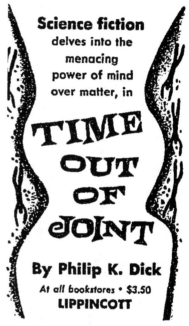

Science fiction delves into the menacing power of mind over matter, in

TIME OUT OF JOINT

By Philip K. Dick
At all bookstores • $3.50
LIPPINCOTT

1959

THE
1960s

The book advertisements in this chapter, like the 1960s themselves, start somewhat demurely and get increasingly wilder, pushier, and alive.

A 1960 advertisement for Harper Lee's *To Kill a Mockingbird* was pure innocence. The novel was selling, the ad suggested, because "it makes you so glad to be alive." Three years later, a full-page advertisement for James Baldwin's manifesto *The Fire Next Time* seemed to have come from another planet. "Actually I don't want to marry your daughter," the text reads, next to a photo of Baldwin staring out amusedly and impassively. "I just want to get you off my back."

Author photographs, in the 1960s, were increasingly put to bold use. Susan Sontag pops out of a 1963 ad for her first novel, *The Benefactor*, glancing provocatively from the page as if she were an intellectual Cleopatra. Then there's Edna O'Brien, smoking a cigarette in a 1965 advertisement for her novel *August Is a Wicked Month*; she was clearly the closest thing the book world had to Marianne Faithfull. In an ad for his 1968 novel *Outer Dark*—a bleak story about incest and a baby left in the woods to die—Cormac McCarthy looks as bland, studly, and genial as a major league third baseman. (The ad's quotations, from midwestern book reviews, don't hint at the book's grim content, either.)

Other ads were more enigmatic. The advertisement—spare and filled with white space—for Thomas Pynchon's first novel, *V.* (1963), hinted at the book's—and its author's—evanescent qualities. The lead quotation, from the *Saturday Review*, reads: "It is easier to nail a blob of mercury than to describe this first novel *V.* by Thomas Pynchon."

Publishers were as eager as ever to link their young talent with galaxies of bigger names. See the pushy yet cheerful ad for Harry Crews's 1969 novel *Naked in Garden Hills*. "Will William Faulkner, Eudora Welty, Cormac McCarthy, Carson McCullers, and Truman Capote please move over," the ad says. "Harry Crews is here!" ◆

"Actually I don't want to marry your daughter. I just want to get you off my back."

When **JAMES BALDWIN** speaks, all America listens. In these last tense weeks, James Baldwin has made front-page headlines in this and every other American newspaper. You've seen him on television and in magazines—on the cover of *Time* and in a nine-page close-up in *Life*. And every week, thousands of readers have been electrified by his book—the searing book that is rapidly becoming the manifesto of America's new fever for freedom. James Baldwin's *The Fire Next Time* is laced with truths which no American, white or black, has ever dared enunciate before. You may read it as the grim warning of an enemy or the agonized plea of a friend. *But read it you must*—for James Baldwin's bestseller is part of the time-bomb which has already gone off in Birmingham and Englewood—a time-bomb which may engulf all America tomorrow ... *God gave Noah the rainbow sign ... No more water—*

THE FIRE NEXT TIME

9th big printing
$3.50 at all bookstores

THE DIAL PRESS

1963

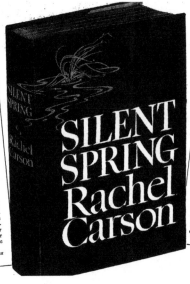
1962

1968

ONE FLEW
OVER THE
CUCKOO'S NEST

1962

And now from England a new rush of applause for JOSEPH HELLER'S

CATCH-22

PHILIP TOYNBEE, GRAHAM GREENE, and the press of England — where it has just been published and is #1 bestseller (with a 3rd printing ordered two days after publication) —

> **WHAT LONDON IS READING**
>
> JOSEPH HELLER'S satirical novel of a war-time American air base, Catch-22, has taken first place within a week of publication, pushing Iris Murdoch's novel, An Unofficial Rose and J. D. Salinger's Franny & Zooey into second and third place. Still fourth and fifth are Derek Tangye's A Cat in the Window and Elspeth Huxley's autobiography, The Mottled Lizard. Sixth place is taken by a newcomer, The Shell Country Book.
>
> Compiled with the co-operation of the Army and Navy Stores, Bumpus, Foyles, Hatchards, Selfridges, W. H. Smith and The Times Bookshop.
>
> —London Evening Standard-News

now join Americans in hailing Joseph Heller's extraordinary first novel. Here are excerpts from the first reviews. [Aside to veteran Catch-ad readers: all the tributes in this one are brand-new.]

"Here's greatness in satire. A reviewer must always keep an anxious eye on the state of his currency. If he announces too many masterpieces he risks inflation. But at the risk of inflation I cannot help writing that Catch-22 is the greatest satirical work in English since Erewhon.

"It has an immense and devastating theme, but this theme is illustrated by means of an observed reality. Though (the theme) places Mr. Heller in a very strong satirical position it would not, by itself, have enabled him to write a great book. He has done this because he is a man of deep and urgent compassion whose raging pity is concerned with the nature of human existence itself no less than with specific and curable iniquities.

"Yet it can hardly be too much insisted that Catch-22 is a very, very funny book and by no means a depressing one. To counter his horror of death Mr. Heller celebrates sexuality in a richly comic tone which is blessedly unLawrentian. What is so remarkable, and perhaps unique, is that Mr. Heller can move us from farce into tragedy within a page or two, and that we can accept the transition without demur. This is a book that I could wish everyone to read. It is a book which should help us to feel more clearly."

—PHILIP TOYNBEE, in The Observer

"An astonishing range of imagination. A novelist of exciting capabilities." —GRAHAM GREENE

"A uniquely funny, grimly serious extravagance — the looming horror of a Kafka adapted for a Victoria Palace Crazy Gang show. It has been a keen pleasure to read. It is a mind-spinning rave of a novel. The title has been slipped along from circle to circle like a secret password. When I was in America recently, in conversation with writers and critics — with Anthony West, Edmund Wilson, Dwight Macdonald — inevitably up cropped Catch-22. Now it seems suddenly to have burst into full public consciousness."

—Daily Mail

"A book of enormous richness and art, of deep thought and brilliant writing. Its basic assumption is that in war all men are equally mad; bombs fall on insane friend and crazy enemy alike. It is, in fact, a surrealist Iliad. Within its own terms it is wholly consistent, creating legend out of the wildest farce and the most painful realism, constructing its own system of probability." —The Spectator

"This is a brilliant and entertaining book, a heady mixture of humor and horror." —Oxford Mail

"For me this is the funniest book the second world war has yet produced. If one generation is to explain anything to another about war, it is best done in the form of a nightmare. This is what Joseph Heller has succeeded in doing so brilliantly in Catch-22. Everything is bound together in one big, vulgar, vital book that expresses a resentment against war that may well be read and understood in a hundred years." —London Daily Telegraph

Meanwhile, back in Chicago, a last word from a first admirer

"Catch is a classic. It employs fantasy to depict truth too devastating to tell by factual narration.

"How long has it been since any writer has satirized the inhumanity of man to man with such comic force? I know of only one, the Czech, Jaroslav Hasek [author of The Good Soldier Schweik]. Having considered this, I wrote that Catch-22 was the best American novel to appear in years.

"A curious silence ensued while some professional critics waited to see which way the wind would blow. But here and there Americans began laughing. The word that had begun as a whisper blew to gale force till even begrudgers began joining the chorus."

—NELSON ALGREN, in a new tribute to Catch-22 that appeared recently in the Chicago Daily News

and in New York, a 6th printing. Price $5.95. Simon and Schuster

PIONEER CATCH-ADMIRERS ON RECORD INCLUDE Robert Brustein, Art Buchwald, Oscar Cargill, Maurice Dolbier, Seymour Epstein, Ed and Pegeen Fitzgerald, Ernest K. Gann, Gladwyn Hill, Walt Kelly, Harper Lee, James Jones, Murray Kempton, Alexander King, Manfred Lee, Leo Lerman, A. J. Liebling, Merle Miller, Harry T. Moore, S. J. Perelman, Norman Podhoretz, Orville Prescott, Selden Rodman, Muriel Rukeyser, Irwin Shaw, Jean Shepherd, Richard Starnes, Niccolo Tucci, Kenneth Tynan, Richard Watts, Morris West.

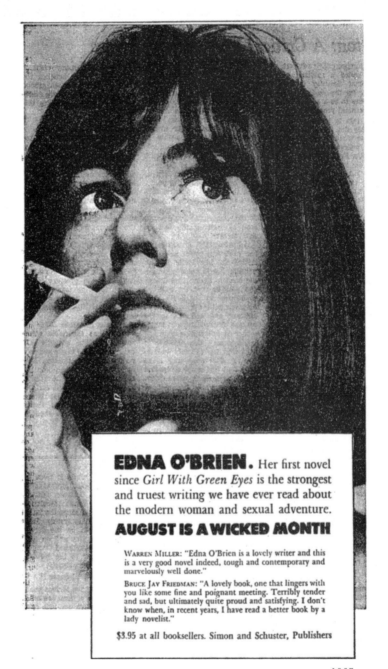

EDNA O'BRIEN. Her first novel
since *Girl With Green Eyes* is the strongest
and truest writing we have ever read about
the modern woman and sexual adventure.

AUGUST IS A WICKED MONTH

WARREN MILLER: "Edna O'Brien is a lovely writer and this
is a very good novel indeed, tough and contemporary and
marvelously well done."

BRUCE JAY FRIEDMAN: "A lovely book, one that lingers with
you like some fine and poignant meeting. Terribly tender
and sad, but ultimately quite proud and satisfying. I don't
know when, in recent years, I have read a better book by a
lady novelist."

$3.95 at all booksellers. Simon and Schuster, Publishers

1965

Acclaim for the
first novel by
Susan Sontag

HANNAH ARENDT: "A major writer . . . I especially admired how she can make a real story out of dreams and thoughts."

ELIZABETH HARDWICK: "Susan Sontag is the new writer who most interests me. She is strikingly able to write about serious subjects in a felicitous manner."

JOHN HAWKES: "An extraordinary imaginative achievement that plays over the reader's senses with boldness, grace and daring . . . I feel that I've been reading the prose of a truly gifted innovator."

HARRY T. MOORE: "THE BENEFACTOR is a novel one reads with sharp enjoyment for its lively adventures, its ingenious fantasy, and its disciplined irony; it is a bridge between the picaresque and the surrealist, handling both manners expertly, and remaining always sophisticatedly amusing."

KENNETH BURKE: "An exceptionally good fantasy. It is intelligent, and it digs deep. It is a true literary treat."

THE BENEFACTOR

$4.50, now at your bookstore
FARRAR, STRAUS & CO.

1963

. . . To Read
JOAN DIDION
Is To Fall A
Little Bit In
Love With Her . . .

That goes for men and women alike. If you follow her articles and essays in *Saturday Evening Post, Holiday, Vogue,* and most of America's leading magazines, you know what we mean by the above statement. You also know that Joan Didion is a most remarkable young writer.

In this, her second book, she has brought together the best of her non-fiction writing in which you will find "bits" and "pieces" of yourself. We urge you to read it and discover a remarkably acute vision of the contempora͏ ͏.

SLOUCHING
TOWARDS
BETHLEHEM
by Joan Didion $4.95
Autographed Copies Available

1968

1964

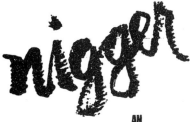

Do you know anybody who hasn't read it?
Do you know anybody who isn't talking about it?

"Jackie has done it again with THE LOVE MACHINE. Another rip-roaring wham-banging, popular smash hit!"
—JOYCE HABER, *Los Angeles Times*

"She is a natural story teller. *The Love Machine* is a far better book than *Valley of the Dolls* — better written, better plotted, better structured."
—NORA EPHRON, *The New York Times Book Review*

"Makes *La Dolce Vita* seem like a Sunday School picnic."—PERCY SHAIN, *Boston Globe*

"*The Love Machine* is going to be devoured like popcorn at a Saturday matinee."
—CHRISTOPHER LEHMANN-HAUPT, *The New York Times*

"I read it in one greedy gulp, enjoying every minute."—LIZ SMITH, *Book World*

"Another smash hit . . . a long, sexy saga of the rise and fall of a TV mogul, all a-glitter with show-biz glamor and boudoir athleticism."
—JOHN BARKHAM, *Saturday Review Syndicate*

"A fascinating book. I found myself caring about each and every character, even the unlikable ones."—SHIRLEY EDER, *Detroit Free Press*

"Dialogue sexy and sophisticated enough to make *Valley of the Dolls* seem like *Little Women* . . . a great storyteller."—REX REED, *Cosmopolitan*

"It cost me an entire Saturday of missing errands and appointments while I read compulsively to the end."—EDITH HILLS COGLER, *Atlantic Journal*

"Jacqueline Susann has another giant blockbuster in everybody's hands."
—EARL WILSON

Photo by Mel Sokolosky

Jacqueline Susann

THE LOVE Machine
by the author of VALLEY OF THE DOLLS

Jacqueline Susann's great bestseller, THE LOVE MACHINE, will be made into a major motion picture by Frankovich Productions for Columbia Pictures

$6.95 · SIMON AND SCHUSTER

1969

SEX AND THE SINGLE GIRL

HELEN GURLEY BROWN

"**T**HEORETICALLY, a 'nice' single woman has no sex life. What nonsense!" says Helen Brown, the author of SEX AND THE SINGLE GIRL. Her new book is the first that dares to recognize the physical as well as the emotional needs of the single woman.

Helen Brown is a successful career woman who led a glamorous, busy *single* social life until she was happily wedded at 37. SEX AND THE SINGLE GIRL is based on her own experiences and those of her friends. It is a complete, sophisticated guide to the unique situations that every single girl faces today.

How to Handle Men

SEX AND THE SINGLE GIRL is an eminently practical book. It includes, for example:

- A five-minute lesson on the art of flirting
- A chapter on The Affair, from beginning to end, including advice on how to live through the trouble times and the break-up
- 17 different ways to meet men, and 10 ways to get them to notice you
- The pros and cons of having anything at all to do with a married man
- An analysis of the special charms of the Don Juan — and the warning signals to look out for
- An appraisal of the Ultimatum and how long you should wait before pressing for a proposal
- An eye-opening discussion of virginity—its problems, its future
- A dozen surprising and effective ways for becoming more feminine

Today's glamour girl — the single career woman

Being single today is vastly different from what it was in your mother's day. The single career woman is today's new glamour girl. She has the time and the money to indulge herself. She can be a fashion-plate, a traveler, a knockout. She can do *what* she wants to *when* she wants to. She answers to nobody for her actions, her decisions, her behavior. She can have a marvelous, unburdened, exciting time during these years. And

BESTSELLER!

1st printing sold out	7,500
2nd printing sold out	15,000
3rd printing sold out	20,000
4th printing on press	35,000
Total in print	77,500

Here's what people who know are saying about this refreshingly honest book:

SUZY PARKER:
"I admire the brilliant wit, courage, and sound intelligence of Helen Gurley Brown. Judging by the delighted response of *every* woman who read the book over my shoulder, I'm sure that it will have a happy audience of millions."

DR. ALBERT ELLIS:
"Faces up to the problem of premarital sex relations with refreshing candor. The discussion of the single girl and her premarital affairs is unusual for its honesty and realism — and remarkable for having been written by a woman."

MAXINE DAVIS, author of *The Sexual Responsibility of Woman:*
"Makes the state of single blessedness so stimulating and challenging that any *wife* wonders why she ever married. It gives advice, delightful as well as realistic, on the technique of enjoying and getting along with men. It makes the strategy so diverting that one wonders whether the fruits of success could possibly be as much fun as the campaign. However, neither the author — nor I — have any doubts about *that.*"

JOAN CRAWFORD:
"Can be a textbook for all women, single and married: It should be put on every man's bed table — when he's free, that is. It's enchanting."

that's exactly what Helen Brown shows you how to do in this buoyant, joyful guide to living single in superlative style.

Man-centered life

Since the basic theme of this book is you and men, Helen Brown discusses every area of your life in terms of its effect on men. She tells you:

- How to fill your apartment with man-attractors
- 15 steps for building a wardrobe that's guaranteed to delight men while leaving your budget intact
- How to wear make-up so he can brag to his friends about your 'natural beauty'
- How to listen to a man so that he knows you're interested, charmed, impressed
- How to make your telephone conversations something he'll look forward to
- How to find a job that will enable you to meet men
- How to make dinners *a deux* occasions he'll remember as the ultimate in comfort, coziness and relaxation

Special Offer — Send No Money

Once you have read SEX AND THE SINGLE GIRL you will be amazed at the new sparkle, zest and fun in your life. Use the coupon below to send for SEX AND THE SINGLE GIRL, only $4.95. Write to Bernard Geis Associates, Dept. T-107, 239 Great Neck Road, Great Neck, N. Y. If you do not agree that it can brighten your life and help you attract and win the right man, you may return it within 10 days and owe nothing.

Mail Today For 10-Day Free Examination

To your favorite bookstore, or
BERNARD GEIS ASSOCIATES, Dept. T-107
239 Great Neck Road, Great Neck, N. Y.

Please send me a copy of Helen Brown's remarkable new book SEX AND THE SINGLE GIRL for 10 days' free examination. If not convinced that this book can show me how to get more enjoyment out of single life while greatly improving my ability to attract men and win a husband, I may return it in ten days and pay nothing. Otherwise I will keep the book and remit only $4.95 plus shipping charges as payment in full.

Name..

Address.......................................

City...................Zone...State.......

☐ SAVE MONEY! Check here if you ENCLOSE $4.95 as payment in full — then WE PAY POSTAGE. Same 10 day examination, with full refund GUARANTEED. (NYC residents please add 3% sales tax.)

1962

He rose from hoodlum, thief, dope peddler, pimp...to become the most dynamic leader of the Black Revolution. He said he would be murdered before this book appeared.

This is how a hater of white men is made:

"I remember being suddenly snatched awake into a frightening confusion of pistol shots and shouting and smoke and flames. My father had shouted and shot at the two white men who had set the fire and were running away. Our home was burning down around us. We were lunging and bumping and tumbling all over each other trying to escape. My mother, with the baby in her arms, just made it into the yard before the house crashed in. The white police and firemen came and stood around watching . . ."

This is what it's like to pull a stickup:

"For working, I carried a .32, a .38 or a .45. I saw how when the eyes stared at the big black hole, the faces fell slack and the mouths sagged open. And when I spoke, the people seemed to hear as though they were far away, and they would do whatever I asked . . ."

This is how the vice trade of Harlem serves its white patrons:

"A madam I'd come to know introduced me to a special facet of the Harlem night world. It was the world where, behind locked doors, Negroes catered to moneyed white people's weird sexual tastes . . . Anything they could name, anything they could imagine, anything they could describe, they could do, or could have done to them, just as long as they paid . . . The perversities! I thought I had heard the whole range of perversities until I became a steerer taking white men to what they wanted . . ."

This is how to get the beginning of an education in prison:

"I spent two days just riffling uncertainly through the dictionary's pages. I'd never realized so many words existed! I didn't know which words I needed to learn. Finally, just to start some kind of action, I began copying. In my slow, painstaking, ragged handwriting, I copied into my tablet everything printed on the first page, down to the punctuation marks. I believe it took me a day. Then, aloud, I read back to myself everything I'd written. Over and over, aloud, to myself, I read my own handwriting . . ."

This is what it's like to be a man marked for death:

"Every morning when I wake up, now, I regard it as having another borrowed day. In any city, wherever I go . . . black men are watching every move I make, awaiting their chance to kill me . . . I know, too, that I could suddenly die at the hands of some white racists. Or I could die at the hands of some Negro hired by the white man. Or it could be some brainwashed Negro acting on his own idea that by eliminating me he would be helping out the white man, because I talk about the white man the way I do."

Much more than an absorbing personal narrative, THE AUTOBIOGRAPHY OF MALCOLM X is a testament of great emotional power, from which every American has much to learn.

It is one of the most revealing portraits of the Negro underworld ever written down—not by an outsider, but by one who was a part of it.

It is also a unique inside view of the "Black Muslims", as seen through the eyes of its master organizer, the magnetic and articulate leader, ultimately at odds with the movement he helped to build.

But above all, this book shows the Malcolm X that very few people knew, the man behind the stereotyped image of the hate-preacher—a sensitive, proud man whose plan to move into the mainstream of the Negro Revolution was cut short by a hail of assassins' bullets.

"This is one of the great books of the world. Its dead level honesty, its passion, its exalted purpose, even its manifold unsolved ambiguities will make it stand a monument forever to the most painful of truths."
—TRUMAN NELSON, *The Nation*

THE AUTOBIOGRAPHY OF
MALCOLM X

With the assistance of Alex Haley. Introduction by M. S. Handler. Epilogue by Alex Haley. With 32 illustrations. 2nd printing before publication.

$7.50, now at your bookstore, or direct from the publisher. (Please enclose payment with order).
GROVE PRESS
80 University Place, New York, N. Y. 10003

1965

TUNE IN—TURN ON—DROP OUT!

TIMOTHY LEARY

invites you on a mind-stretching trip into

The Politics of Ecstasy

Here, at last, is the "high priest of LSD's" own kaleidoscopic view of the psychedelic way of life, ranging from *The Religious Experience Is the Highest Kick* to *The Fifth Freedom—the Right to Get High.* Candid, startling, hotly controversial, it's the book only Timothy Leary could write, the book that will turn you on and tune you in on the "now" generation: what it's looking for—and finding.

"An important, massive and revealing book . . . [that] ought to engross any honestly inquiring reader on either side of the generation gap. . . . Amazing . . . marvelously readable, stimulating."*—Publishers' Weekly*

"Charged with prophetic enormity." —Allen Ginsberg

"The Gospel according to St. Tim. . . . Recommended . . . an unusual personal document."*—Library Journal*

Just Published / $6.95 from your bookseller

G. P. PUTNAM'S SONS

1968

1965

1961

1960

The inside story of how Nixon was *really* elected

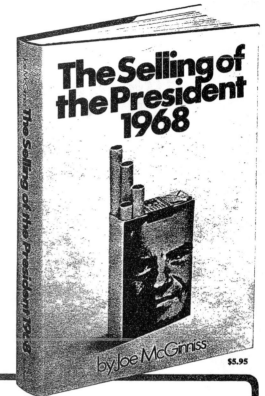

The Selling of the President 1968

by Joe McGinniss

$5.95

Nixon might have been a box of cereal or a bar of soap, as far as Madison Avenue was concerned. He just happened to be a presidential candidate.

They posed Richard Nixon with the "right" Negroes, and coached him in the folksy manner of John Wayne, and wrote him a sense of humor. They made their "law and order" TV commercials, and laughed at the "corn balls" who "believed."

The cynical peddlers were successful. Their pitch worked. But they made one monumental blunder—they let Joe McGinniss sit in on all their "packaging" sessions. The young reporter watched and listened and put every juicy detail into *The Selling of the President 1968.*

See what expert observers have to say below about this fascinating book. Then read it yourself. Every voter should.

1969

"IF 1,000,000 PEOPLE WOULD READ THIS BOOK IT WOULD CHANGE THE WORLD"

(Russell Kirk)
Famous Political Author

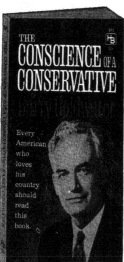

Current runaway best seller...
on all best seller lists

375,000 copies sold...
paperback and hard-bound
editions

A Book Not Only For This Year—But For The Years

United States Senator Barry Goldwater (Brigadier General, U.S.A.F. Res.) restates the case for a sensible, responsible Conservatism which is the most direct challenge to the Liberals and the Radicals that has been written in a decade.

If you want both sides of the ledger, the assets and the liabilities of Conservatism and Liberalism—if you want to know of the great struggle of ideas that is taking place in the world today, you must read this book.

Pick up your copy today. On sale at bookstores and newsstands everywhere. And if your bookstore or local newsstand is sold out, mail the coupon at right and your copy of "The Conscience of a Conservative" will be sent prepaid by return mail.

HARD-BOUND EDITION, $3.00
VICTOR PUBLISHING COMPANY
NO. 1 FOURTH AVENUE
SHEPHERDSVILLE, KENTUCKY

PAPERBACK EDITION, 50c
HILLMAN BOOKS—HILLMAN PERIODICALS INC.
535 FIFTH AVENUE
NEW YORK 17, NEW YORK

1960

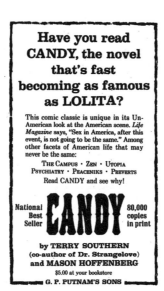

Here's why Rex Reed's *Do You Sleep in the Nude?* has become the new underground* bestseller.

Because of what Rex Reed says about the celebrities he has interviewed:

BARBRA STREISAND: Word comes, from on high, that the superstar is ready for her audience. Three and a half hours late, she plods into the room, plotzes into a chair with her legs spread out, tears open a basket of fruit, bites into a green banana, and says, 'Okay, ya got twenty minutes, whaddya wanna know?'

WARREN BEATTY: So what if he comes on strong? If you had, at some point in your life, been swooned over by Vanessa Redgrave, Natalie Wood, Joan Collins, Faye Dunaway, Leslie Caron, Inger Stevens, Princess Margaret, Maya Plisetskaya, Lee Radziwill, Candy Bergen, Julie Christie, and God knows who else, wouldn't you be full of it?

MIKE NICHOLS: In person, he suggests a Steinberg drawing of a cross between Peanuts and Gertrude Stein.

SANDY DENNIS: One of the kookiest girls I ever met, but when I printed that she had dirty feet and ate cold sauerkraut out of a Mason jar and served ginger ale in a champagne glass full of cat hairs she nearly went into a coma.

AVA GARDNER: The Ava legs dangle limply from the arm of a lavender chair while the Ava neck, pale and tall as a milkwood vase, rises above the room like a Southern landowner inspecting a cotton field. At forty-four, she is still one of the most beautiful women in the world.

HAYLEY MILLS: Freckles and chocolate-ice-cream smudges have long since been replaced by mascara and hot-pink lipstick. She smokes. She drinks. She wears nightgowns. She even has a nude scene standing in a bathtub.

Because of what the celebrities have said about him:

MELINA MERCOURI: I love him veddy much. He makes me suffer.

SANDY DENNIS: I'd like to write about him.

PETER FONDA: He's tough, man, but he tells it like it is. The most honest thing ever written about me.

TALLULAH BANKHEAD: Divine, dahling.

GEORGE PEPPARD: Gosh, did I really say crap?

SUZY KNICKERBOCKER: Don't ever change, you darling dimpled little devil.

MARLENE DIETRICH: He knows things, that one.

BILL COSBY: Beautiful, man, beautiful!

AVA GARDNER: @*!!#@?&#*%!!

NATALIE WOOD: Made me sound like a gun moll.

ANGELA LANSBURY: He has antennae most people haven't even heard of.

JACQUELINE SUSANN: If I had an affair with Jack the Ripper, the offspring would be Rex Reed.

GWEN VERDON: Other than the first time I ever saw my name in the paper, it was the only time I ever really enjoyed reading about myself.

Because of what the press says about his sparkling collection of profiles:

TIME: The young man who wrote all those scandalous things . . . is the Now Kid, the jet set's latest instant celebrity—seen at the poshest places, invited to the nicest parties, cajoled by the sweetest people. At 28, Reed is both the most entertaining new journalist in America since Tom Wolfe and the most unprincipled knave to turn name dropping and voyeurism into a joyous, journalistic living.

COSMOPOLITAN: 'Reed,' said a hiphep Manhattan PR recently, 'is the hottest, hottest byline around. You can hate what he writes about your clients, but you read him—he's so fascinating.'

NEWSWEEK: There is nothing impartial about Rex Reed. Whether turning his feature pieces into a theater of cruelty or his articles into Swiftian examinations of the warts and cicatrices of the famous, Reed has rewritten the rules of interviewing . . . Lots of people hate him, but the final jury, his readers, eat up his ferociously intimate, detailed dissections.

NEW YORK TIMES BOOK REVIEW: Reed is a saucy, snoopy, bitchy man who sees with sharp eyes and writes with a mean pen and succeeds in making voyeurs of us all . . . It is impossible to read this book without wondering how on earth Reed gets his subjects to say the things they do . . . His prose is lush, and full of metaphors that are literally delicious.

CHICAGO TRIBUNE: Reed admits that some of those he has interviewed no longer speak to him, and it is not too difficult to guess why . . . Lively reading indeed.

*Because the publisher couldn't keep it in stock. Now in its sixth printing—stock being rushed to bookstores daily

An NAL Book. **WORLD PUBLISHING** $5.95 at bookstores

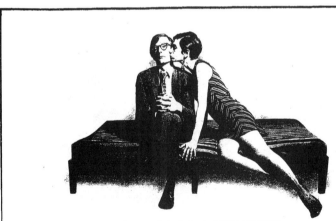

The game she's playing is—FRIGID WOMAN!

She's waiting for him to make a move.

Once he does—brrrrr.

But this young man knows the name of the game. You can tell by (1) his knowing expression, and (2) his prudent posture of aloofness.

He's read GAMES PEOPLE PLAY.

GAMES PEOPLE PLAY is the perennial bestseller that has now sold over half a million copies, and been on the *Times* Bestseller list more than one hundred consecutive weeks.

The author, DR. ERIC BERNE — the famous psychiatrist —

explains the "rules" of more than 100 of the unconscious games people play all the time, for hidden psychological kicks. We play these games at parties . . . in the office . . . in the bedroom . . . and even on the psychiatrist's couch.

The doctor has given names to all of these games. Sometimes the names are whimsical, like *Schlemiel . . . Wooden Leg . . . Kick Me.* Sometimes they are matter-of-fact, like *Alcoholic* and *Homosexuality.* Sometimes they are intriguingly acronymous, like *TAGAWI* and *WAHM.* But each hits the bull's-eye dead center.

When you read GAMES PEOPLE PLAY, you'll learn a whole lot about what makes people tick, including yourself. All right, young fellow — your move.

GAMES PEOPLE PLAY

By ERIC BERNE, M.D. $5.00, now at your bookstore. Or order directly from the publisher. (Please enclose payment with order.)

GROVE PRESS, 315 Hudson Street, New York, N. Y. 10013

1967

the Diary of a Rapist

January 1. Last night Bianca shook me awake and told me to stop grinding my teeth. Nothing gives her more satisfaction than to humiliate me. So one year ends another begins. January 2. This afternoon on the way home from work saw three women fighting in the streets. One had fallen to her knees clothing pulled to rags, two others were jerking at her hair hitting her furiously across the back with awkwardly closed fists. How clumsy women are. Shrieks and cries. A circle of attentive men there a sort of dreadful augury in the birdcall screams of women. January 3. Violence! Violence! Had scarcely left the Bureau when I saw a man struck by a taxi—no accident the driver noticed him start across the street I'm sure of it and am sure there was time enough to stop the cab. Instead what? A chance for revenge! How many of us wouldn't do the same. Yes when that

One of the most amazing books we have ever published. The new novel by **EVAN S. CONNELL, JR.**

$4.95. Simon and Schuster

1966

"Truman Capote has written a masterpiece"

—CONRAD KNICKERBOCKER,
New York Times Book Review

...and it's the country's No. 1 Best Seller

1966

1965

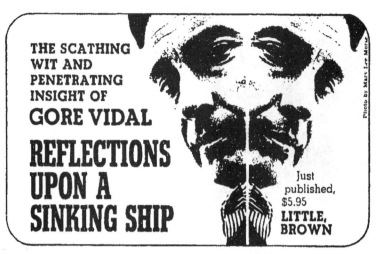

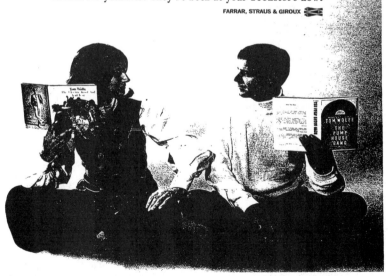

"A work of genius"

"Homosexual, criminal, perverse, religious, sacrilegious, voluble, dynamic, poetic, schizophrenic, honest. Can a great novel justify all of these adjectives at once? OUR LADY OF THE FLOWERS does justify them, and emerges as a work of genius."
—ROBERT LOWRY, *Chicago Sun-Times*

"A matchless contemporary classic . . . like *Ulysses* in its own day, so creatively formidable that any comment on its merit becomes at once presumptuous."
—TERRY SOUTHERN

"Overwhelming . . . the very greatest kind of book. May seem shamelessly immoral. It is not...I don't know whether to praise more its language, its daring method of construction, or the endless fertility of its ideas . . . Only a handful of 20th-century writers, such as Kafka and Proust, have as important, as authoritative, as irrevocable a voice and style."
—SUSAN SONTAG, *Book Week*

"It is inconceivable that for the last twenty years this country has done without Our Lady of the Flowers."—ALFRED CHESTER

"A work of artistic genius . . . It will occupy a significant place in the intellectual and ethical life of modern man for a long time to come."
—HAYDEN CARRUTH, *Chicago Daily News*

"Certainly a masterpiece . . . the greatest novel since Faulkner . . . Sartre's introduction can only be described in superlatives; it is one of the most amazing pieces of literary analysis I have ever read."
—LIONEL ABEL, *New York Review of Books*

"The work of a master of words whose insights alternate between those of a naive child and those of a jaded whore . . . It has no real counterpart in American writing. His scenes spur the imagination like vivid movie sequences . . . Whether we read Genet and Sartre as voyeurs or self-seekers we are listening to two of the major voices in France today."—*New York Times Book Review*

"I know of nothing in English at all like this book . . . It is written so beautifully, it sings so divine a melody, that one thinks of the prose poems of Baudelaire."
—DAY THORPE, *Washington Star*

"A shocker . . . The hallucinations of a sick soul reach heights of veritable beauty, and the cry of rapture and horror which they call forth is of the purest lyrical quality."
—*Saturday Review*

FIRST AMERICAN PUBLICATION: Jean Genet's OUR LADY OF THE FLOWERS

Introduction by JEAN-PAUL SARTRE
3RD PRINTING. $6.50, now at your bookstore. **GROVE PRESS**

You will also want to read SAINT GENET: ACTOR AND MARTYR, by Jean-Paul Sartre. Published by GEORGE BRAZILLER. $8.50

1963

Hannah Arendt

Now, the complete book version of her brilliant account, nearly all of which ran as a five-part series in *The New Yorker*. $5.50

EICHMANN IN JERUSALEM
A REPORT ON THE BANALITY OF EVIL

1963

John Updike

MIDPOINT
and other poems

In the boldly eclectic title poem of his new book, John Updike employs the meters of Dante, Spenser, Pope, Whitman, and Pound, as well as the pictographic tactics of concrete poetry, to take an inventory of his life at the end of his 35th year—at midpoint.

The poem's five cantos (only the third has previously been in print—it appeared in *Scientific American*) are both a joke on the antique genre of the long poem and, in Mr. Updike's words "an attempt to write one: an earnest meditation on the mysteries of the ego, lost time and the mundane."

The remainder of the volume is a six years' harvest of light verse and incidental lyrics—poems dealing with love and death, animals and angels, persons, pandemonium and a minority report on A^2M^2E^2R^2I^2C^2A.

Price $4.50 • Published by Alfred • A • Knopf

1969

■ Because John Knowles is "beyond question one of the ablest young American novelists to appear on the literary horizon in years"... and because he has written "a most excellent, small first novel which you must not think of missing"... ■ ■

we direct your attention to

A SEPARATE PEACE

a novel by John Knowles

This is the novel your friends are talking about. In addition to the excellent reviews, quoted above, of Orville Prescott in the *New York Times* and John K. Hutchens in the *New York Herald Tribune*, A SEPARATE PEACE has been highly praised by such distinguished critics and authors as John Barkham, Edmund Fuller, E. M. Forster, Aubrey Menen, Angus Wilson, John Davenport and Truman Capote. The interest generated by their endorsements has nearly exhausted the second printing of this fine novel. We suggest that you order a copy immediately from your bookseller. $3.50. *The Macmillan Company*

1960

"When I began to write *All the Little Live Things* more than three years ago. I intended to write a good-natured story about a fairly typical, unstratified, overprivileged, upper-middle-class bedroom community in California—an inside look at the Garden of Eden to which so many Americans hope to retire.

"But a novel grows, sometimes, like a child, obedient to coding that its immediate parent may not understand; it develops a will and direction of its own.... It turned out not to want to be a novel about a California bedroom community. It wanted to make use of the non-community of a new California town in order to say something about the impossibility of retirement from life, commitment, or feeling. It steadily demanded of me that I take the comic sense in my narrator Joe Allston, a comic sense which was like the definitive skill of a good boxer with a glass jaw, and turn it toward the illumination of a somber theme....

"The cult of youth, the Hippy Revolution, and the excruciating conflict between the generations were and are facts of contemporary life.... In Joe Allston and Jim Peck I wanted to pose the antagonism between square parents and hippy children in its most irreconcilable terms.... If there is an answer both to Peck's lust for kicks and Joe Allston's impulse to flinch away and retire, it is in Marian Catlin's openness to all experience and her affection for all life."
—Wallace Stegner in *Wings*

The Viking Press
PUBLISHERS / New York

All the Little Live Things

Viking Wallace Stegner

All the Little Live Things

A novel by

Wallace Stegner

The author of *A Shooting Star* and *The Big Rock Candy Mountain* writes a powerful novel of remarkable timeliness. His scene is the world of the Northern California coast—bursting with life and with new mores, new ideas. In it, he poses two generations—the staid and the hippie, clashing in perilous equality—and considers their conflict with understanding and charity. A Literary Guild Selection. At all bookstores $5.75

1967

RALPH NADER

has written the most explosive and influential book of the year!

UNSAFE AT ANY SPEED / NADER

UNSAFE AT ANY SPEED
The Designed-In Dangers Of The American Automobile
By Ralph Nader

● "Nader has done more than any other person, whether amateur or unstinting professional, to alert the nation, the victimized public, the legal profession, and especially the trial bar to the hazards of the unsafe automobile His timely, topical and terrifying book is a slashing, fully documented indictment of industrial irresponsibility, governmental default and public apathy . . . The book is Pulitzer Prize material and Nader a singular public servant."
—*American Trial Lawyers Association Journal*

$5.95, now at your bookstore
GROSSMAN PUBLISHERS

1966

This is the man

LIFE magazine hailed as "the chief exponent of the burgeoning Zen movement in America".

His name is **ALAN WATTS**

He is one of the most stimulating and unconventional philosophers of our time. He is a teacher, a lecturer, a philosopher, an author, and a former Anglican priest.

This is IT

and other Essays on Zen and Spiritual Experience is the title of his new book. This volume includes his famous *Beat Zen, Square Zen, and Zen* ($3.50). Other books by Alan Watts are:

BEHOLD THE SPIRIT. A study in the necessity of mystical religion. $3.50
NATURE, MAN, AND WOMAN. A discussion, in the light of the Chinese philosophy of the Tao, of man's relation to nature and woman. $3.95
THE WAY OF ZEN. The first comprehensive account of Zen in its historical and cultural setting. $4.75
THE WISDOM OF INSECURITY. How man can live in a world of insecurity without succumbing to anxiety. $3.00

NOW AT YOUR BOOKSTORE **PANTHEON**

1961

1969

THIS IS A KEROUAC YOU'VE NEVER SEEN BEFORE

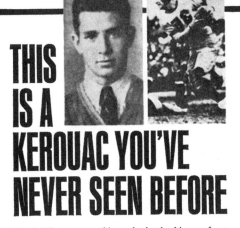

The brilliant young athlete who battles his way from Lowell, Mass., to varsity football at Columbia . . . the sailor on the high seas in World War II . . . first experiments in matrimony—and drugs—in the early days of the New York underground . . . a sensational murder in Riverside Park. You'll find all of these in the new Jack Kerouac—direct and evocative, exhilarating and nostalgic.

"**Vanity of Duluoz is the capstone of one of the most extraordinary, influential, maddening, and ultimately prodigious achievements in recent literature.**"
—*John Clellon Holmes, in the National Observer*

"**In the Vanity of Duluoz he writes of a past that is already nostalgic. His superb narrative gift has developed with the years. I recommend this book as an example of the lost art of telling a story.**"
—*William Burroughs*

VANITY OF DULUOZ
An Adventurous Education, 1935-1946

$5.50 at bookstores

COWARD-McCANN

1968

JACK KEROUAC'S famous underground novel!

© JERRY BAUER

Already celebrated in the literary underground as the missing link in *The Duluoz Legend*—now available to the public for the first time—DESOLATION ANGELS is the *Moveable Feast* of the Beat Generation. It's a vibrant autobiographical novel of the fabulous year before the publication of *On the Road*, when Kerouac, Ginsberg, Corso and Burroughs converged on San Francisco and Mexico to form the literary movement that was to breathe fresh life into American writing and set the swinging style of an era.

"This odyssey from Zen to Luce of the author's self-styled hero gains considerable momentum when Mr. Kerouac in-group gossips about the singular in-bed and in-print one-upmanship practiced by his beat-buddies."—*Saturday Review*

"Breathless and sometimes inspired prose. . . . It has much of the Kerouac freewheeling magic with words."—*Publishers' Weekly*

"No one else writing in America at this time has achieved a rhythm as close to jazz, action, the actual speed of the mind, and the reality of a nationwide scene that has been lived by thousands of us between the ages of seventeen and forty-five."
—SEYMOUR KRIM, from his Introduction

DESOLATION ANGELS
With an Introduction by SEYMOUR KRIM

$5.95 at your bookstore
COWARD-McCANN, INC.

1965

this is suzuki beane,
a very swinging chick.

she shares a village pad with hugh
(her father), and marcia (her mother).
they don't have much bread,
 but like suzuki says, bread is not
really very important when you
 have like good relationships.
so here is the story of suzuki's
relationship with her square boyfriend,
and how they got on the road for endsville.
 sandra scoppettone wrote it.
louise fitzhugh drew the pictures.
 they're way out. so —
move, man! — give your
 bookseller $2.50, and meet

suzuki
beane

it's frantic.

doubleday & co., inc.
garden city, n. y.

1961

Robert Creeley
WORDS

Here is all the poetry Mr.
Creeley has written since *For
Love* (1961), and it is his finest
work. His precision of phrase
and image, his subtle ear for
idiom, the variations of breath
in discourse and prosody are
tuned to a fine pitch, with a
new ease and variety. This vol-
ume marks the full develop-
ment of a distinguished poet.
$4.95 ($2.25 paperbound)

Schiller

At all bookstores
CHARLES SCRIBNER'S SONS

1967

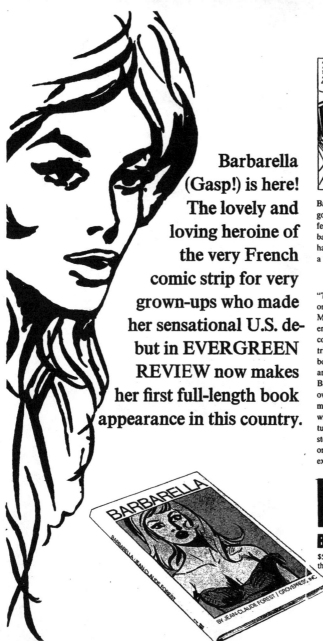

"I <u>am</u> a lover"

"*Si, un'amatore.* I tell you true. I love the life — *la dolce vita* — North Beach have plenty to love. Maybe we gotta keep the eye open sometime but we have good things. You can see 'em in "I am a Lover" by the photographer boy, Jerry Stoll. This boy he know what happen here. He take the pictures of everything ... da Chinese ... da kids ... da bums ... he got 'em all. Laughing, crying, singing 'n' real ... why the hell should I tell you, eh? You buy da book yourself." ✍ If you enjoyed "The Family of Man" then be sure to get "I am a Lover" — you'll find it a rich and rewarding addition to your pictorial library. Evan S. Connell, Jr., supplies comments, culled from many sources, ranging from Roosevelt's speeches to the Bhagavad Gita, which add another dimension to this book. ✍ We feel that "I am a Lover" will become one of the most frequently discussed books of the year. Be sure to get your copy early. It has just been released — $2.95 a copy. Order now from your bookstore or direct from the publishers: P. O. Box 755, Sausalito, California, CONTACT EDITIONS

1961

"*But I don't look good in a bikini...*"

If you insist on knee-length bathing suits and dark stockings, then paperbacks probably shock you, too. But if you enjoy the bold, the new, the provocative, then **EVERGREEN ORIGINALS** belong in your beach bag. They are *first editions*, in handsome paper covers, of the best of today's writing from all over the world . . . fiction, drama, criticism, poetry. Here are some new titles:

PULL MY DAISY
Text by JACK KEROUAC, Photos by ROBERT FRANK. The complete text for his movie on life among the "beats" on New York's Lower East Side. "Refreshing, spontaneous, alive."—DWIGHT MACDONALD. $1.45

THE WAY TO COLONOS
A Greek Triptych by KAY CICELLIS. In three contemporary reconstructions, *Oedipus at Colonos, Electra* and *Philoctetes*, the brilliant Greek writer depicts the emotions that lead people to destruction as irrevocably today as they did in the days of Sophocles. $1.95

PROBLEMS OF HISTORICAL PSYCHOLOGY
By ZEVEDEI BARBU. The author of *Democracy and Dictatorship* here explores the interaction between society and the individual psyche. His book, in effect, establishes a bridge between history and psychology. $1.95

SONS AND COMRADES
A novel by KAZIMIERZ BRANDYS. The outstanding novel of the Polish "thaw," the book the *London Times Literary Supplement* called "the most successful attempt from inside the Communist camp at finding the truth about the degeneration of Communist ideology and practice." $1.75

THE DYING GLADIATORS and other ESSAYS
By HORACE GREGORY. Such writers as Alexander Pope, Samuel Johnson, Walter de la Mare, F. Scott Fitzgerald, James Joyce, Samuel Beckett, and Dylan Thomas are the subjects of this brilliant, unconventional analysis of literature. $1.95

THE NEW BOOK/A BOOK OF TORTURE
By MICHAEL McCLURE. A collection of poems by one of the leading young poets of the San Francisco Renaissance. "McClure's poetry," says Allen Ginsberg, "is a blob of protoplasmic energy." $1.45

ESSAYS IN ZEN BUDDHISM
First Series by D. T. SUZUKI. Some of the most important writings of one of the world's leading authorities on Zen. Includes his famous study, *Enlightenment and Ignorance.* $2.95

EVERGREEN REVIEW #18
Featuring a section of Jean Genet's famous, *Our Lady of the Flowers,* and a report on New York by that bawdy and explosive Irishman, Brendan Behan, plus work by Allen Ginsberg, Aidan Higgins, Michel Butor and others. $1.00

1961

Only the author of

FROM HERE TO ETERNITY

James Jones

could have written

THE THIN RED LINE

Here is the combat novel a million readers hoped James Jones would write.

It tells the story of an Army rifle company named C-for-Charlie from the moment of landing on Guadalcanal through jungle-patrol and the bloody and exhausting struggle for a complex of hills. There are no heroes in this book but more than a dozen highly individualized characters observed under the numbing impact of war.

Only James Jones could have recreated the adventures, nightmares, self-discoveries and absurdities of men under fire as they are recounted here, against a graphic and unexcelled picture of battle.

His new novel will stand as a major achievement in the history of American war literature. $5.95

"The Thin Red Line, the line between man and beast, so easily crossed, is a realistic fable, symbolic without symbols, mythological and yet completely factual... Touched by a weird, resigned and yet light-hearted, ironic, and even optimistic acceptance of our animal nature, with constant flashes of a sly, dark peculiar humor, written with a deceptive facility that is the mark of truly great writing, this extraordinary novel achieves epic proportions through the magic of a joyful love of life and humanity, absolutely unique in contemporary literature. This book belongs to that vein of poetical realism which is the rarest and to me the most precious thing in the whole history of the novel: it is essentially an epic love poem about the human predicament and like all great books it leaves one with a feeling of wonder and hope."
—**Romain Gary**

At all bookstores **CHARLES SCRIBNER'S SONS**

1962

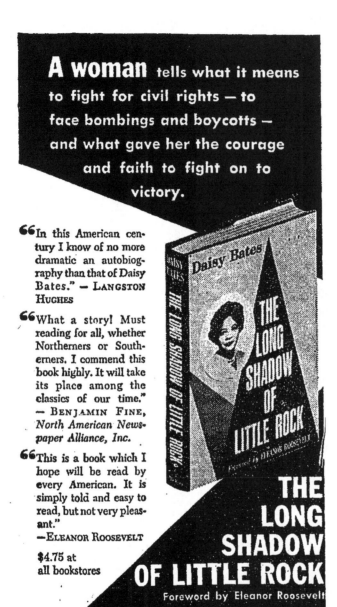

1967

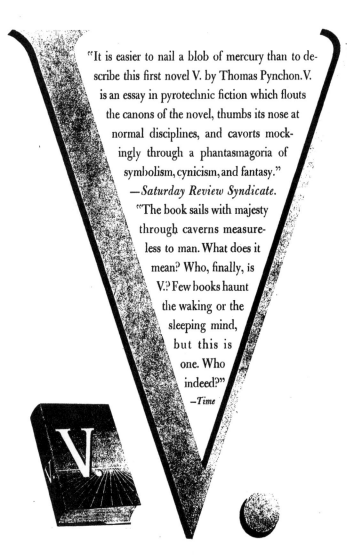

"It is easier to nail a blob of mercury than to describe this first novel V. by Thomas Pynchon. V. is an essay in pyrotechnic fiction which flouts the canons of the novel, thumbs its nose at normal disciplines, and cavorts mockingly through a phantasmagoria of symbolism, cynicism, and fantasy."
—*Saturday Review Syndicate.*

"The book sails with majesty through caverns measureless to man. What does it mean? Who, finally, is V.? Few books haunt the waking or the sleeping mind, but this is one. Who indeed?"
—*Time*

V. by Thomas Pynchon introduces a new and astonishing writer who tells a wild, macabre tale of a twentieth-century search for the mysterious **V.**—a tale that ranges from New York to Cairo to Alexandria to Malta. The characters include sailors, spies, bums, bawds, priests, and philosophers. The talk is sometimes bawdy, sometimes sublime, always fascinating. **V.** by Thomas Pynchon may remind you of Durrell or Joyce or Joseph Heller or Samuel Beckett — but only briefly because in **V.** Thomas Pynchon exercises one of the most boldly original talents to appear on the literary scene.

V. a novel by Thomas Pynchon. At bookstores $5.95

Philadelphia J. B. LIPPINCOTT COMPANY New York
Good Books Since 1792

1963

"An extraordinary success... A book we need to read, and to reread."

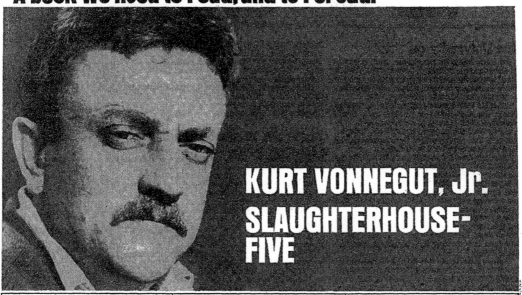

KURT VONNEGUT, Jr.
SLAUGHTERHOUSE-FIVE

"**Splendid art and simplicity** . . . Kurt Vonnegut was present as a prisoner of war (so it goes, as he would say) at the Dresden fire-bomb raid in 1945—possibly the greatest atrocity ever committed by Americans and certainly the quietest . . . Vonnegut says it took him more than 20 years to write a novel about it, and in a sense he hasn't written one yet. As though blinded by the glare of the fire bombs, he has turned his back on the raid and written a parable instead . . . SLAUGHTERHOUSE-FIVE is written with nerve-racking control: a funny book at which you are not permitted to laugh, a sad book without tears, a book of carefully strangled emotions. A tale told in a slaughterhouse."
—*Wilfrid Sheed, Life Magazine*

"**Very tough and very funny;** it is sad and it is delightful; and it works . . . Kurt Vonnegut knows all the tricks of the writing game. So he has not even tried to describe the bombing. Instead he has written around it in a highly imaginative, often funny, nearly psychedelic story."
—*Christopher Lehmann-Haupt, New York Times*

"**A work of keen literary artistry** . . . by one of our most gifted and incisive novelists . . . On the basis of one brief meeting and a few short novels, the suspicion grew on me that Kurt Vonnegut, Jr. was perhaps the best person of all in this nation of ours that now numbers more than two hundred million citizens. His new novel, SLAUGHTERHOUSE-FIVE, strengthens that strange notion considerably."
—*Joseph Heller, author of 'Catch-22'*

"**Uniquely fascinating** on a level attained by only our best novelists."
—*Barbara Bannon, Publishers' Weekly*

"**Vivid reading** . . . [It is] in a class above war books that tell it straight—this is a deliberately staged hunt for the poetry there's supposed to be in the pity, but which isn't there at all. Vonnegut's patient but loaded account of Billy Pilgrim's misadventures in the abattoir called history is his way of specifying the meaninglessness of war . . . A work of sensitive acerbity, in which imagination triumphs in the presence of so much human ash, SLAUGHTERHOUSE-FIVE is also an object-lesson in the mind's agility and fecundity. It shows what the mind can manage to do with itself when confronted with horrors it cannot dismiss and cannot change."
—*Paul West, Chicago Sun-Times Book Week*

"**Terrifying implications** . . . Vonnegut really is a sardonic humorist and satirist in the vein of Mark Twain and Jonathan Swift . . . His satire sweeps widely, touching on education, religion, advertising, and many other subjects. There is a passage about free will that Mark Twain might have written in his late and bitter years . . . There is some amusing business about pornography . . . But the central target is the institution of war . . .
"As I read it, I could hear Vonnegut's mild voice, see his dead pan as he told a ludicrous story, and gasp as I grasped the terrifying implications of some calm remark. . . . Vonnegut lives and breathes in the book, and that is one reason why it is the best he has written."
—*Granville Hicks, Saturday Review*

"**Funny, compassionate and wise** . . . Serious critics have shown some reluctance to acknowledge that Vonnegut is among the best writers of his generation. He is, I suspect, both too funny and too intelligent for many, who confuse muddled earnestness with profundity. Vonnegut is not confused. He sees all too clearly . . . He is a true artist."
—*Robert Scholes, front page New York Times Book Review*

1969

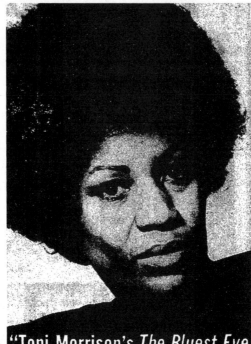

THE
1970s

"Can we actually know the universe? My God, it's hard enough finding your way around Chinatown." That's Woody Allen, quoted in an advertisement for his 1971 collection *Getting Even*. It's a terrific ad, one that flickers down the side of a page like the images on a reel of celluloid. Allen, we read, "has graciously consented to entrust the world with this modest masterpiece."

The best book ads of the 1970s were modest masterpieces themselves. The advertisement for Toni Morrison's first novel, *The Bluest Eye* (1970), was one of the best, perhaps because it was made of the simplest pieces, including a striking, soulful photograph of the author and a passionate rave from John Leonard. "Toni Morrison's *The Bluest Eye* is an inquiry into the reasons why beauty gets wasted in this country," Leonard wrote. "The beauty in this case is black; the wasting is done by a cultural engine that seems to have been designed specifically to murder possibilities; the 'bluest eye' refers to the blue eyes of the blond American myth, by which standard the black-skinned and brown-eyed always measure up as inadequate."

Striking statements abounded in this decade's advertising. "The poet is a monster and a fiend," read the top of a 1970 ad for James Dickey's *Self-Interviews*. "Anybody who is nobody knows who Seymour Krim is," declared a 1971 ad for a book of essays by this yea-saying critic. "We are everywhere," said an impish ad for a 1971 memoir from the political activist Jerry Rubin.

The 1971 full-page advertisement for Bob Dylan's first (and, so far, his only) novel, *Tarantula*, didn't tell any lies. Its tagline: "The book by Bob Dylan." About its unreadable text, the publisher—in the small type—could not have been more honest: "It is not easy to get it all the first time." ❧

"The poet is a fiend and a monster...

"In addition to being more human than other people, the poet is also a fiend and a monster. He's got to have that conviction about his work with which nothing can interfere. He's got to have that absolute certainty that what he's doing is important.**"**

Self-Interviews is a new and revealing kind of literary criticism. A prize-winning American poet- who is also a bestselling novelist takes a tape recorder and a page of provocative questions by Barbara and James Reiss, and delivers himself of some of the most candid and intimate shop talk in the history of poetry.

On his early literary career:

"I remember the first reference to me in print . . . He wrote that there was a new breed of poets emerging . . . and some of them were simple, and some of them were complicated, but no one had the right to be as complicated as James Dickey! Well, I slowly worked away from the extremely allusive kind of poetry . . .**"**

On lyricism, lucidity, and verse forms:

"I have what Richard Wilbur called, speaking of himself, 'a thump-loving American ear'.**"**

And on the future of his, and other, poetry:

"If what I wish to do works out, I'll write even more discontinuous and undoubtedly more obscure poems, moving, I hope, eventually toward a greater clarity than I or anybody else has yet had. We can hope. Indeed, we must, and sometimes we can.**"**

James Dickey's self-interviews are personal, poem-by-poem glimpses into an important poet's private world. James Dickey's SELF-INTERVIEWS is unique.

$5.95 at all booksellers

DOUBLEDAY

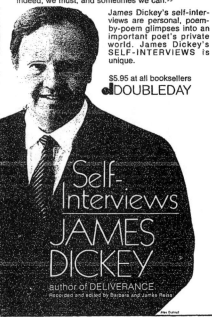

Self-Interviews
JAMES DICKEY
author of DELIVERANCE.
Recorded and edited by Barbara and James Reiss

1970

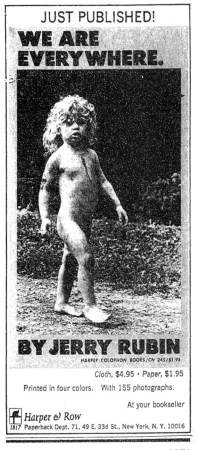

JUST PUBLISHED!

WE ARE EVERYWHERE.

BY JERRY RUBIN

HARPER COLOPHON BOOKS/CN 245/$1.95

Cloth, $4.95 • Paper, $1.95

Printed in four colors. With 155 photographs.

At your bookseller

Harper & Row
1817 Paperback Dept. 71, 49 E. 33d St., New York, N. Y. 10016

1971

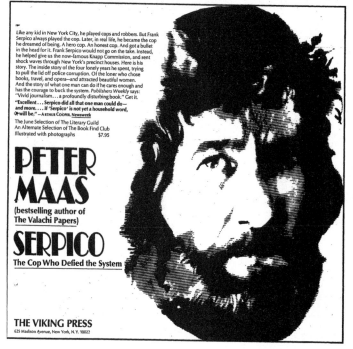

SERPICO

The honest cop who almost died to stay that way.

Like any kid in New York City, he played cops and robbers. But Frank Serpico always played the cop. Later, in real life, he became the cop he dreamed of being. A hero cop. An honest cop. And got a bullet in the head for it. Frank Serpico would not go on the take. Instead, he helped give us the now-famous Knapp Commission, and sent shock waves through New York's precinct houses. *Here is his story. The inside story of the four lonely years he spent, trying to pull the lid off police corruption. Of the loner who chose books, travel, and opera—and attracted beautiful women.* And the story of what one man can do if he cares enough and has the courage to buck the system. *Publishers Weekly* says: "Vivid journalism... a profoundly disturbing book." Get it.

"Excellent... Serpico did all that one man could do— and more.... If 'Serpico' is not yet a household word, it will be." —ARTHUR COOPER, Newsweek

The June Selection of The Literary Guild
An Alternate Selection of The Book Find Club
Illustrated with photographs $7.95

PETER MAAS

(bestselling author of
The Valachi Papers)

SERPICO
The Cop Who Defied the System

THE VIKING PRESS
625 Madison Avenue, New York, N.Y. 10022

1973

Pauline Kael

I LOST IT AT THE MOVIES 1965

Deeper

KISS KISS BANG BANG 1968

and
deeper

GOING STEADY 1970

and
deeper

THE CITIZEN KANE BOOK 1971

and now

Deeper Into Movies

The new book by Pauline Kael, "the best movie critic now writing in the United States." —*Chicago Daily News*

At all bookstores
ATLANTIC-LITTLE, BROWN

1973

"Can we actually know the universe? My God, it's hard enough finding your way around Chinatown."

"She wore a short skirt and a tight sweater and her figure described a set of parabolas that could cause cardiac arrest in a yak."

"As I told the tribunal at Nuremberg, I did not know that Hitler was a Nazi. For years I thought he worked for the phone company."

"The universe is merely a fleeting idea in God's mind — a pretty uncomfortable thought, particularly if you've just made a down payment on a house."

"Identifying criminals is up to each of us. Usually they can be recognized by their large cuff links and their failure to stop eating when the man next to them is hit by a falling anvil."

"Dr. Helmholtz was a pioneer in psychoanalysis. He is perhaps best known for his experiments in behavior, in which he proved that death is an acquired trait."

WOODY ALLEN

Is currently writing a major philosophical work to be called *The Cosmos on $5 a Day* and revising his autobiography to include himself. In the meantime, he has graciously consented to entrust the world with this modest masterpiece.

GETTING EVEN

$5.95, now at your bookstore
RANDOM HOUSE

1971

1970

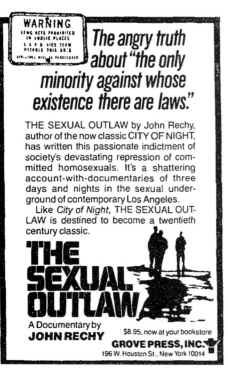

The angry truth about "the only minority against whose existence there are laws."

THE SEXUAL OUTLAW by John Rechy, author of the now classic CITY OF NIGHT, has written this passionate indictment of society's devastating repression of committed homosexuals. It's a shattering account-with-documentaries of three days and nights in the sexual underground of contemporary Los Angeles.

Like *City of Night*, THE SEXUAL OUTLAW is destined to become a twentieth century classic.

THE SEXUAL OUTLAW

A Documentary by **JOHN RECHY**

$8.95. now at your bookstore

GROVE PRESS, INC.
196 W. Houston St., New York 10014

1977

"*Fear of Flying...* belongs to, and hilariously extends, the tradition of *Catcher in the Rye* and *Portnoy's Complaint*."

—John Updike, *The New Yorker*

"It has class and sass, brightness and bite [Mr. Updike continues].... She sprinkles on the four-letter words as if women had invented them; her cheerful sexual frankness brings new flavor to female prose.... The Wife of Bath, were she young and gorgeous, neurotic and Jewish, urban and contemporary, might have written like this.... Fearless and fresh, tender and exact, Mrs. Jong has arrived non-stop at the point of being a literary personality; may she now travel on toward Canterbury."

"The heroine of *Fear of Flying*, Erica Jong's funny, horny first novel, will scare any male pig who believes women 'don't think like that.'"
—WALTER CLEMONS, *Newsweek*

"I gulped this raunchy tale in one day and enjoyed it sinfully.... *Fear of Flying* is the latest and most outrageously entertaining women's libretto yet, lusty raw material served up by a new writer of great talent."
—MARY ELLIN BARRETT, *Cosmopolitan*

Fear of Flying
a novel by Erica Jong

$6.95 at all bookstores

Holt, Rinehart & Winston

1973

"One of those rare books that truly makes a difference. One wants to urge, cajole and plead with women—and men, too, most of them equally ignorant of the female body—to read it, study it, discuss it with friends, use it as a reference, and perhaps even lend it to a doctor." —Genevieve Stuttaford, *Saturday Review*

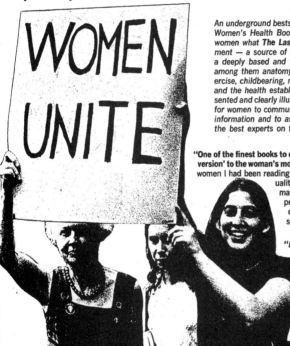

An underground bestseller since it was first printed locally by the Boston Women's Health Book Collective, **Our Bodies, Ourselves** has been to women what **The Last Whole Earth Catalogue** was to the Youth Movement — a source of information and encouragement, a rallying point, a deeply based and fundamental revolution. The subjects covered — among them anatomy, sexuality, birth control, abortion, nutrition, exercise, childbearing, menopause, common medical problems of women, and the health establishment — are carefully researched, directly presented and clearly illustrated. **Our Bodies, Ourselves** is written by women for women to communicate their excitement about the power of shared information and to assert that in an age of professionals, women are the best experts on themselves, their feelings and their futures.

"One of the finest books to come out of the new woman's movement. I owe my 'conversion' to the woman's movement to it. It brought home to me that like most other women I had been reading the opinions of male experts on women and female sexuality all my life, without realizing the obvious fact that no man, by any stretch of the imagination, can ever be an expert on what it is to be a woman. The simple sisterhood, deep humanity, and reaching out of this book were irresistible to me." —Stephanie Caruana, *Los Angeles Times*

"A masterpiece. If anyone has any doubt left that women can really get it together, they should have a look at this book. The subject is our bodies — our relationship to them, to ourselves, to men, to each other, and to our society. If you don't think you have any questions about your body, you'll probably be surprised. And if you're looking for a stronger, clearer sense of yourself as a woman, you'll be satisfied.
—Diana Shugart, *The Whole Earth Catalogue*

OUR BODIES OURSELVES

A BOOK BY AND FOR WOMEN

by The Boston Women's Health Book Collective
Cloth $8.95, Touchstone paperback $2.95 • Simon and Schuster

Photo: Robert Parent

1973

NORMAN MAILER

Pulitzer Prize-winner and self-confessed Prisoner of Wedlock, in his late forties, "drenched like many another in the sexual memories of his life," sets out to discover what he really thinks about sex. After reading the books on Women's Lib, brooding upon them seriously (no other male author has given as much time to the literature of the Liberation) he explores the very foundations of sex—fidelity, promiscuity, heterosexuality, homosexuality—returning with a book which may have more to say about the sexuality of women (and men) than anything published on the subject in decades.

THE PRISONER OF SEX

Just published. A selection of the Book Find Club.

$5.95 at bookstores

Little, Brown

1971

I, Pig

OR HOW THE WORLD'S MOST FAMOUS COP, ME, IS FIGHTING CITY HALL

by **Jack Muller** with Paul Neimark

Photo: Don Bronstein

"More powerful than Abbie Hoffman! Faster on the guff than Bella Abzug! Able to leap Baron Munchàusen in a single bound! It's Supercop Jack Muller, the Chicago letter-of-the-law man who for 25 years has been causing pain and embarrassment to the city's politicians, smug elite and privileged hoodlums. He actually believes the law was written to apply equally to everyone. He really has seen men and institutions at their very worst. That he spares no middleclass sensibilities in describing what he has observed makes him a source of indispensable embarrassment."—TIME

$4.95

WILLIAM MORROW

1971

John D. MacDonald makes a sock in the jaw a literary event.

John D. MacDonald, creator of the Travis McGee series, is one of the unrivalled masters of the tough guy adventure story. If you're looking for action McGee will give it to you with both hands.

But there's more to John D. MacDonald than two-fisted adventure. Kurt Vonnegut, Jr., says, "To diggers a thousand years from now . . . the works of John D. MacDonald would be a treasure on the order of the tomb of Tutankhamen." Richard Condon, author of *The Manchurian Candidate*, says, "McGee is for me. John D. MacDonald is the great American storyteller." And a recent *New York Times Book Review* roundup of adventure series called the McGee books "probably the best written of them all."

If you've never discovered McGee, here's your chance to start on his biggest, most exciting caper yet—a tale of marijuana smuggling, land development scheming, swingles living and mayhem, in not-so-sunny Florida.

If you're a McGee fan already—enough said, here's the new one:

THE DREADFUL LEMON SKY
The new Travis McGee novel by John D. MacDonald

A Detective Book Club Selection
A Book-of-the-Month Club Alternate
$6.95 at bookstores now

Lippincott
J.B. Lippincott Company

1975

THOMAS McGUANE

"He is an important as well as brilliant novelist, one of our most truthful recorders of a dreadful time. Like Mailer and Pynchon, Thomas McGuane makes the page, the paragraph, the sentence itself a record of continuous imaginative activity."—Thomas R. Edwards, front page, *N.Y. Times Book Review*

"A saturnine virtuoso moving, with increasing poise and ferocity, toward mastery . . . McGuane's sense of place, his harsh and delicate exactness of detail are at their keenest in NINETY-TWO IN THE SHADE."—Walter Clemons, *Newsweek*

"The best book yet of a very strong young writer. McGuane brings powers of concentration to writing that recall Camus as much as Hemingway."
—Martha Duffy, *Time*

"It's a remarkable, original novel, superbly — if with gallows humor — told. Thomas McGuane writes like a man afflicted or sanctified with four or five extra pairs of eyes: he sees around the corners of things, and records the visions in more than three dimensions."—Richard Rhodes, *Chicago Tribune Book World*

"Full of surprises and rewards and an exhilaration one feels only rarely . . . **I offer a gentle exhortation — please read the book.**"—*Newsday*

Ninety-Two in the Shade

$6.95, now at your bookstore

FARRAR
STRAUS
GIROUX

Photo: Guy de la Valdène

1973

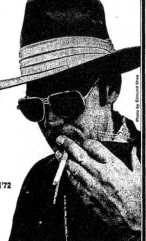
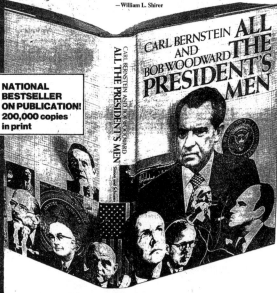

1972

Nancy Dickerson
recalls her Washington life

—the news scoops, the social whirl, private evenings with Presidents

AMONG THOSE PRESENT

A Reporter's View of Twenty-Five Years in Washington

Crowded with anecdotes, reminiscences, and behind-the-headlines revelations, this sparkling memoir by TV's first woman network correspondent is a portrait of a Washington only a very privileged few could know.

From youthful dates with JFK to hectic eighteen-hour days covering political conventions…from a hilarious evening with Wilbur Mills and Fanne Foxx to a bizarre middle-of-the-night phone call from Richard Nixon.. this is Nancy Dickerson's revealing chronicle of her glamorous career in the capital—and an intimate portrait of the famous and powerful people she came to know.

Eight pages of photos
$8.95, now at your bookstore **RANDOM HOUSE**

1976

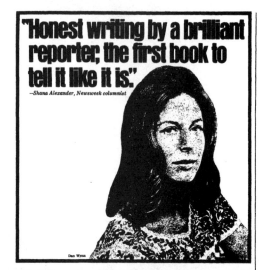

"Honest writing by a brilliant reporter; the first book to tell it like it is."
—Shana Alexander, Newsweek columnist

Dan Wynn

Hustling
PROSTITUTION IN OUR WIDE OPEN SOCIETY
GAIL SHEEHY

"Bristling with valuable information . . .
Most enlightening on any number of subjects—the psychology of prostitutes; their origins and backgrounds; their caste systems; the texture of their lives . . . A remarkably exhaustive piece of reportage on a difficult subject."
—Christopher Lehmann-Haupt, New York Times

"A brilliant piece of work."
—Tom Wolfe

"Sparkling and at times bitterly incisive;
Sheehy, after all, was the reporter who exposed the society owners of some of the 42nd Street porno palaces, and who dug out information that even a mayor's task force was having trouble getting. Her book is likely to intrigue (or enrage) the reading public."
—Library Journal

"Gail Sheehy is a basic resource of New York City."
—Mayor John V. Lindsay

"A perfect match of talent and topic . . .
A vivid, hoydenish writer, so apparently open to the experiences of David the Pimp, Venire the Madam, Redpants, Minnesota Marsha, Sugarman, et al, you might mistake brilliance for whitewash. Don't."—Mary Ellin Barrett, Cosmopolitan

"An intelligent, tough-minded book
that gives the lie, among other things, to the image of the harlot with a heart of gold."—Dorothy Rabinowitz, World Magazine

$7.95 at all bookstores

delacorte press
DELL PUBLISHING CO. INC.

1973

Captain Fiction

Five years ago Gordon Lish and his wife were driving along a freeway after see-ing an unimpressive movie. The future seemed pretty un-promising and Barbara Lish asked Gordon: "What do you really want to be?" Gordon doesn't know why, but his an-swer was: "The fiction editor of a big magazine!" A year later Gordon Lish became just that. The magazine was *Esquire*.

Gordon Lish says he got to be fiction editor of *Esquire* by being at the right place at the right time. Maybe. Gordon talks a lot about Captain Mid-night. Some people call Gor-don Captain Fiction. He cer-tainly is devoted to the craft. How devoted can be seen in the pages of *Esquire* Magazine every month and in a hand-some and lively book he has edited and we have just pub-lished: THE SECRET LIFE OF OUR TIMES: New Fiction from *Esquire*.

This is a Lish extravaganza, from his own Introduction-in-ten-beats (there is a second Intro. by Tom Wolfe) to the thirty-six stories he has se-lected. You'll find writers in this collection you know well: Nabokov, Márquez, John Gardner, Richard Brautigan, Joyce Carol Oates, Bernard Malamud. You'll meet others you will want to meet again: Joy Williams, A. B. Yehoshua, Hima Wolitzer, Raymond Kennedy. Wherever you start in the volume, the effect, says Anatole Broyard in the *New York Times*, is like a "series of shock treatments."

That's the way Captain Fic-tion meant it to be. If it's ◄ you to try fiction to discover what *else* might be in you, we promise a productive — yes, electrifying experience.

L.L. Day

Editor-at-Large.

DOUBLEDAY PUBLISHES GORDON LISH

1973

Why did E.L. Doctorow choose a young writer's first novel as one of the three books he most enjoyed in the past year?

As the author of *Ragtime* wrote in the *N.Y. Times Book Review*: "Richard Ford is a new Southern voice, here, I think, with situations and characters of considerable power."

And other critics agree: *The National Review* hailed Richard Ford's novel as a "signal work of nativist fiction . . . probably one of the finest of its genre in the last twenty years." *The Soho News* calls it "strong, terrifyingly eloquent . . . Ford makes the novel hum and churn, bubble and hiss, as if we had never seen locale and characters like this before." And *The Book-of-the-Month Club News* praises it as "a much-heralded novel in the tradition of Flannery O'Connor and William Faulkner."

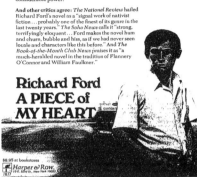

Richard Ford
A PIECE of
MY HEART

$8.95 at bookstores

Harper & Row, 10 E. 53d St., New York 10022

1977

AWAITED BY LITERARY AMERICA SINCE 1955

The new novel by the author of <u>The Recognitions</u>
William Gaddis

"Brilliant, mad humor . . . an enormous, rhythmic dream preserved as if on the rolls of a player piano."
—*Playboy*

"Gaddis is a towering figure . . . In the blank spaces on their maps, the ancient cartographers wrote: 'Here Be Monsters.' Gaddis has gone to such a place and has returned to tell the tale." —National Observer

"Calling it a work of genius— which it is—seems pallid . . . Im-probable, magnificently success-ful, and hilarious . . . For years we have been calling in vain for stronger wine and madder music. Now we have them [in] a marvel-ous and horrific work of art!"
—L. J. Davis, National Observer

"Gleefully authentic . . . Gaddis is un-compromising, and so is the effect of J R . . . a kind of fearful exhilaration . . . What keeps the reader up is humor. The philosopher's stone is revealed as wit . . . A. G. (After Gad-dis) dialogue may never be the same."
—Bob Miner, Village Voice

"JR is marvelous.
JR is wonderfully, unashamedly farcical.
Gaddis is a genius.

. . . What he wants is, well, he wants you to read J R at one sitting. It might be done: there's entertainment enough in those 736 pages . . . Spoken words in J R do everything. They do, period. They are physical . . . Gad-dis has set himself unique and difficult challenges— challenges that are significant to the ongoing business of literature. He has executed them perfectly, while at the same time confecting a novel that intrigues, satis-fies, overwhelms."
—D. Keith Mano, Harper's Bookletter

"The absurdity of an 11-year-old boy's gaining control of a huge financial empire is the ultimate burlesque ex-pression of an idea dramatized everywhere in this re-markable novel . . . His vision of what is happening in our world is profound."
—John W. Aldridge, Saturday Review

"An epic of money and moneymaking, success and failure."
—Atlantic Monthly

"Continuously stimulating and funny. An exceptional achievement. A rare novel."
—Bruce Allen, Chicago Tribune Book World

Who is J R?

Who stands at the center of this rushing, raucous master-piece about money and its in-fluence, love and its absence? An ambitious sixth-grader in torn sneakers, operating from phone booths and a seedy N.Y. cafeteria, parlaying a deal for thousands of surplus Navy pic-nic forks into a nationwide hydra-headed conglomerate that engulfs brokers, widows, Congressmen, hardware-soft-ware educationalists, in a flood tide of money, deals, public re-lations and private betrayals . . .

"William Gaddis' first novel, *The Recognitions*, has become an un-derground classic over the years since it was published in 1955. J R should earn the author a rightful place in the sun as a major American novelist."
—Roger H. Smith, Publishers Weekly

736 pages. Issued simultaneously in hardcover at $15 and softcover at $5.95.

Just published by Alfred·A·Knopf

1975

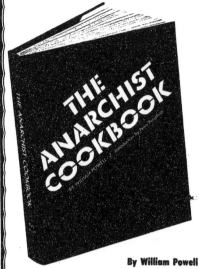

By William Powell

with a prefatory note on anarchism today
by PETER M. BERGMAN

— will shock, disturb and provoke. It places in perspective an era when "turn on, burn down, blow up!" are revolutionary slogans of the day.

— THE ANARCHIST COOKBOOK may be the most disquieting "how-to" book of our time.

Says Lothar Salin in *The Pacific Sun:*

". . . we cannot dismiss it without looking at it in . . . perspective. One of the tenuous rationales for publishing this kind of book is the idea that the people of the counter culture must arm themselves for guerrilla warfare since they cannot expect justice from a court system rigged to do the bidding of the Establishment.

"At the present time this may still be far-out, but Mainstream America is suffering from a dangerous blind spot in not recognizing that the feeling of distrust exists very strongly and needs to be proved wrong by court practice rather than by rhetoric, especially as it applies to trials which the counter culture rightly or wrongly regards as political . . ."

THE ANARCHIST COOKBOOK

$12. Softbound edition: $5.95

Available at most bookshops. Or you may order directly from the publisher by using the coupon below:

1971

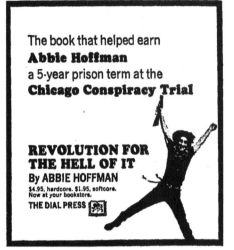

The book that helped earn
Abbie Hoffman
a 5-year prison term at the
Chicago Conspiracy Trial

REVOLUTION FOR THE HELL OF IT
By ABBIE HOFFMAN
$4.95, hardcore. $1.95, softcore.
Now at your bookstore.
THE DIAL PRESS

1970

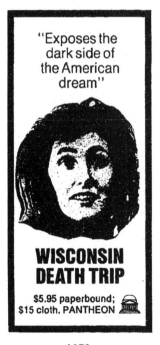

"Exposes the dark side of the American dream"

WISCONSIN DEATH TRIP

$5.95 paperbound;
$15 cloth. PANTHEON

1973

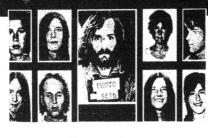

1974

An astonishing new novelist makes an explosive debut

THE WANDERERS

by Richard Price

PHOTO © MARION ABBOTT

JOHN FOWLES: "I haven't read a better fictional account of the dark side of the American dream for many years."

WILLIAM S. BURROUGHS: "Not since *Last Exit to Brooklyn* has dialogue been so accurately reproduced."

HUBERT SELBY, JR.: "This book is about the coming of age of the children of my generation. We experience the emotions of *The Wanderers*, and they are the same that man has felt and experienced since the first scratches on walls."

The Kirkus Reviews: "A literary *American Graffiti* set in a preternaturally decaying housing project in the Bronx, circa 1962...This is a fine first novel—gritty, incisive, unpatronizing, authentic in its detail."

HANNAH GREEN: "*The Wanderers* is a wonderful book and I loved it. From the first moment it filled me with delight—the delight of knowing from the first instant that you are in the hands of a real artist, the rarest kind of writer...There is more tenderness, warmth, love, humanity and understanding than I've come across in a book in a long time."

ISHMAEL REED: "I was beginning to think that New York writing had become all style, fashion, frills, and existentialist newspeak until I read Richard Price's *The Wanderers.*"

RONALD SUKENICK: "Captures the sense of growing up in teengang Bronx...a passionate comic book about the tough, doomed kids of the New York streets."

AND IN ADDITION:

- A Book-of-the-Month Club Alternate

- Paperback rights sold for a high five figures

- Movie option signed with Samuel Goldwyn, Jr.

At your bookstore · $5.95

HOUGHTON MIFFLIN COMPANY
Publisher of The American Heritage Dictionary

1974

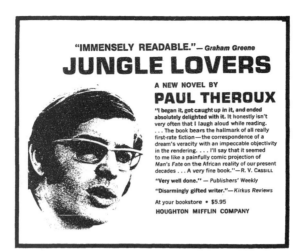

1971

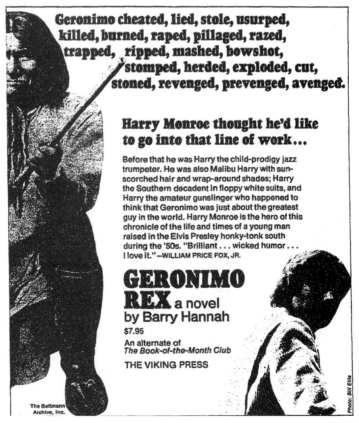

1972

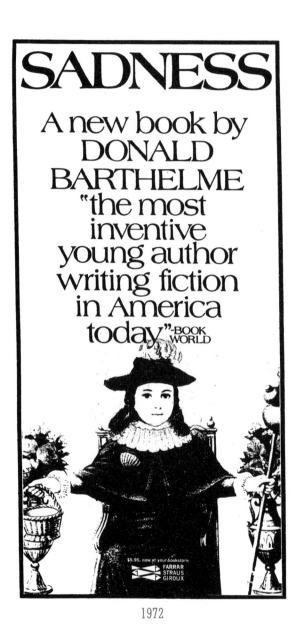

SADNESS

A new book by
DONALD
BARTHELME
"the most
inventive
young author
writing fiction
in America
today"-BOOK
WORLD

$5.95, now at your bookstore

FARRAR
STRAUS
GIROUX

1972

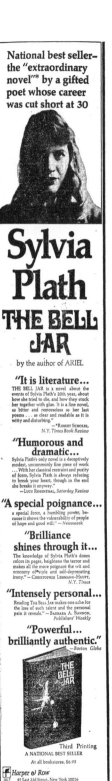

National best seller—
the "extraordinary
novel"* by a gifted
poet whose career
was cut short at 30

Sylvia Plath

THE BELL JAR

by the author of ARIEL

"It is literature...
THE BELL JAR is a novel about the
events of Sylvia Plath's 20th year, about
how she tried to die, and how they stuck
her together with glue. It is a fine novel,
as bitter and remorseless as her last
poems . . . as clear and readable as it is
witty and disturbing."
— *ROBERT SCHOLES,
N.Y. Times Book Review

"Humorous and
dramatic...
Sylvia Plath's only novel is a deceptively
modest, uncommonly fine piece of work
...With her classical restraint and purity
of form, Sylvia Plath is always refusing
to break your heart, though in the end
she breaks it anyway."
—LUCY ROSENTHAL, Saturday Review

"A special poignance...
a special force, a humbling power, be-
cause it shows the vulnerability of people
of hope and good will." — Newsweek

"Brilliance
shines through it...
The knowledge of Sylvia Plath's doom
colors its pages, heightens the terror and
makes all the more poignant the wit and
economy of style and self-deprecating
irony." — CHRISTOPHER LEHMANN-HAUPT,
N.Y. Times

"Intensely personal...
Reading THE BELL JAR makes one ache for
the loss of such talent and the personal
pain it reveals." — BARBARA A. BANNON,
Publishers' Weekly

"Powerful...
brilliantly authentic."
—Boston Globe

Third Printing
A NATIONAL BEST SELLER
At all bookstores, $6.95

Harper & Row
49 East 33d Street, New York 10016

1971

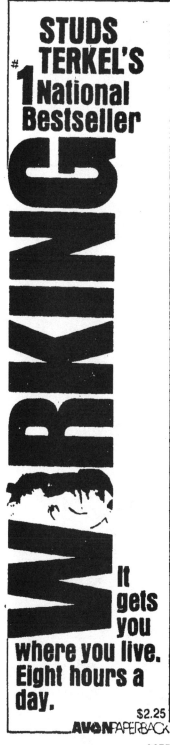

1971

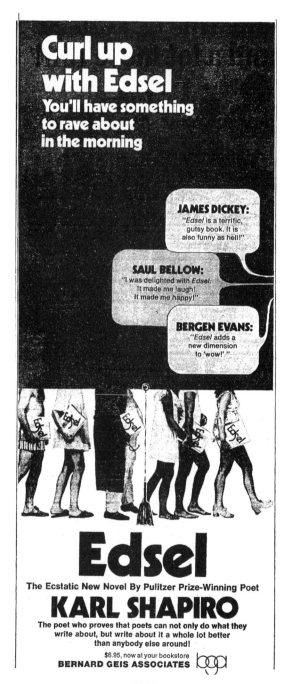

From being nervous and pregnant and poor
in Butcher Holler to living with wealth and
fame as the reigning queen of Nashville—
this is Loretta's own story...

Loretta Lynn
Coal Miner's Daughter

by LORETTA LYNN with George Vecsey

SINCE Loretta Lynn admits she is better
at "talkin' than writin'," she found a
writer to put her story down on paper
for her. George Vecsey is a *New York Times*
reporter Loretta first met when he was cover-
ing Appalachia and the author of *One Sunset
a Week*, the highly praised account of the
daily existence of a poor coal mining family.
Loretta explains how she and "my writer" got
to understand each other very well, but she
hastens to add: "You can bet your last scrip
penny that I checked out every word...and if
I didn't like it, out it went."

The result is a book that's just as honest
and likeable as the lady on the records.
Loretta talks openly about her 25-year mar-
riage to Doolittle Lynn (she was a bride at
thirteen and a mother of four at eighteen who
took up playing a Sears-Roebuck guitar and
writing songs between rocking babies), about
her medical problems (she confesses she was
ruining her health with aspirin), about the
gossip that she and Conway Twitty have
something going besides friendship and the
Vocal Duo of the Year Award and, of course,
about Nashville behind the scenes.

"Hillbillies are going out of fashion in
Nashville," notes Loretta as she speaks
frankly about the intrigues, power games, and
personal battles fought along the way to star-
dom. She doesn't spare a poke or two at
people who would have held her back, but she
also depicts a warmer side of Music City life
that isn't all cash and competition and tells
scores of anecdotes about the big names in
country music.

Above all, COAL MINER'S DAUGHTER gives
us a chance to really see Loretta Lynn as she
sees herself—willing to take the good with the
bad and turn it into a song. "An affecting and
engaging story that will delight her fans and
may even win her some converts. What's so
refreshing is Lynn's complete frankness about
what she is, who she is, and how she feels....
It's funny, sad, intense, but what makes it is
Loretta Lynn herself."—*Publishers Weekly*

16 pages of photographs
$7.95 at bookstores everywhere
A Bernard Geis Associates Book

**HENRY
Regnery
COMPANY
Chicago, Illinois**

1976

When Bouton
pitches,
America listens!

Jim Bouton exposes baseball.
And other games people play.

You can no more call *Ball Four* just a book about
baseball than you can call *Moby Dick* a book about
whaling. It's a comment on a whole morality, a whole
society. In this frank, iconoclastic account of
his baseball career, pitcher Jim Bouton names
names, pricks balloons, and shatters the
shibboleths of our national pastime—and throws
a curve at wheelers and dealers everywhere.
You don't have to be a baseball fan to love *Ball Four*.

"*Ball Four* is a people book, not just a baseball book."
—*New York Times*

"Fast, flip and often funny...
He gets his digs in all along the way."—*Time*

"Sparkles with anecdotes...
It's funny, lively and just about the best."
—*Publishers' Weekly*

BALL FOUR

by Jim Bouton
Edited by Leonard Shecter

$6.95

WORLD PUBLISHING
TIMES MIRROR

1970

The book by Bob Dylan

 Tarantula is Bob Dylan's first book, the only book he has ever written. It is a work of power and imagination, of variety and richness—of words and spirit.

 Tarantula is filled with peaks of brilliance and fields of humor. It is the plain truth. It is the complicated truth.

 Tarantula. You may wish to read it through more than once, for it is not easy to get it all the first time. $3.95

THE MACMILLAN COMPANY
A CCM COMPANY
866 Third Avenue, New York, N.Y. 10022

A master critic applies his own theories. Brilliantly.

In works such as *The Anxiety of Influence, Kabbalah and Criticism,* and *A Map of Misreading,* Harold Bloom elucidated the principles of "antithetical criticism." Now he shows how the theory works in a specific setting— the Romantic literary tradition and its influence on "the native strain" of American poetry.

"Clarifies contemporary poetry's debt to the masters, especially Coleridge and Emerson, with emphasis on those they influenced, notably Wallace Stevens, A. R. Ammons and John Ashbery. . . . Always as engaging as the poets treated."—*Library Journal*

Harold Bloom
Figures of Capable Imagination
A Continuum Book
$11.95 at bookstores

THE SEABURY PRESS
815 Second Avenue
New York, N.Y. 10017

1976

1975

One Hundred Years of Solitude "is one of the best novels to be published in this country in several years...

"one of the rare novels that can continually surprise the reader. The story concerns the history of Macondo, an imaginary town in the interior of Colombia, and six generations of the Buendía family, the leaders of the town from its birth until its destruction. If you look sideways at Macondo, you may see in it the story of all of South America — a story of dreams and adventure, of corruption, war and decadence, all in a dramatic landscape — but if you open both eyes wide in wonder, Macondo's story becomes that of the world itself."

— PETER S. PRESCOTT, *Look Magazine*

"While we have been wondering about the great American novel, it looks as if García Márquez may well have written the great novel of the Americas — and had a grand time doing it too. . . . ONE HUNDRED YEARS OF SOLITUDE is a book of wonders written by a man who, like one of his characters, has an unbridled imagination . . . It has enough ghosts, necromancers, gypsies, cannibals, levitating priests and incestuous lovers for a side show, while its golden chamber pots, plagues of insomnia, rains of yellow flowers, flying carpets qualify it as one of the very best if not, in truth, the greatest show on earth." — RONALD CHRIST, *Commonweal*

One Hundred Years of Solitude
by GABRIEL GARCÍA MÁRQUEZ
TRANSLATED BY GREGORY RABASSA

"**Fecund, savage, irresistible** . . . You have the sense of living along with the Buendías (and the rest), in them, through them and in spite of them, in all their loves, madnesses and wars, their alliances, compromises, dreams and deaths . . . The characters rear up large and rippling with life against the green pressure of nature itself."

— PAUL WEST, *Book World*

"**This novel should be around for a long time.** It is very special, an instrument of rare magic that performs astonishing miracles of transformation. It is a comic masterpiece. It is intelligent. It is slippery with the juice of life . . . In short, everything works and everything delights." — GEOFFREY WOLFF, *Newsweek*

$7.95 AT ALL BOOKSTORES

Harper & Row
1817

1970

1972

1970

To see,
to think,
to feel,
to remember.

Traveling on Credit

Poems by Daniel Halpern

"Daniel Halpern is a young man who has been everywhere,
tried everything, let nothing get by. Travel is his metaphor for
flight and for quest, the restless investigations of an unrooted
generation. Wherever he goes, he exercises his taste for the exotic,
his curiosity about states of disorientation and the fevers of a civilization.
The ultimate and inescapable geography of his poems is the heightened
world of the poet's senses." — STANLEY KUNITZ
"Despite their assurance, their casualness, their acceptance of the exotic
as commonplace, Halpern's poems exist as emblems of survival, an
unusual survival, full of charm, wit, and a saving, though precarious,
uncertainty. Halpern says he travels on credit. I say he
pays hard cash."—MARK STRAND

Cloth $4.95; paper $1.95

THE VIKING PRESS

Trisha Orr

FUNNY AND SERIOUS

August 13 will be a banner day for us, because on that day we'll be publishing not one, but two books by an exciting new writer — Ann Beattie.

A teacher of creative writing at the University of Virginia, she is a frequent contributor to *The New Yorker*, and her stories have appeared in such other magazines as *Transatlantic Review* and *The Atlantic*. Now we are publishing her first novel, CHILLY SCENES OF WINTER, simultaneously with a collection of the stories, DISTORTIONS, to bring her the attention she deserves as a major new American writer.

Ann Beattie has a notable ability to present the surface of everyday existence, the kinds of events we recognize from our own observations, with uncanny faithfulness and coherence. But it's how she uses these events that counts, and in CHILLY SCENES OF WINTER she has created one of the funniest serious books of the year.

CHILLY SCENES OF WINTER makes sense, as no other novel I've read has, of what life in the Seventies means for a whole generation: people men in their late twenties (the author is one of them herself), burdened with memories of a looser time, a time of rebellion and the prospect of change.

There's a unique style to Ann Beattie's writing: cool, precise, flexible. She doesn't strain for effect, doesn't indulge in leaden satire or surreal exaggeration. She records what she sees, intensifying it to get at the core of how people feel about their lives, and how they act on their feelings.

Be the first on your block to read Ann Beattie!

L.L. Day
Editor-at-Large

DOUBLEDAY PUBLISHES ANN BEATTIE

1976

Fred Bauer

ANOTHER ROADSIDE ATTRACTION

Tom Robbins lives in a little fishing village on Puget Sound. I've never been there myself but I'm beginning to believe what Tom's been telling me: that his rain forest home is the center of the universe.

For one thing, emanating from the person of Tom Robbins is a wonderful joy, peace, happiness, and inner tranquility that I imagine could only come when a person has his head and heart connected to some spiritual center. And for another, there is the evidence of Tom's novel, ANOTHER ROADSIDE ATTRACTION.

On the surface, ANOTHER ROADSIDE ATTRACTION is a story that Tom describes as "an apocalyptic entertainment, a metaphysical suspense." The book works out such questions as, What would happen if the Second Coming didn't quite come off as planned? What if The Corpse in Captain Kendrick's Memorial Hot Dog Wildlife Preserve is really who they say it is? What if a clairvoyant young girl named Amanda suddenly glided out of a cactus patch and signaled a return to paganism, magic, and fertility worship as the principal religious forms of our modern technocracy? But in the answers to these controversial questions, a secret message is being tapped out. It's this primitive, cryptic communication that plays between the lines that intrigues me. It is this *I Ching* quality of ANOTHER ROADSIDE ATTRACTION that makes me think Tom Robbins might well be transmitting words of wisdom from the center of the universe.

To test this notion, I sent his book to others to read. Lawrence Ferlinghetti said: "It's got everything." Herb Gold called it "an extraordinary book!" Graham Greene didn't write, he cabled: "Robbins' book magnificent." Now I'm not sure what each of these men found in ANOTHER ROADSIDE ATTRACTION, nor do I know where to go from here with my investigation. What's certain is that something special is going on in these pages that is worth looking into.

L.L. Day
Editor-at-Large

DOUBLEDAY PUBLISHES TOM ROBBINS

1971

RICHARD
BRAUTIGAN

Revenge of the Lawn is the title story in this marvelous collection of 62 stories from Richard Brautigan whom the *Hudson Review* calls "One of the most gifted innovators in our literature."

Brautigan is the author of four novels and seven books of poetry, including *Trout Fishing in America, The Abortion: An Historical Romance 1966* and *Rommel Drives on Deep into Egypt*—all among the most widely read books in America.

Photo by Edmund Shea

REVENGE OF
THE LAWN

Cloth $5.95; Touchstone paper, $1.95

SIMON AND SCHUSTER

1971

THE
1980s

James Thurber, E. B. White, A. J. Liebling, and S. J. Perelman. . . . squeeze over to make a little room." This is a classic formulation for a book ad, and in this case it was deployed in the service of Garrison Keillor's first book, the 1982 collection *Happy to Be Here*. Fran Lebowitz, who also had a volume in stores, said in this ad: "If you can buy only two collections of comic prose this year, *Happy to Be Here* is the other one."

The book advertisements of the 1980s could be amusing to read, but they were, by and large, conventional. It wasn't a time of radical visual experimentation or bold language. Most of the ads were built from straightforward ingredients. Some of the best harked back to the 1960s. The cover line on a resonant ad for Jayne Anne Phillips's 1985 novel *Machine Dreams* read: "Coming of Age in the 1960s, You Had Twice as Much Innocence to Lose." And an ad welcoming Ken Kesey's 1986 book *Demon Box* read simply: "Kesey Rides Again!"

Another 1960s artifact, John Kennedy Toole's posthumous novel *A Confederacy of Dunces*, was finally published in 1980. Here's what Greil Marcus had to say about it in *Rolling Stone*: "*A Confederacy of Dunces* has been reviewed almost everywhere, and every reviewer has loved it. For once, everyone is right."

One forward-thinker was the novelist Michael Crichton. In 1983, the year before Apple released the first real home computer, the Macintosh, he published a book called *Electronic Life: How to Think about Computers*. The jolly advertisement for Crichton's book, printed in this chapter, is worth spending some time with. One way to assuage your fears about these machines, Crichton wrote, was to walk up to one and force it to print these words: "This computer is a pussycat." ◆

1980

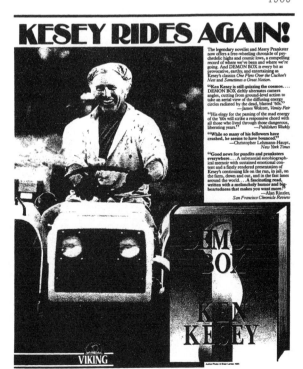

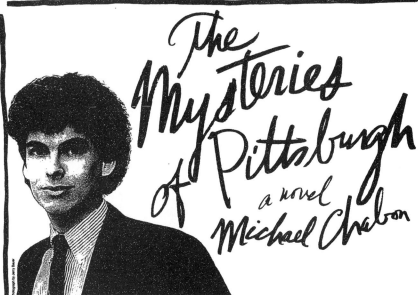

The Mysteries of Pittsburgh
a novel
Michael Chabon

"This season's 'hot' book."*

"A thoroughly wonderful novel. ...[It] did two things no book has done for me in a long time: it made me feel good and it took me completely by surprise."
—*David Leavitt*

"Anybody can write a *realistic* account of his first post-graduation summer of growing up and making love, but to make such a story the stuff of legend, as Chabon has done here (and Fitzgerald did before him) takes something close to genius."
—*Tom Disch, PLAYBOY*

"As magical and mysterious, puzzled and luminous as youth itself....Impossible to put down."
—*Susan Fromberg Schaeffer*

"This youthful, larky novel is exceedingly well written."
—*Walter Clemons, NEWSWEEK*

"Warm-blooded, wide-eyed, wistful....Settle in and read this appealing *bildungsroman*."
—*Arthur Lubow, VANITY FAIR*

"Full of youthful power and energy that's as refreshing as a spring rain."
—*MacDonald Harris*

"Simply, the best first novel I've read in years....It will find its place beside ON THE ROAD and CATCHER IN THE RYE."
—*Carolyn Forché*

"Michael Chabon has written a vivid story, guiding characters and reader alike through a strange labyrinth with astonishing skill."
—*Elizabeth Spencer*

"This season's 'hot' book turns out to merit the advance hoopla. ...Beautifully controlled...eloquent, compassionate and wise."
— *PUBLISHERS WEEKLY**

ALTERNATE SELECTION OF THE BOOK-OF-THE-MONTH CLUB ● FEATURED ALTERNATE AT QUALITY PAPERBACK BOOK CLUB

William Morrow

1988

A story that could have been written
only by the woman who lived it...

PRISCILLA BEAULIEU PRESLEY

Elvis Presley and Priscilla Beaulieu were together fourteen years. This is Priscilla Presley's powerful and poignant story of her life with the most successful entertainer of all time.

When they met, she was an innocent fourteen-year-old girl, someone whom he could mold to his own ideas. He taught her everything—how he wanted her to walk, wear makeup, style her hair, dress, behave and how to make love his way. In the course of time, he came to be her friend, lover, father, husband and, very nearly, God.

It is a love story unlike any other of our time.

ELVIS
AND
ME

Written with Sandra Harmon.
Illustrated with never-before-published family photographs.

Now at your bookstore,
G.P. PUTNAM'S SONS
A Member of the Putnam Publishing Group

1985

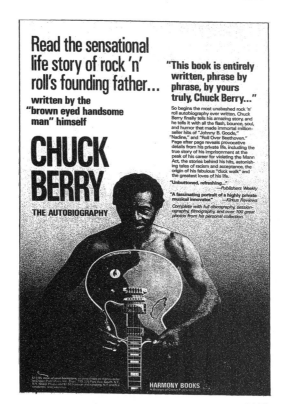

Read the sensational life story of rock 'n' roll's founding father...

written by the "brown eyed handsome man" himself

CHUCK BERRY
THE AUTOBIOGRAPHY

"This book is entirely written, phrase by phrase, by yours truly, Chuck Berry..."

So begins the most unabashed rock 'n' roll autobiography ever written. Chuck Berry finally tells his amazing story, and he tells it with all the flash, bounce, soul, and humor that made immortal million-seller hits of "Johnny B. Goode," "Nadine," and "Roll Over Beethoven." Page after page reveals provocative details from his private life, including the true story of his imprisonment at the peak of his career for violating the Mann Act, the stories behind his hits, astonishing tales of racism and acceptance, the origin of his fabulous "duck walk" and the greatest loves of his life.

"Unbuttoned, refreshing..."
—*Publishers Weekly*

"A fascinating portrait of a highly private musical innovator."
—*Kirkus Reviews*

Complete with full discography, sessionography, filmography, and over 100 great photos from his personal collection.

HARMONY BOOKS
A Division of Crown Publishers, Inc.

1987

1983

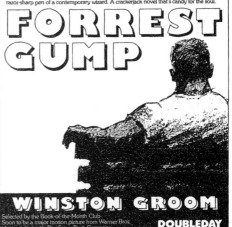
1986

She's the talk of the town.

She's "laugh-out-loud funny."¹
She's an "immensely interesting,
talented writer."² She's "a
Catskills comic with a punk
hairdo."³ She's
TAMA JANOWITZ
and this is her outrageous new novel!

In *A Cannibal in Manhattan*, Tama Janowitz,
the bestselling author of *Slaves of New York*,
reveals what happens when a purple-skinned,
middle-aged, hen-pecked, erudite and bemused
one-time cannibal enters the maelstrom of
Manhattan. With marvelous drawings, maps, and
photos (posed by such luminaries as Andy
Warhol!).

¹*Washington Post* ²*Mademoiselle* ³*Newsweek*

Now at your bookstore.

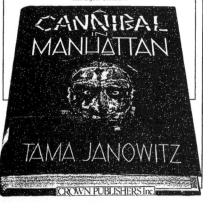

1987

"A literary Diane Arbus.

First the grotesque and the normal become inseparable;
then they become indistinguishable."
—Margo Jefferson, *Vogue*

"Full of spunk and energy...."
A vivid tale of poverty told with passion, wild humor."
—Thomas Williams, *Chicago Tribune Book World*

"Startling and original....
Carolyn Chute's infernally white-trash Beans of Maine
have taken a chunk out of the literary turf formerly
owned and operated by Jeeter Lester of 'Tobacco Road'
and the more grotesque of Faulkner's Mississippians."
—Bertha Harris, *New York Times Book Review*

**"Fiction at its most involving,
resonant and clear....**
There are layers of Christian symbolism here, in perverted
form, plumbed by few since Faulkner, and a portrait of a
woman as dehumanized and brutalized, yet alive, as the
women of Alice Walker's *The Color Purple*."
—*Publishers Weekly*

"Language as efficient as a good deer rifle,
as biting as a chain saw, as sad and beautiful as a mother-
less fawn.... We are present at the birth of a great
American artist. —Bruce DeSilva, *Hartford Courant*

THE BEANS
OF EGYPT, MAINE
CAROLYN CHUTE

$15.95 cloth, $7.95 paper
TICKNOR & FIELDS **3rd big printing before publication**
52 Vanderbilt Avenue, N.Y., N.Y. 10017

1985

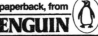

PRIMO LEVI

"has turned out to be one of the most valuable writers of our time."

—Alfred Kazin, Front Page Review, *The New York Times Book Review**

"An Italian Jewish chemist who is a survivor of Auschwitz and was for 30 years the manager of a paint factory has in his quiet way turned out to be one of the most valuable writers of our time.

"His wonderful series of autobiographical tales, 'The Periodic Table,' wove together the intimate relation of man to the chemical elements with accounts of his scientific inquiries.

"THE MONKEY'S WRENCH is an equally unexpected book, more genial and even more amusing than its predecessors...Faussone, a rough-talking character, cocky and irreverent, a womanizer when he has the time, a pain to his stiff-necked maiden aunts. Talking to Mr. Levi as his recorder and not altogether trustful of writers, he struts his way through one hair-raising assignment after another, unsure that he should be telling all this ...

"Ezra Pound said that more writers fail from lack of character than from lack of intelligence. Everything in Levi's excellent book represents an eminently healthy character expressing itself as curiosity, intelligence, a love of man at his positive best—man at work." *

And in his review of THE MONKEY'S WRENCH in the daily *Times*, Walter Goodman praises its **"glow of humane intelligence**...Faussone's tales are straightforward, entertaining and full of small accumulating revelations of what drives the rigger around the globe...By the end of these subtle tales, seemingly so simple yet complex, we are deep into the essentials, participating in an intimacy based on a shared passion for work."

"A remarkable narrative of a worklife as told to Primo Levi, who is as great a listener as he is a creative artist. The storyteller's whole being is stunningly revealed...."
—Studs Terkel

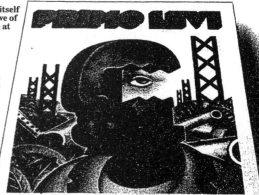

Primo Levi (left) with Philip Roth.

Philip Roth, Front Page Interview, *The New York Times Book Review*

"It is probably not as surprising as one might think to find that writers divide like the rest of mankind into two categories: those who listen to you and those who don't. Levi listens, and with his entire face, a precisely-modeled face tipped with a white chin beard that, at 67, is at once youthfully Pan-like but professorial as well, the face of irrepressible curiosity and of the esteemed *dottore*. I can believe Faussone when he says to Primo Levi early in THE MONKEY'S WRENCH, 'You're quite a guy, making me tell these stories that, except for you, I've never told anybody....'

"Of all the intellectually gifted artists of this century—and Levi's uniqueness is that he is even more the artist-chemist than the chemist-writer—he may well be the most thoroughly adapted to the totality of the life around him."

SUMMIT BOOKS
Simon & Schuster, Inc. • A G + W Company

1986

1986

1985

A N A GRAMS

LORRIE MOORE's

exciting①
unfailingly funny②
deeply touching③
first novel

Last year, her first book of stories, SELF-HELP, was resoundingly praised. Now the critics welcome her even more astonishing and magical first novel.

The N.Y. Times Book Review hails

"An extraordinary, often hilarious first novel
...an appealing heroine."　—CAROL HILL

①**"Filled with so much wit and grit, it's a delight**
to read...The book is unfailingly funny. Moore uses humor not as marginal comic relief. It's the book's soul."　—DAN CRYER, Newsday

"Startling, involving
...Her first novel is clever, funny, and touching...A talent to watch."　—Booklist

②**"The most exciting new fiction I've ventured across all year**
...Anagrams has all the wit and inveigling playfulness of Self-Help, plus an organic sophistication astonishing in a first novel...A prodigious novel."
—KAREN RILE, Philadelphia Inquirer

③**"Read Anagrams!**
It will bowl you over**
...Lorrie Moore's collection of stories, published last year, was an impressive debut...Yet good as it is, it doesn't begin to suggest the power of her very funny, very moving first novel...Its surface sparkles with wit...but underneath there's a seriousness of purpose that's deeply touching."
—ALICIA METCALF MILLER, Cleveland Plain Dealer

Published by Knopf

1986

GEEK LOVE

Katherine Dunn's

novel of circus freaks and family love
is

"Provocative, inventive, funny, grisly and hugely compelling
...Like most great novels, this one keeps the reader marveling at the daring of the author...Geek Love speaks directly to what it means to be human."
—KEN KALFUS, Philadelphia Inquirer

"Riveting... bizarre...Like all good yarns, it advances energetically and with vivid imagery...You'll find yourself laughing, too...It will keep you turning the pages."
—JAMES IDEMA, Chicago Tribune

"Geekiness,"
says the N.Y. Times **Book Review**, "the comic exploration of the peculiar as an end in itself, is what gives Geek Love its main success: that and Ms. Dunn's tremendous imagination...Along the way are dozens of peculiar characters, complicated passions and antipathies, buckets of jokes."—STEPHEN DOBYNS

"A tale-spinning machine [that] we are unlikely, ever, to forget... A novelist to watch and extol."　—PAUL WEST, Washington Post Book World

"There's nothing else quite like it
...Probably one of the most extraordinary American novels of this decade ...Like any great work of art, Geek Love creates its own rules and fleshes them into an unforgettable world."
—MICHAEL UPCHURCH, Seattle Times

Already in its 2nd printing
Knopf

1989

1983

"A young writer of such extraordinary gifts that one is tempted to compare his debut to Hemingway's." —Joyce Carol Oates, *New York Times Book Review*

"Breece Pancake's stories comprise no less than an American *Dubliners*."
—Jayne Anne Phillips,
author of *Black Tickets*

"A cumulative power rare in books of unlinked fiction....Everywhere we sense the intensity and the uniqueness of vision that all real writers must possess."
—David Bosworth, *Boston Globe*

The Stories of Breece D'J Pancake
—Foreword by—
James Alan McPherson
Afterword by John Casey

Serialized in *The Atlantic*
An Atlantic Monthly Press Book
LITTLE, BROWN and COMPANY

1983

Love, American Style. French Style. Vadim Style.

The French have a word for it. Vadim.
Roger Vadim, the famed French film director, tells what it's like to love and be loved by the three most beautiful women in the world.
In a book as frank as it is revealing, Vadim uncovers his love affairs with Brigitte Bardot, Catherine Deneuve, and Jane Fonda—three superstars whose names spell beauty, fame and fortune.

BARDOT DENEUVE FONDA

MY LIFE WITH THE THREE MOST BEAUTIFUL WOMEN IN THE WORLD
ROGER VADIM

—ON BARDOT:—
"Although she had a gift for infidelity, she always suffered if she had an affair with more than one man at a time...."

—ON DENEUVE:—
"Catherine was seventeen, and I was thirty-two. But age didn't make a difference. Neither did experience, for women know many things without needing to learn them...."

—ON FONDA:—
"Our erotic relationship was intellectually balanced between tenderness...and flights of great fantasy...."

Roger Vadim's candid, explicit, funny, and often deeply moving memoir stars three fascinating women who light up the screen and lit up his life. *Photographs*

Simon and Schuster

1986

The epic romantic novel millions of her readers have been waiting for.

THE RING is a love story so dramatic, it takes three generations to fulfill. It begins in Hitler's Germany, with the doomed extramarital affair of a wealthy German woman and a world-famous Jewish novelist. It continues when the woman's daughter, Ariana, is rescued from the Nazi terror by a German officer, only to encounter new tragedy and humiliation. It reaches fruition in present-day America, soon after Ariana's son learns his mother's guilty secret.

Danielle Steel is the author of seven international bestsellers with 10,000,000 copies in print. Her most ambitious and moving novel, THE RING, blends her unique gift for romance and glamour with a panoramic narrative of startling power and impact. "I was riveted to every page and totally engrossed. Ariana's story is turbulent, disturbing, and at times so touching I was frequently moved to tears. A sure-fire hit for old and new fans of Danielle Steel."—Barbara Taylor Bradford, author of *A Woman of Substance*

THE RING

A new national bestseller; $10.95 at all bookstores.

delacorte press

Danielle Steel
author of THE PROMISE

1980

"**Breathlessly exciting** It may be the most satisfactory novel of a sea chase since C.S. Forester perfected the form." — *The Washington Post*

"**First-rate by any standards** I couldn't put it down." — **Jack Higgins**

"**An iron and guts tale** about an undersea world most readers are only vaguely aware exists." — **Clive Cussler**

The Hunt for RED OCTOBER

A NOVEL BY TOM CLANCY
$14.95/388 pages ISBN: 0-87021-285-0

This high-tech thriller, played out in the murky depths of the Atlantic, is
Now At Your Local Bookstore
OR DIRECT FROM
The Naval Institute Press • Annapolis, Maryland • 21402

1984

KAL Flight 007.
Finally, the *truth*.

Only one man has the skills, the tenacity and the high-level contacts to solve the Flight 007 mystery: Pulitzer Prize-winning journalist Seymour M. Hersh.

On September 1, 1983, a Korean Air Lines civilian jet, flying off course over Russia's Sakhalin Island, was shot from the skies by a Russian interceptor—killing all 269 passengers and crew. The next morning, Secretary of State Shultz branded the event an "appalling act." But the Soviets insisted that Flight 007 had been a spy plane, not a passenger plane.

Now America's #1 journalist, Seymour M. Hersh, answers the many questions surrounding the Flight 007 story. A compelling, harrowing, hour-by-hour account of the tragedy and its aftermath, *"The Target Is Destroyed"* is a book that reveals exactly what can happen when sophisticated technology is combined with incompetence, deception, and terrifying misunderstandings.

The true story, the definitive story, and—until now—the *undisclosed* story of Flight 007, *"The Target Is Destroyed"* tells it all for the very first time.

A Book-of-the-Month Club Alternate
Now at your bookstore

🏠 RANDOM HOUSE

SEYMOUR M. HERSH
"The Target Is Destroyed"
What Really Happened To Flight 007
And What America Knew About It

Photo: ©Paul Hosefros

1986

3 by *Cormac McCarthy*

OUTER DARK
$7.50 paper

CHILD OF GOD
$7.50 paper

and

THE ORCHARD KEEPER
$6.95 paper

THE ECCO PRESS
18 West 30th Street, New York 10001

Distributed by W.W. Norton & Company, Inc.
500 Fifth Avenue, New York 10110

1984

Norman Mailer has discovered a major literary voice... Jack Henry Abbott

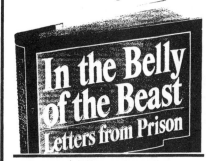

In the Belly of the Beast
Letters from Prison

From Norman Mailer's Introduction...

"In all his adult life Abbott has spent six weeks in the world. He knows prison like the ferryman knows the crossing to Hades...[Reading his letters] I felt all the awe one knows before a phenomenon. Abbott had his own voice. I had heard no other like it. He had an eye for the continuation of his thought that was like the line a racing driver takes around a turn. He wrote like the devil, which is to say that he had a way of making you exclaim to yourself as you read, 'Yes, he's right. My God, yes, it's true.' Needless to say, what was true was also bottomless to contemplate. Reading Abbott's letters did not encourage sweet dreams. Hell was now very clear to behold. It was Maximum Security in a large penitentiary."

"One of the most important books of our age...bold and penetrating."
—*Vogue*

"Remarkably forceful and eloquent." —*Publishers Weekly*

"He is a strong, powerfully expository writer." —*Kirkus Reviews*

$11.95, now at your bookstore **RANDOM HOUSE**

1981

DAUGHTER OF DESTINY

"The woman who emerges in these pages is remarkably free of pomposity, pretense or self-justification."
—Elise O'Shaughnessy, *Chicago Tribune Books*

"A timely and important book by a beautiful, intelligent and well educated woman who, through her tenacity and dedication to her father's memory, emerged from political persecution and exile to become one of the few female leaders of the 20th century.... By her own example, she could improve the status of women in Pakistan."
—Nien Cheng, author of *Life and Death in Shanghai*

"An engrossing story of personal courage and conviction."
—*Booklist*

"A fascinating portrait of the Bhutto family."
—Bruce Palling, *New York Times Book Review*

"A fascinating look at a Western-educated politician promoting democracy in an Islamic country with a history of military rule."
—Caryn James, *New York Times*

"Bhutto writes with poise and passion."
—*Publishers Weekly*

"Enchanting and moving.... Does not disappoint. The heroes are saintly, the villains drip with poison. There are years of exile; there is the wonderful combination of Western high life and ancient Oriental culture; and, finally, there is victory, made all the sweeter for the difficulties of the quest."
—Ian Buruma, *New York Review of Books*

"A remarkable story of adversity, corruption, and brutality, despair and courage: culminating with Benazir Bhutto's unique triumph as first woman president in the Muslim world."
—Alastair Horne, author of *The Price of Glory*

A BOOK-OF-THE-MONTH CLUB ALTERNATE SELECTION

AN AUTOBIOGRAPHY

BENAZIR BHUTTO

1989

"An Arabian nights entertainment...Rushdie's ambitions are huge, and his creativity triumphantly matches them."
—Nadine Gordimer

Salman Rushdie, the internationally acclaimed author of *Midnight's Children* and *Shame*, has written a novel that confirms his stature as one of the most daring, brilliant, and imaginative novelists at work today. In THE SATANIC VERSES, he takes us on an epic journey of tears and laughter, of bewitching stories and astonishing flights of the imagination, a journey toward the evil and good that lies entwined within the hearts of women and men.

"Exhilarating...a roller-coaster ride over a vast landscape of the imagination...a populous, loquacious, sometimes hilarious, extraordinary contemporary novel"
—Angela Carter

"A masterpiece... It is writing of unparalleled power."—Bill Buford, *The Sunday Times* (London)

"The most exciting, original, and generous writer of his generation"
—Andrew Harvey, *Elle*

"Salman Rushdie is a storyteller of prodigious powers, able to conjure up whole geographies, causalities, creatures, customs, out of thin air." —A.G. Mojtabai, *The New York Times Book Review*

The Satanic Verses
Salman Rushdie

At bookstores now

VIKING
Penguin USA

1989

COMING OF AGE IN THE 1960's, YOU HAD TWICE AS MUCH INNOCENCE TO LOSE.

**"AN ENDURING LITER-
ARY ACHIEVEMENT....
This astonishing book
establishes Jayne Anne
Phillips as a novelist
of the first order."**
—*The New York Times*

**"A RARE AND IMPORTANT
WORK OF FICTION...
deeply felt, vividly imag-
ined...a mirror for us all."**
—*Newsday*

**"ONE OF THE FINEST NOV-
ELS IN CONTEMPORARY
FICTION.... Penetrates
into our yearning and our
dreams."**
—*The Wall Street Journal*

**"REACHES ONE'S DEEPEST
EMOTIONS. No number of
books read or films seen
can deaden one to the inti-
mate act of art by which THIS
WONDERFUL YOUNG WRITER
HAS PENETRATED THE DEFINI-
TIVE EXPERIENCE OF HER
GENERATION."**
—Nadine Gordimer

Once in a while there comes a novel
that touches our yearnings and our dreams
with stunning truthfulness, special intensity.
Machine Dreams is such a novel.

Jayne Anne Phillips captures the essence
of American life from the Depression to Viet-
nam, telling the story of one ordinary family's
experiences in a nation's extraordinary times.

Mother and daughter, father and son: their
story becomes your story, because it reveals the
inescapable demands of time, the relentless force
of change, and—ultimately—the triumphant
power of love.

**"AMONG THE WISEST
OF A GENERATION'S
ATTEMPTS TO GRAP-
PLE WITH A WAR
THAT MAIMED US ALL."**
—*The Village Voice*

**"ONE OF THE GREAT
BOOKS OF THIS
DECADE....Jayne Anne
Phillips is a blessing."**
—Robert Stone

**"A VISION OF THE
IMMENSE MEANING OF
MODEST LIVES AND
COMMON EVENTS."**
—E.L. Doctorow

**"BUY THIS SPECTACULAR
BOOK!... Jayne Anne
Phillips is a sorceress, a
witch. She blows on this
material, fills it with air,
makes it shimmer and fly....
Machine Dreams is a novel
so brilliant that it sticks in
your head long after you
read it."** —*Los Angeles Times*

**POCKET BOOKS
Now in paperback!**

1985

Paul Auster

"A literary original who... has reaffirmed the dignity of elegant, intricate plots." —*The Wall Street Journal*

Arturo Patten

"Auster's most accessible, engaging book. He treats us to his best clear-eyed prose."
—*The New York Times Magazine*

"Rich and complex...with fully fleshed characters, fast-paced plot, thematic sophistication and narrative cunning."
—*Boston Globe*

"Unnerving... Contains occasional patches of gorgeous prose, but more often the style is deliberately spare, a stainless steel string for all the gaudy narrative beads."
—*Washington Post Book World*

"He can write with the speed and skill of a self-assured pool player, sending one bizarre event ricocheting neatly and unexpectedly into the next."
—Michiko Kakutani, *The New York Times*

"Auster's sleight of hand imbues his work with a haunting sense of the uncanny." —*San Francisco Chronicle*

LEVIATHAN

A NOVEL

Illustration: Melissa Hayden

Also available in Penguin paperback *The Invention of Solitude* and *In the Country of Last Things*

PAUL AUSTER
THE NEW YORK TRILOGY
CITY OF GLASS
GHOSTS
THE LOCKED ROOM

"Satisfying, even electrifying."

PAUL AUSTER
MOON PALACE

"Shimmers with mysteries."

PAUL AUSTER

"Rich, dazzling."

"Six days ago a man blew himself up by the side of the road..." Paul Auster's daring new novel begins with the facts of a death, and goes on to set down the events of the life preceding it. For the narrator of the story, Peter Aaron, the task is deeply personal. The dead man had been his friend through fifteen years, two divorces, and uncounted moments of intimacy and betrayal.

At bookstores now VIKING
Penguin USA

1992

THE
1990s

As the century drew to a close, old ideas about how to advertise books came back. One of the last advertisements in this book is nearly identical to one of the very first. Flip back to 1900 and look at the ad for Rudyard Kipling's novel *Kim*. Now look at the very similar 1995 ad for Andrew Sullivan's book *Virtually Normal*.

The book advertisements from the 1990s are interesting to scan for blurbs and language, but visually they broke little ground. Take, for example, Alfred A. Knopf's busy advertisement for Norman Rush's lovely 1991 novel *Mating*. It's merely a collection of quotes, under an often-used exclamation ("Breathtaking!"). But the best language is supplied by the publisher: "SHE is the narrator. HE is the object of her pursuit. The setting is Botswana. The medium is wit."

The bold type on an ad for Nicholson Baker's 1994 novel *The Fermata* slyly suggested the work's content—which is delicious but makes one queasy—and made you want to pick the book up: "When sex is great, time stands still. Or is it the other way around?" And an ad for the actress Claire Bloom's 1996 memoir *Leaving a Doll's House* read: "Nothing in Claire Bloom's life as a woman could have prepared her for Philip Roth." (Were the words "as a woman" entirely necessary?)

The 1992 advertisement for Michael Ondaatje's novel *The English Patient* demonstrates that when it comes to delivering words of praise for a book, even the very best novelists can sound like mere mortals. This ad's lineup includes panegyrics from Toni Morrison ("profound, beautiful and heart-quickening"), Don DeLillo ("A masterful novel . . . rich and compelling"), Richard Ford ("an exotic, consuming and richly inspired novel of passion"), and Russell Banks ("One of the best novels I have read in years").

Barack Obama entered America's consciousness in 1995, the year Times Books published his memoir *Dreams from My Father*. Charlayne Hunter-Gault nailed it when she said this was "one of the most powerful books of self-discovery I've ever read." ◆

1996

1994

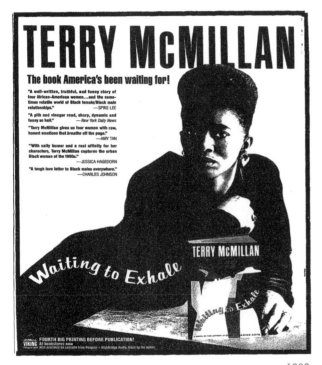

1992

THIS WILD DARKNESS
The Story of My Death

HAROLD BRODKEY

"The insistence on truth is what gives Brodkey's memoir its somberly illuminating power, a very modern kind of heroism, a gesture of courageous and undefensive candor, and a surprising and deeply affecting book."
—Eva Hoffman, *The New York Times Book Review*

"Exemplary...A contemporary *Death of Ivan Ilyich*... How moving is this production of clear, honest, beautifully crafted sentences, right up to the very end."
—Phillip Lopate, *Newsday*

"A tour de force of brilliant observation and cranky willfulness...a brave, uncompromising book."
—Ralph Sipper, *Los Angeles Times Book Review*

"A heartfelt and sometimes heartbreaking memoir... Again and again, Brodkey catches us with such graceful, ghastly insight."
—Margaria Fichtner, *The Miami Herald*

Available at bookstores everywhere

metropolitan books
AN IMPRINT OF HENRY HOLT AND COMPANY

1996

"Breathtaking!"*

NORMAN RUSH's novel astonishes, moves and charms the critics

"Exhilarating ...vigorous and luminous"

The N.Y. Times Book Review describes the pleasure in store for the reader

"Few books evoke so eloquently the state of love at its apogee...

'For me, love is like this,' the narrator tells us, 'you're in one room or apartment which you think is fine, then you walk through a door and close it behind you and find yourself in the next apartment which is even better, larger, a better view. You're happy there and then you go into the next apartment and close the door and this one is even better. And the sequence continues ...each time your new quarters are manifestly better, and each time it's breathtaking, a surprise...'

It's a measure of the success of this novel that the above also describes the reader's experience of Mr. Rush's vigorous and luminous prose."

—From the review by JIM SHEPARD

"Brilliantly written ...utterly sui generis!

It defies comparison with the usual woman-meets-man novels

...Rush has alerted us to the transfiguring power of passion...He deploys the narrative voice with such brio, such wit and perceptiveness...*Mating* is a free standing structure. It is open on many sides, but holds at its center that wonderful nest of paradoxes, the human heart."

—SVEN BIRKERTS in Mirabella

"A charming free-fall novel

...Fireworks sizzle, brain and body chemistry go wild [when the heroine-narrator meets her quarry]...She's a kind of post-Joycean Wonder Girl, her wryness being her most constant companion... It's no wonder Nelson Denoon loves her; what's somewhat more amazing is that they ever find each other...Exhilarating."

—GAIL CALDWELL, Boston Globe

It is a novel about two brilliant, attractive Americans on the loose (one of them on the prowl) in Africa in the 1980s. SHE is the narrator. HE is the object of her pursuit. The setting is Botswana. The medium is wit. The subject is love and the real world.

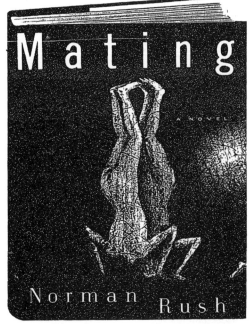

The N.Y Times hails "A simultaneous aura of high comedy and deep gravity

...It penetrates the continent [of Africa] itself. [It] draws the reader steadily in. Not toward the heart of darkness but toward brilliant illumination."

—CHRISTOPHER LEHMANN-HAUPT

"This novel is not to be missed

...Extraordinarily stylish and intelligent, deeply resonant of place and character, and all of it delicately striated with humor...A splendidly eloquent evocation of Africa, as well as of universal male-female natures. Wrought with both verve and soul."

—Booklist

By the author of *Whites* • Already in its 2nd printing

Just published by Knopf

"Witty, intense, totally absorbing ...On almost all counts Rush has succeeded gloriously

...An intricately nuanced portrait of [two] people as passionate about ideas as they are about each other."

—DAN CRYER, Newsday

*"A complex and moving love story... breathtaking in its cunningly intertwined intellectual sweep and brio

...A peculiarly beautiful novel...Denoon and the narrator are such original creations, so completely and triumphantly imagined, that one can't help but silently join in on their freewheeling conversations as they cajole and joke in tandem...*Mating* is beyond doubt a major novel. A masterly combination of picaresque adventure, utopian fiction and a complex and moving love story."

—PHILLIP GRAHAM, Chicago Tribune Books

"It's about everything worth thinking about," says Grace Paley

"—the necessary struggle to create a humane society, how hard it is for women and men to love and live together. The woman narrator has brains, bravery, and determination, an unusual heroine to enter our literature."

"*Mating* is a marvelous novel,

one in which a resolutely independent voice claims new imaginative territory ...Among other things it is a convincing representation of love between two highly cerebral yet thoroughly human and likable people, the best rendering of erotic politics, I think, since D.H. Lawrence...The voice of Rush's narrator is immediate, instructive and endearing ...She is a brilliant creation."

—THOMAS R. EDWARDS, New York Review of Books

THE ENGLISH PATIENT

A new novel by **Michael Ondaatje**

"He has enveloped the reader in a rare and spellbinding web of dreams

…He has fashioned a magic carpet of a novel that soars across worlds and time."—Pico Iyer, TIME Magazine

"It should establish Mr. Ondaatje as one of North America's finest novelists
…The surreal collagelike narratives are totally absorbing…The spell of his haunted villa remains with us inviting us to return and reread passages for the pure pleasure of being there."
—Edward Hower, Wall St. Journal

"An extraordinary novel…poetic, philosophical, moving"
—James Runcie, Daily Telegraph, London

"The best piece of fiction I've read in English in several years"
—Edmund White, The Independent, London

"Yet another dazzler by this accomplished novelist and poet.
Ondaatje seems to whisper, even confess, each scene to his readers."
—Library Journal

"A masterpiece…an extraordinary novel"
—J.D.F. Jones, Financial Times, London

"Sensuous, mysterious, rhapsodic, it transports the reader
to another world, and uncovers that world's connection to our own…The English Patient offers Ondaatje's most probing examination yet of the nature of identity."
—Michael Upchurch, on the front page of San Francisco Chronicle Books

"It is a difficult novel to leave behind for it has the external grip of a war romance and yet the ineffable pull of poetry."
—Gail Caldwell, on the front page of Boston Globe Books

"A narrative of astonishing elegance and power…
It should be recognized as one of the finest novels of recent years—large, rich, and profoundly wise."
—Vince Passaro, Mirabella

Hailed by TONI MORRISON
"Profound, beautiful and heart-quickening"

DON DELILLO:
"A masterful novel… rich and compelling"

RICHARD FORD:
"An exotic, consuming and richly inspired novel of passion.
In its elegance and its satisfactions it resembles no book I know."

RUSSELL BANKS:
"One of the best novels I have read in years"

What happens
IN A DESERTED ITALIAN VILLA, during the last moments of World War II, four people come together. "One by one," says TIME, "Ondaatje introduces his characters, and slowly he unlocks their secrets, leading us through their lives as through the darkened corridors of a huge and secret house…Scene after scene shimmers [with] jeweled brilliance."

"It seduces and beguiles us with its many-layered mysteries,
its brilliantly taut and lyrical prose, its tender regard for its characters…On every page The English Patient pulses with intellectual and aesthetic excitement."
—Dan Cryer, Newsday

"A tale of many pleasures –
an intensely theatrical tour-de-force but grounded in Michael Ondaatje's strong feeling for distant times and places."
—Judith Grossman, New York Times Book Review

"A wise and graceful book"
—The Sunday Times, London

"Ondaatje's language is of such riveting beauty that one is made to stop and stare."
—Sally Laird, The Observer, London

"A magically told novel…
The motivating power comes in part from story and character but even more from white flashes of phrase or image. It is a night journey; we move from one starshell burst to the next, and the countryside shows suddenly familiar and strange."
—Richard Eder, Los Angeles Times

Winner of the 1992 Booker Prize
Already in its 4th printing • Just published by Knopf

1992

Haruki Murakami

"Murakami is a genius of sorts"—Chicago Tribune
"Murakami [is] some kind of wizard"—New York Magazine

THE WIND-UP BIRD CHRONICLE

"This overwhelming tidal wave of a story [is] absolutely mesmerizing, befuddling, unaccountably brilliant."—Booklist

"A bold and generous book"
says the New York Times Book Review, hailing
"The brilliance of his invention…"

Western critics searching for parallels have variously likened him to Raymond Carver, Raymond Chandler, Arthur C. Clarke, Don DeLillo, Philip K. Dick, Bret Easton Ellis and Thomas Pynchon—a roster so ill assorted as to suggest that Murakami may in fact be an original…And no matter how fantastical the events the novel describes may be, the straight-ahead storytelling never loses its propulsive force."
—Jamie James

TIME calls Murakami "a postwar successor [to] the Big Three of modern Japanese literature: Mishima, Kawabata and Tanizaki
…A cool 48-year-old who once ran a jazz bar, has translated John Irving, Truman Capote and Raymond Carver into Japanese, Murakami has been perfectly positioned to serve as the voice of hip Westernized Japan. His Norwegian Wood sold more than 2 million copies around the globe. Yet none of his earlier books prepare us for his massive new Wind-Up Bird Chronicle, which digs relentlessly into the buried secrets of Japan's recent past."
—Pico Iyer

"Murakami's variations on some of the main idioms of recent American fiction yield a vision no American novelist could have invented."
—A.O. Scott, Newsday

"The Wind-Up Bird Chronicle soars, thanks to Murakami's virtuosic control of his characters and his complex, disturbing view of human nature."
—Ben Greenman, Time Out N.Y.

"Mesmerizing, original…fascinating, daring, mysterious and profoundly rewarding"
—Joan Mellen, Baltimore Sun

"'Every secret struggles to reveal itself,' Isaac Bashevis Singer once wrote. That's exactly what happens in The Wind-Up Bird Chronicle, and that's precisely why the book is so compelling and ultimately so convincing."—Jonathan Kirsch, Los Angeles Times

"As sculpted and implacable as a bird by Brancusi"
says New York Magazine
—and explains:
"The apparent simplicity of Murakami's expression… nearly disguises the fact that The Wind-Up Bird Chronicle is, in the most time-honored sense, an epic…Tallamanic items—a baseball bat, a bottle of Cutty Sark, the overture to Rossini's Thieving Magpie, the cry of the wind-up bird—migrate ceaselessly among material, historical and metaphysical realms… Every character, every story, nearly every circumstantial detail appears to connect with every other in some ectoplasmic cat's cradle… In the meantime, you just travel through the narrator's adventures, drawn along as hypnotically as he is."
—Luc Sante

"A major work…a fully mature, engrossing tale of individual and national destinies entwined. It will be hard to surpass."
—Kirkus Reviews

Translated by Jay Rubin
Just published by Knopf
Visit Knopf's Borzoi Reader: www.randomhouse.com/knopf/borzoi

1997

WALTER MOSLEY

introduces Socrates Fortlow, a hero of stunning originality, in his most powerful and eloquent work to date.

Seeking to restore order to the mean streets of Watts, tough, brooding ex-convict Socrates Fortlow is Walter Mosley's most compelling character since the immortal detective Easy Rawlins. In Always Outnumbered, Always Outgunned, Socrates is a man in search of morality in a crime-ridden, poverty-stricken, racist world.

"Hard-hitting, unrelenting, poignant…" —Booklist (starred review)

NORTON Independent publishers since 1923 http://www.wwnorton.com

1997

256 ✦ READ ME

1997

1994

1996

1994

"Minot takes age-old riddles about love and marriage—and gives them a peculiar twist.... This is Minot at her uncanny best."
—DEBORAH GARRISON, *The New Yorker*

"Dazzling....FOLLY places her beside the most gifted of our young writers." —ANDY SOLOMON, *Chicago Tribune*

"Utterly compelling....Minot's most persuasive, most mature work of fiction." —DAN CRYER, *Newsday*

"Rich with pleasures from start to end." —*Kirkus Reviews*

Folly
A Novel
Susan Minot

A BOOK-OF-THE-MONTH CLUB SELECTION

HOUGHTON MIFFLIN / SEYMOUR LAWRENCE

1992

1995

1996

DREAMS

FROM MY

FATHER

A Story of Race and Inheritance

BARACK OBAMA

"One of the most powerful books of self-discovery I've ever read. Paced like a good novel."
— Charlayne Hunter-Gault, author and journalist

"We learn in Barack Obama's soaring book that survival demands resilience in the face of frustrated expectations, and that one's committed opposition to America's obsession with color cultivates a vision of life that is nourished by struggle."
— Derrick Bell, author of
Faces at the Bottom of the Well

"An honest, often poetic memoir about growing up biracial."
— *Kirkus Reviews*

"An exquisite, sensitive study of this wonderful young author's journey into adulthood. Perceptive and wise, this book will tell you something about yourself whether you are black or white."
— Marian Wright Edelman,
President, Children's Defense Fund

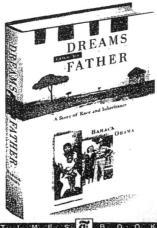

TIMES BOOKS

1995

Acknowledgments

I owe thanks to many who offered invaluable assistance in the compilation and writing of this book. My first debt is to my wise agent, Sarah Chalfant of the Wylie Agency, who placed this book in the attentive and cheerful hands of the editors Daniel Halpern and Matt Weiland at Ecco. Thanks to Mary Austin Speaker at Ecco for her intuitive design. Edward Orloff of the Wylie Agency provided smart and timely advice on many occasions. I'd also like to thank two researchers, Sophie Fels and Brian Dwyer, who helped me pore through thousands of pages of newspapers and magazines, online and off.

Any errors in this book are entirely my own, but I would like to thank Michael Winship, Iris Howard Regents Professor of English II at the University of Texas at Austin, for reading an early version of the introduction and catching mistakes as well as making suggestions for amplifications and further reading.

Thank you to the publishers of Ballantine Books; Basic Books; Crown Books; Dial Press; Doubleday; Dutton; Ecco; Farrar, Straus & Giroux; Free Press; Grove/Atlantic; Harmony Books; HarperCollins Publishers; Holt; Houghton Mifflin Harcourt; Alfred A. Knopf; Little, Brown and Company; Macmillan; McGraw Hill; Modern Library; William Morrow; New Directions; W. W. Norton & Company; Pantheon Books; Putnam; Random House; Regnery Publishing; Scribner;

Simon & Schuster; Viking; and Wiley for permission to reprint these advertisements.

Thank you to Robert Silvers and Eve Bowen of the *New York Review of Books* for trusting me with rare back issues.

Thank you to Katherine Bouton, Robert Harris, Charles McGrath, Sam Sifton, Laura Sonnenfeld, Mick Sussman, and Sam Tanenhaus at the *New York Times*.

For their steady encouragement, advice, and good cheer, I would finally like to thank: Jonathan and Catherine Miles, R. W. Rappel, Lynn Hawley and Walter Garschagen, Elizabeth Gilbert and Jose Nunes, Erin Hanley and David Weinstein, Paula Routly and Tim Ashe, Charles Taylor and Stephanie Zacharek, George Marcou, D. Fred Garner, Jane Orr DeRollo, Bruce LeFavour and Faith Echtermeyer, and—most importantly—my wife, Cree LeFavour.

Bibliography

Anonymous. "Advertising." *The Eclectic Magazine of Foreign Literature*, October 1855.

Anonymous. "Literary Intelligence." *American Publisher's Circular and Literary Gazette*, May 7, 1859.

Baury, Louis. "Art in Publicity." *The Bookman*, October 1912.

Benton, Megan L. *Beauty and the Book: Fine Editions and Cultural Distinctions in America*. New Haven: Yale University Press, 2000.

Bowers, Fredson. *Principles of Bibliographical Description*. Winchester: St. Paul's Bibliographies, 1994.

Carter, Robert A. "Why Does a Publisher Advertise?" *Publishing Research Quarterly* 14 (1998): 52.

Casper, Scott E., Joanne D. Chaison, Jeffrey D. Groves, eds. *Perspectives on American Book History: Artifacts and Commentary*. Amherst: University of Massachusetts Press, 2002.

Cholmondeley, Mary. "An Art in its Infancy." *The Living Age*, July 27, 1901.

Collins, Jas. H. "Notes for a History of Book Puffery." *The Bookman*, September 1906.

Coser, Lewis A., Charles Kadushin, and Walter W. Powell. *Books: The Culture and Commerce of Publishing*. New York: Basic Books, 1982.

Eaton, Walter Prichard. "Three Great American Printers." *The Bookman*, August 1924.

Finkelstein, David, and Alistair McCleery, eds. *Book History Reader*. London: Routledge, 2002.

Grannis, Chandler B., ed. *What Happens in Book Publishing*. New York: Columbia University Press, 1967.

Hoggart, Richard. *The Uses of Literacy*. New Brunswick: Transaction Publishers, 1992.

Johns, Adrian. *The Nature of the Book*. Chicago: University of Chicago Press, 1998.

Lears, Jackson. *Fables of Abundance: A Cultural History of Advertising in America*. New York: Basic Books, 1994.

Lehmann-Haupt, Hellmut. *The Book in America*. New York: R.R. Bowker Co., 1952.

Ohmann, Richard, ed. *Making and Selling Culture*. Hanover: Wesleyan University Press, 1996.

———*Politics of Letters*. Hanover: Wesleyan University Press, 1987.

———*Selling Culture: Magazines, Markets, and Class at the Turn of the Century*. London: Verso, 1998.

Tassin, Algernon. "The Story of Modern Book Advertising." *The Bookman*, April 1911.

Tebbel, John William. *A History of Book Publishing in the United States, Vols I-IV*. New York: R.R. Bowker Co., 1972-1981.

Turner, Catherine. *Marketing Modernism Between the Two World Wars*. Amherst: University of Massachusetts Press, 2003.

Winship, Michael. "Uncle Tom's Cabin: History of the Book in the 19th-Century United States." Paper presented at the June 2007 "Uncle Tom's Cabin in the Web of Culture" conference, Hartford, Connecticut.

Author Index